EDWARD STEICHEN

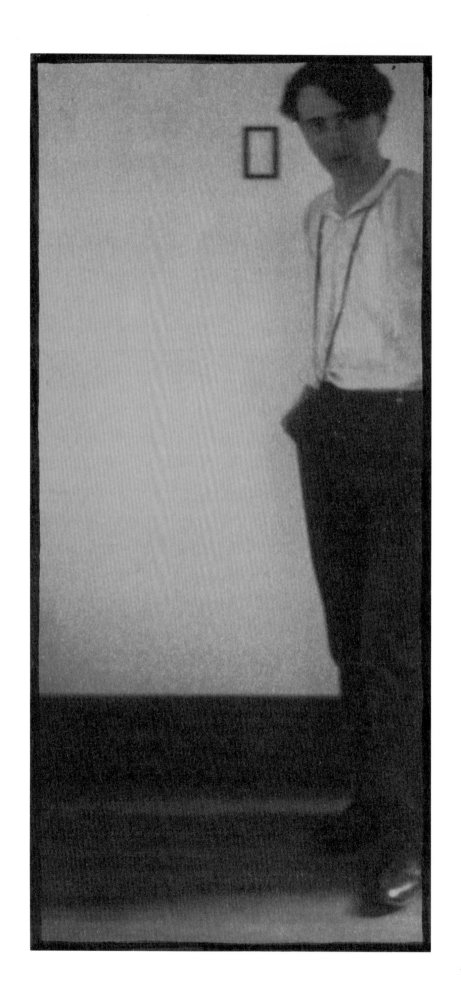

EDWARD STEICHEN

THE EARLY YEARS

JOEL SMITH

PRINCETON UNIVERSITY PRESS

IN ASSOCIATION WITH

THE METROPOLITAN MUSEUM OF ART

This publication is made possible in part by a grant from the Horace W. Goldsmith Foundation

Published by Princeton University Press in association with The Metropolitan Museum of Art, New York

Princeton University Press, 41 William Street, Princeton, New Jersey 08540
In the United Kingdom: Princeton University Press, Chichester, West Sussex

Frontispiece: Edward Steichen, *Self-Portrait*, 1899. Platinum print. The Metropolitan Museum of Art, New York.

Alfred Stieglitz Collection, 1933 (33.43.1)

Second Printing, 1999

Printed and bound in Italy

10 9 8 7 6 5 4 3 2 1

Library of Congress Cataloging-in-Publication Data

Smith, Joel, 1964–

Edward Steichen : the early years / Joel Smith.

p. cm.

ISBN 0-691-04873-8 (alk. paper)

1. Photography, Artistic. 2. Steichen, Edward, 1879–1973.

I. Steichen, Edward, 1879–1973. II. Title.

TR653.S595 1999 779'.092—dc21 99-26617 CIP

CONTENTS

FOREWORD

· 7 ·

EDWARD STEICHEN: THE EARLY YEARS

· 9 ·

PLATES

· 47 ·

NOTES ON THE PRINTS

· 161 ·

LIST OF PLATES

· 163 ·

FOREWORD

The beginnings of photography at the Metropolitan Museum of Art are grounded in the generosity and foresight of Alfred Stieglitz. He assured the medium's future in this institution, first rather quietly in 1928, when he made a select donation of his own recent work, then spectacularly in 1933, with a gift of over four hundred pictures by members of the Photo-Secession, the turn-of-the-century movement that under his direction had led the call for photography's recognition as a fine art. At the core of the 1933 gift were fifty-two magnificent prints by Edward Steichen, the first and most crucial of Stieglitz's allies in the Photo-Secession, its journal *Camera Work,* and its gallery 291. The work of Steichen's youth is more than just a time capsule in which the origins of twentieth-century notions of glamour and celebrity were preserved. It is the art of a master printer, whose high aesthetic ambitions for photography as a medium of exquisitely rendered objects had been a revelation even to Stieglitz, his putative mentor. Steichen's own cache of prints and negatives suffered irremediable damage in France during World War I, and in later years the artist looked upon the Metropolitan's holdings as the definitive record of his early aims and achievements as a photographer.

Remarkably, Steichen's photographs—the jewel in the crown of the Museum's Alfred Stieglitz Collection—have escaped close study as a group until this, the centennial of the earliest images among them. Maria Morris Hambourg, Curator in Charge in the Department of Photographs, noticed the need and opportunity for a reassessment of Steichen's early career as she completed work on her revealing 1998 exhibition, *Paul Strand circa 1916*. In Strand's early work, Hambourg had discovered a symbiosis between the vision of an original young artist and the polemical aims of a visionary—Stieglitz—who was never greater than in his willingness to convert himself and his gallery audience into pupils of the new. What would the young Steichen's story look like without the trappings of the Stieglitz-woven narrative through which it had always been understood? Were the Photo-Secession's beginnings, like its closing years, in large part the reflection of energies other than Stieglitz's own? Hambourg posed these questions to Joel Smith, former Jane and Morgan Whitney Fellow in the Department of Photographs. In this volume, Smith has reexamined the basic character of America's first modernist institutions, tracing Steichen's distinctive role within the international avant-garde of the Belle Epoque and finding between him and Stieglitz one of the remarkable partnerships, like that between Picasso and Braque, through which the promise of a century was invented.

At the Metropolitan Museum of Art, Nora Kennedy, Conservator for Photographs, and Dana Hemmenway, Mellon Fellow in Conservation, analyzed and treated Steichen's prints so that they might be accurately described and reproduced. Laura Muir, Research Associate in the Department of Photographs, expertly coordinated the many aspects of assembling the contents of this volume. Susan Chun in the Editorial Department steered this project through its early stages. At Princeton University Press, the team of Patricia Fidler, Editor, Curtis Scott, Production Editor, and Ken Wong, Production Manager, provided the guidance and expertise that resulted in this beautiful book. Finally, we are pleased to acknowledge the generous support of the Horace W. Goldsmith Foundation and the Spears Fund of the Department of Art and Archaeology, Princeton University.

It is our hope, as always, that this handsomely illustrated volume will convey much of the richness of surface and spirit found in Edward Steichen's early work, and that our readers will become visitors, experiencing these masterpieces in the original on repeated trips to the Metropolitan Museum of Art.

Philippe de Montebello
Director

EDWARD STEICHEN

THE EARLY YEARS

n the final years of the nineteenth century, the dialogue between industry and handicraft in the visual arts received fresh input from a new quarter. The British designer and educator William Morris had forged the nostalgia of the Pre-Raphaelite painters into the credo of the progressive Arts and Crafts movement, which heralded the virtues of handwork as a school of personal integrity, the private home as a proving ground for the aesthetic quality of wares, and the skill of united craftsmen as a bulwark against the cheap anonymity of modern factory production. Morris's vision became associated, over time, with another one: that of Aestheticism, a movement epitomized in the decorative sensibility of the painter James McNeill Whistler, which advanced the pleasures of "art for art's sake."

By 1890, Arts and Crafts objects had found a place in the exhibition programs of Continental avant-gardist groups such as Belgium's L'Esthetique Libre and the Secession movements of Germany and Austria, for whom the integrated display of the fine and applied arts expressed dissent from state-run academies and salons. Among the more isolated artists on American shores, on the other hand, dozens of localized Arts and Crafts movements and Aestheticist periodicals arising in the 1890s augured at once the dawning of cosmopolitanism and a new democratization of taste.

A new kind of visual populism came to art's back door with the advent of the box camera, a marketing sensation that swept the world in the 1890s. The Kodak's slogan, "You press the button, we do the rest," foretold photography's future as a medium of the masses: effortless, ubiquitous, and, in the eyes of artistic elites, trivial. As the 1890s progressed, camera clubs in large cities everywhere became sites of conflict between those amateurs for whom "snapshooting" was just a part of a weekend outing, and a more serious breed of photographers who called themselves pictorialists, since their photographs looked like "pictures," meaning paintings. Their efforts ranged in aes-

thetic orientation from Pre-Raphaelite polish to Impressionist tactility (figs. 1, 2), but the pictorialists agreed upon the essential validity of modeling the photograph's aesthetics after those of the established fine arts.[1]

Entwined with the pictorialists' ambition to make photographs morally salutary—an Arts and Crafts ideal—was the Aestheticist notion of earning them value and status as art objects. Photographs had seldom yet found their way onto museum walls, a goal that some pictorialists came to realize would elude them as long as they remained attached to the apparatus of the hobby club. In the late 1890s, aesthetic photographers increasingly broke off to form new groups of their own, such as L'Effort in Brussels, the Photo-Club de Paris, and the Kamera-Club of Vienna. But the most prestigious of the pictorialist "secessions" was a London group called the Brotherhood of the Linked Ring, the product of a major falling-out in England's Royal Photographic Society in 1893. The Ring's annual autumn salon, founded that year, had come to rival the Royal's own by 1900.[2]

No exclusively pictorialist camera clubs had yet taken shape in the United States, although the painter-dominated jury of the Philadelphia Photographic Salon did look kindly—and not without controversy—upon "artistic" photographs.[3] A handful of American photographers had even been elected into the company of the London "Links." The most prominent figure among them, respected even in European pictorialist circles, was Alfred Stieglitz of the Camera Club of New York. A thirty-six-year-old German-educated son of cultured Jewish immigrants, Stieglitz was attempting to use his position as editor of the club's beautifully printed quarterly journal, *Camera Notes*, to educate, cajole, and shame his fellow amateurs into recognizing the superiority of artistic photography to other uses of the medium. It was, in a curious way, the strategy of an idealist, but it was winning Stieglitz fewer converts than complaints. What his campaign needed was someone to play

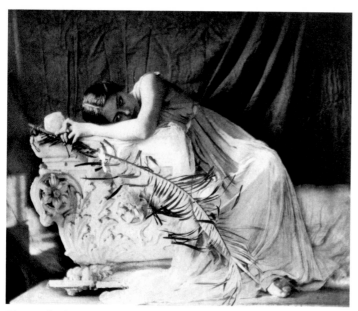

Fig. 1. Charles I. Berg, *Requiescat in Pace,* 1896. Photogravure in *The Photographic Times* 29 (Oct. 1897)

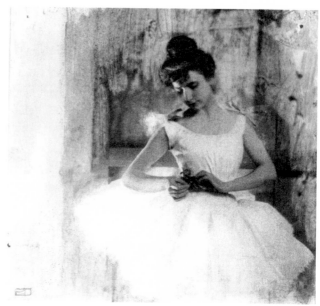

Fig. 2. Robert Demachy, *A Ballerina,* 1900. Gum bichromate print. The Metropolitan Museum of Art, New York. Alfred Stieglitz Collection, 1933 (33.43.58)

Whistler to his Morris: a born artist, for whom style was substance, controversy was the greatest of all good fun, and self-confidence was second nature.

· · · ·

A hardy perennial among the anecdotes of photographic history tells of Edward Steichen's arrival at the Camera Club of New York one day late in the spring of 1900 to show his work to Stieglitz, who was hanging an exhibition in the rooms.[4] The lanky twenty-one-year-old, having quit his position at a Milwaukee lithographers' shop, was on his way to Paris to see Auguste Rodin's pavilion outside the Exposition Universelle and to seek his fortune as a painter. Within his folder of photographs, Steichen had brought along several drawings, paintings, and lithographs, which he needed to make his application for entry at the Académie Julian. Stieglitz looked at the whole portfolio, and soon, to his own surprise, Steichen had sold the world's most unsparing photographic connoisseur three platinum prints for five dollars each.[5] He promptly dealt out several more photographs to Stieglitz for consideration as illustrations in *Camera Notes*, and then others to be submitted to upcoming salons and competitions as Stieglitz saw fit.

That the unknown Steichen succeeded in deputizing work to a prominent man fifteen years his senior, and that Stieglitz embraced the job, says a great deal about both of them on the day they met. By 1900, the life of a well-to-do German-American papa was shrinking on Stieglitz like a damp smok-

ing jacket. Inwardly mourning the lost liberty of his student years in Berlin, Stieglitz was escaping from the conventional domestic life he shared with his wife Emmy and their daughter Kitty by throwing himself into the allied virtual worlds of club-life politics and the published word. He had been known for years on both sides of the Atlantic as a master among pictorialists, and with his hand on the wheel of the widely distributed *Camera Notes*, he enjoyed the added advantage of centrality in the field. As a juror for photographic salons, sitting in judgment in Philadelphia alongside influential painters like William Merritt Chase, he was respected, if not feared (or simply resented), for the vehemence of his convictions. But Stieglitz was also perpetually eager to put new developments before the public. Before him stood an aspiring fine arts painter who elected to make photographs—in itself a publicity coup for which he had surely been watching the horizon. More importantly, the painter was a young one, whose pictures showed him to be not only of his moment but on its leading edge.

Indeed, Steichen was every inch a citizen of the moment, bound for Paris unencumbered by obligations or modesty. Invisibly buoying him into the company of big names was his relationship with his younger sister Lilian, a teenager drawn to education the way her brother was to action. The mantra in their correspondence during his years in France would be "aim high." Confidence was their inheritance from an astounding mother, whose persistence had spared her children the peasant life that would have been their lot in her native Luxembourg.

Mrs. Steichen ran a hat and dress business at the heart of Milwaukee's Germantown, while her husband, his health broken in the copper mines of Michigan's upper peninsula, stayed home to tend his large flower and vegetable gardens. Edward and Lilian intuitively approached the world as ambassadors from an enlightened nation of three, and Stieglitz could not have failed to recognize in his blue-eyed visitor the energy of a fellow true believer.

Stieglitz had already seen and heard plenty to pique his curiosity about the visit. Steichen came recommended by the established pictorialist Clarence H. White, organizer of the Newark (Ohio) Camera Club and a juror at the current Chicago Photographic Salon at the Art Institute of Chicago, which included three of Steichen's photographs. The salon's souvenir brochure included a reproduction of one titled *Keats* (fig. 3), a little print depicting a young lady looking up from a book she held in a "'soul's awakening' clasp."[6] If her soul was awakening, it was to the notion that art, on a Grecian urn or otherwise, led the way from life as routine to life as revelation—to the inhalation of what Walter Pater had called the "spiritual perfume" that infused Victorian society when industry's wheels crushed the flower of faith. Pictorialism was only one facet of a general spiritualization of middle-class life in the 1890s, the other vehicles of which included Arts and Crafts biennials like those that the General Federation of Women's Clubs hosted at the Milwaukee Public Library, magazines like *House Beautiful* that described the home as a venue for "self-expression," and countless new sects of professed Socialism (progressive social groups, though withal less revolutionary than religious in character) such as the Wisconsin chapter of the Social Democratic Party, soon to become the focus of Lilian Steichen's energy.[7] The soul awakening in Steichen's picture was that of Steichen's own generation of Americans, coming of age after the closing of the frontier and hungry for new horizons.

Stieglitz had used his influence as a juror a few months earlier to admit three of Steichen's mailed-in submissions to the Second Philadelphia Salon, among them *Lady in the Doorway* (fig. 4).[8] More than a few visitors to the salon had felt that this "impressionistic" photograph not only failed to describe its lady very clearly, but left one wondering whether she was coming or going through her doorway. The picture's indistinctness recalled works by the late American painter and mystic George Inness, such as the sunset view that Frederick Layton, Milwaukee's leading arts patron, had succeeded in obtaining for his public gallery the previous year (fig. 5).[9] For visitors who came to the Layton Gallery to enjoy its rooms full of irre-

proachably academic Bouguereaus, Gerômes, and Bastien-Lepages, Inness's scumbled, tone-saturated views of figures in landscapes represented a new kind of optical wilderness. But Steichen, whether through close perusal of journals like *The Studio* or by the alchemical intuitions of youth, found himself quite at home there.[10] Inness used his subjects to help set a painting's "tone," both in the visual and in the theatrical senses of the word. Steichen's own paintings (fig. 6), in a more forthright and less interesting way than his photographs, would long employ the same vocabulary, in which the frame of the picture is a proscenium arch, and the events within it a mannered stage fantasy. For Stieglitz, whose taste in contemporary painting had run toward the lusty minotaurs and snake-draped *femmes fatales* of the German Secessionist master Franz Stuck, Steichen's photographs must have conveyed an uncanny sense of having stepped backstage into an altogether new kind of theater.

A small self-portrait Stieglitz purchased that day (frontispiece) showed Steichen to be, for all his midwestern good cheer,

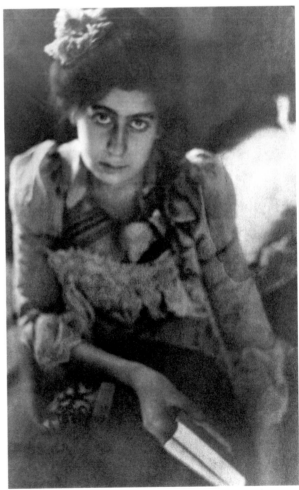

Fig. 3. Edward Steichen, *Girl Reading Keats*, 1898. Platinum print. The Museum of Modern Art, New York. Gift of the photographer (copy print © 1999 The Museum of Modern Art, New York)

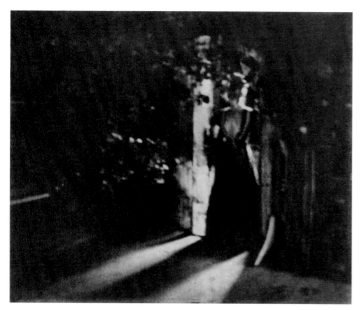

Fig. 4. Edward Steichen, *Lady in the Doorway,* 1898. Bromide print. The Museum of Modern Art, New York. Gift of the photographer (copy print © 1999 The Museum of Modern Art, New York)

a curious kind of dandy, half Lincoln, half Whistler. As willfully odd as the arrangement of his suspenders was his placement in — that is, half out of — the frame, a joke that found its punch line in the vacated little picture frame on the wall behind him. When Stieglitz published the image, critics quickly recognized Steichen's composition as a camera adaptation of Will Bradley's illustrations for the Chicago-based journal *The*

Chap Book.[11] Diagramming his identity as, quite literally, an "eccentric," Steichen threw the door open to the public scorn that Whistler had shown to be far more useful than praise to an enterprising young American artist. Steichen was not to be disappointed; the picture's public appearances over the following year never failed to inspire gleeful satires and — a keynote of all his early notices — indignation at his pretensions to "portraiture."[12]

The other two prints Stieglitz bought that day depicted twilight scenes Steichen had photographed in woodlots at the end of a trolley line outside Milwaukee (plates 1, 3); years later, Stieglitz wrote on the verso of one that it was "Steichen's first 'masterpiece.'"[13] In the opening paragraphs of a review of the current Chicago Photographic Salon, he may have seen Steichen's landscapes made the target of a diatribe against "ultra-impressionist" photography, "the type that shows so little that it is not even worth while to guess at what the camera was levelled."[14] Optical imprecision was only the first of their audacities; critic and buyer could have agreed that the pictures were as void of allegorical, narrative, or moral content as they were of factual data about trees, soil, and sky. Instead their purpose was one which, by the end of the 1890s, English-language magazine articles had begun to recognize by its preferred French terms, "Symbolist" and "decadent": namely, to project a mood.[15] The ethic of raw self-inquiry in these pictures was apprehensible (to a self-selecting audience) as much through their material qualities — they are fluid-saturated, chalk-scraped, intensively handled sheets of thin paper — as in their

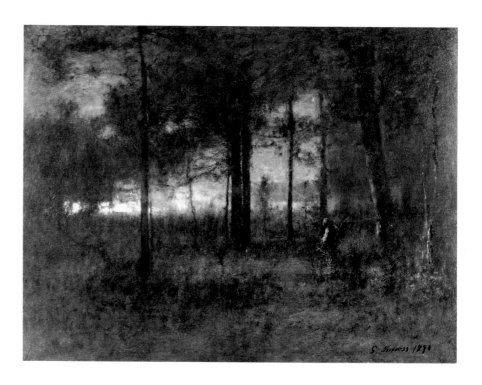

Fig. 5. George Inness, *Sunset in Georgia,* 1890. Oil on canvas. Milwaukee Art Museum. Layton Art Collection, Gift of Frederick Layton

imaging of the dense, trackless copse of late adolescence. Steichen was no great reader himself, but having Lilian along on his moonlight rambles, telling him what Emerson, Thoreau, Ibsen, and Maeterlinck had to say about nature and silence, had surely helped to convince him that his creative intuitions about the forest had a lineage and a future. He got another hint: when he wrote to Stieglitz a few months later, telling him to pick out another photograph for himself from the reserve in hand, Stieglitz chose another woodscape (plate 2).[16]

Steichen recognized that his career had really begun now; his visit to "Stieglitz's" soon took on the proportions of an originary myth within his family.[17] As he sailed towards Le Havre in steerage class with a friend from home, Steichen doubtless relived the scene in his mind. One piece of his handiwork that he had probably been wise enough not to show Stieglitz, but which described an important dimension of his gifts, was a lithographic illustration he had made for a series of press and poster advertisements touting a medicine called Cascarets Candy Cathartic. Steichen's illustration depicted a voluptuous young woman asleep on a signature *C* bearing the logo, "They work while you sleep" (fig. 7). Since the preceding year, the advertisement had appeared in magazines and newspapers nationwide. At the moment, it was incarnate as a vast mural on a Manhattan warehouse: just the kind of sight from which Stieglitz, prowling the downtown streets with a detective camera under his arm, would have averted his eyes in his search for picturesque subjects among the laboring classes. Steichen, on the other hand, later wrote that upon finding his work thus monumentalized, he "decided then and there that New York must be the art center of the world."[18]

Steichen had designed the ad while under contract at a Milwaukee lithographers' shop, the American Fine Arts Company. After eight years of Jesuit schooling, his four-year apprenticeship at the shop had honed the boy's hand and eye, and two years of paid work there (at twenty-five, then fifty dollars a month) had allowed him to save enough money for the ocean crossing and a few months' expenses in Paris. Years later Steichen recounted how he himself had introduced photography into the shop's methods, making photographs of pigs at a local farm to serve as prototypes for decorated bags of feed. His prints, Steichen recalled, provided a realistic alternative to the stock illustrations of hogs in the shop's European cheat books, and his artistic interest in the camera was awakened by this proof of its "usefulness."[19] The Cascarets advertisement suggests that in young Steichen's mind the fine arts might actually have loomed larger as a subject of fascination, and as a source of imagery, than livestock. But regardless of the assignment at

Fig. 6. Edward Steichen, *Nocturne, Temple d'Amour,* 1910. Oil on canvas. The Metropolitan Museum of Art, New York. Gift of Watson B. Dickerman, 1911 (13.17)

hand, to join utility to delight was a task Steichen clearly relished from the beginning.

Steichen's design relied on the fin-de-siècle's most distinctive new medium of consumer appeal—sex—and was modeled after that icon of nineteenth-century academic nudes, Alexandre Cabanel's *Birth of Venus* (fig. 8).[20] But he clad her—prudently, and enticingly—in dreamy gauzerie cribbed from magazine reproductions of a current Parisian sensation: the theater posters Alphons Mucha had designed for the "divine" Sarah Bernhardt. The illustration combines three strategies: bring together the most provocative sources you can; seduce your audience and let them enjoy it in good conscience; and when in doubt, point to Paris.

·　·　·　·

Steichen's work already displayed keen aesthetic ambition before he arrived in Paris—which is to say that he simulated more daring painting styles of the time than other photographers did. The prints he had left for Stieglitz to mount and send to salons and publishers attracted gratifying shares of fame and scorn alike.[21] But during his two years in Paris, opinions on both sides sharpened; as a French correspondent wrote in *Camera Notes,* Steichen's work began to have "the same effect on old-fashioned photographers as a red flag on a bull."[22] If

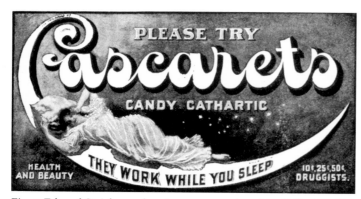

Stieglitz elicited groans from club men for his unbending judgments, Steichen set about cultivating an air of moral disinterest and aesthetic provocation that made him more explicitly resented, disliked, and even feared, as an avatar of the Modern.

In all the arts, seriousness at this moment was signaled by one's readiness to avoid the moralistic and the obviously charming. This could mean sheathing familiar late-Victorian sentiments in a carapace of Symbolist fatalism, or, more plastically, omitting narrative and symbolic cues from one's work entirely. The problem raised for viewers by the latter tactic was, quite literally, What to say? "Never has this class of work been treated in so truly artistic a spirit," a London critic would write of Steichen's nudes in 1902, adding: "We will not say that as pictures they have not been surpassed, for Mr. Steichen has evidently not troubled about a pictorial motive for any one of them."[23]

Even when Steichen acted upon familiar "pictorial motives," the results could be disagreeable. If Charles I. Berg, the vice president of the Camera Club of New York, wished to picture sorrow, he produced a picture like *Requiescat in Pace* (see fig. 1), a clearly focused, conventionally printed studio view of a blond girl in a chiton, displaying conventional signifiers of mourning: bent pose, palm frond, crumbled antique fragments, and a shadow that darkens but does not obscure her pretty features. In his unpretty *In Memoriam* (plate 11), treating the same subject, Steichen strips his model naked, plunges her entire head into darkness, and uses her exposed body masses to suggest the burdens of time, hardship, and sorrow. Berg's photograph records a *tableau vivant* arranged to resemble a painting, the components of which signify sadness; Steichen's photograph is built up, or wants to be, of visual analogues to misery.[24] Alfred Horsley Hinton, of the Linked Ring, would later write to Stieglitz, "I admire Steichen's work for myself but it is the admiration one feels for something strange and uncanny—I can't think that such work is healthy or would *in this* country have a beneficial influence. Many, nay most, of his things were very well exhibited to his fellow artists in his studio. [But] I still hanker after that in Art which shall make men kind, generous, noble and make them good citizens. I see no reason why the artist should...despise his surroundings and be continually yearning."[25] That was a good sign. The "camera work" Stieglitz and Steichen would soon be promoting was of this kind: the infusion of artistic dissent into every choice making up a photograph, from concept to exhibition.

It was by no means foreordained that his time in Paris would take Steichen in this direction. He went there, after all,

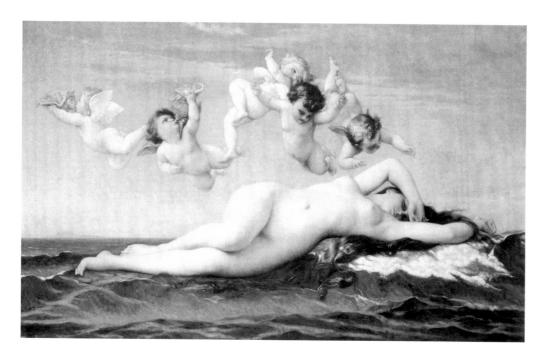

Fig. 8. Alexandre Cabanel, *The Birth of Venus,* 1875. Oil on canvas. The Metropolitan Museum of Art, New York. Gift of John Wolfe, 1893 (94.24.1)

in order to study painting at the Académie Julian, for some two decades the preferred commercial school for American art students seeking academic validation. His letters to Stieglitz suggest that Steichen attended studio sessions for a season at the most; later he stated that it had been as little as two weeks. That he should have enrolled at the Julian at all points to the young man's Algeresque expectation that the prescribed routes to success—and the established definitions of what success was—were sound, even if the degree of it one had in mind for oneself would naturally require some contrivance.

By the time Steichen returned to the United States in 1902, long-haired and loden-caped, he would be disillusioned, in a blasé way, about the academy, telling one of the many Milwaukee newspaper reporters called to the house by his mother that the Julian had "killed more artists than one can number."[26] But his respect for academic standards of craft and eloquence remained high enough while he was in Paris that he wrote to Stieglitz to praise a studio talk given by J. J. Benjamin-Constant, a ranking member of the Institut de France and the Julian's most prestigious visiting tutor.[27] When complaining to Stieglitz about Parisian art photographers' critiques of his work, Steichen contrasted their japes to the praises he was garnering from supposed masters like the saccharine genre painter Pascal-Adolphe-Jean Dagnan-Bouveret, whom he did not hesitate to call "one of the greatest living painters."[28]

A more important teacher than any tutor was Paris itself, which in the summer of 1900 was given over to the Exposition Universelle that marked the new century's arrival. As he walked past the storefronts and through the art galleries of Paris, through Germany's state-of-the-art Exposition displays and Siegfried Bing's gallery, L'Art Nouveau, Steichen was brought face-to-face with the trend in the arts now associated with that gallery's name. Germans—Bing and the multimedia Secession groups of Munich, Vienna, and Berlin—had set the current tone, incorporating works of a wide array of formats and materials into carefully arranged ensembles, and transposing composer

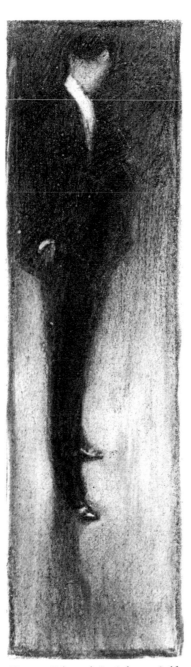

Fig. 9. Edward Steichen, *Self-Portrait*, 1901. Charcoal on paper. Collection of Harriette and Noel Levine

Richard Wagner's dream of the *Gesamtkunstwerk*—a "total," all-embracing artwork—to the components of the bourgeois interior.[29] The market had caught up with Symbolism and made it a house style; the mysterious and the provoking defined the height of fashion. Objects of art were to complement one another yet allow for recombination, like accessories in a Parisienne's wardrobe. Makers of "cabinet pictures" had learned that skinny or squat paintings that fit into corners or above doors found a place amid the glassware, tilework, ceramics, furniture, tapestry, and electric light fixtures that were the moment's starring players. Isolated nude figures and absorbing, shadow-haunted landscapes were especially easy to place.[30] This was a form of "usefulness" that pictorialism had not begun to approach. Steichen quickly set about tailoring himself to fit the artistic métier he was to make his own: refined, masculine, and seductively obscure (fig. 9).

The critic Arthur Symons, ambassador between Anglo-American culture and the art world of Paris, described the aesthetic ideals of the moment as "slightness" and "intensity": "To be slight, as Whistler, as Verlaine, is slight, is to have refined away, by a process of ardent, often of arduous, craftsmanship, all but what is essential in outward form, in intellectual substance. It is because a painter, a poet of this kind is able to fill every line, every word, with so intense a life, that he can afford to dispense with that amplification, that reiterance, which an artist of less passionate vitality must needs expend upon the substance of his art."[31] Rodin's sculpture summarized the ambitions Symons described. Restricting himself to that most fundamental of forms, the unclad human body, Rodin left viewers with no interpretive option but to internalize the physical sensations sweeping his figures into action, reverie, or rapture. Classical in resonance but altogether contemporary in their anxiety and ambiguity, his works embodied the Symbolist faith that external forms were the imperfect sign language of a more compelling psychological life within. What might be called the Romance of Rodin, too, unified the generation of young Paris

artists of which Steichen was a member. Countless articles told of the sculptor's early trials as a three-time reject at the Ecole des Beaux-Arts; his long years of anonymous toil in a decorative sculptor's studio; the controversies attending the anatomical literalness of his *Age of Bronze* figure and the abstractness of his *Balzac*; and his pitiless endorsement of hard work and nature as the artist's only teachers. Rodin's one-man art movement had burgeoned into a workshop full of craftsmen, turning out bronze and marble editions of his sculptures. Like the swarming *Gates of Hell* that he unveiled at his one-man exhibition in 1900, the epic chapters of Rodin's life provided a living concordance to the heroic possibilities of the Modern.[32]

As Steichen told it sixty years later, he had come to Paris specifically to see the Rodin pavilion. During the previous two years, Milwaukee newspapers had told of the Société des Gens de Lettres's outrage at the earthiness of Rodin's *Balzac* figure and their retraction of the monument commission. Dozens of leading French intellectuals had responded with a fruitless public subscription drive to have the work cast and put in place. Rodin's plaster figure of the author as a sleepless genius, wrapped in his robe and gazing out his study window, had inspired adulation from some and laughter from others; the resulting polarization of public opinion surrounding it prefigured, then became hopelessly entangled in, the political agonies of the Dreyfus Affair in 1899.[33] In the *Balzac* controversy, modern art was on trial, wedded to the principle that a great man could be recognized by the quality of his interior state, his capacity for thought and feeling, rather than by allusion to his official services to the nation. (Likewise, the hybrid character of the year 1900 is expressed in the public battle to erect a bronze statue to such a notion, as though the psyche were just the latest general on a rearing horse.)

Steichen's main project during his first year in Paris was the befriending and photographing of notable artists. He approached the task from its publicity end, pursuing those whose names were in the general press, whose works attracted attention and purchase, and whose appearance — not incidentally, to a portraitist — was striking. The most prominent prototype for his enterprise was the work of the London art-reproduction photographer Frederick Hollyer, an intimate of John Ruskin and the Pre-Raphaelites, whose Monday portrait sittings for painters, writers, and other cultural figures had long filled a niche in the British art world. In 1900 there was no missing Hollyer's portraits, which were prominently featured both in the Exposition display of the Linked Ring and at the group's London salon in the fall.[34] Steichen revered certain of Hollyer's

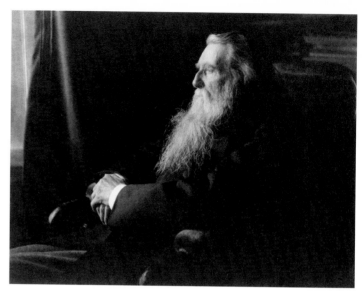

Fig. 10. Frederick Hollyer, *John Ruskin at Brantwood,* 1896. Platinum print. The Royal Photographic Society Collection, Bath

most highly praised compositions (fig. 10), but he clearly found the older Briton's understated formula lacking in graphic energy. In the course of a visit to London in the fall, Steichen made a direct invasion of Hollyer's territory with a profile portrait of the aging painter G. F. Watts (plate 13), the last remaining figure of the Pre-Raphaelite generation and for some years Hollyer's chief patron.[35]

Portraits of artists helped Steichen's work to stand out in group exhibitions over the next several years, and their leading role among his works boosted him into artistic renown by association. His prizewinning, much-reproduced likenesses also reinforced the painters' notoriety; to appear in the papers was at least as important as engineering a good location for one's painting in a gallery. (The flamboyant Whistler, in self-imposed exile in London and Paris, had kept himself known in his native America in large part through news reports about his clothes and his court battles; his wit and egotism dependably made for "good copy.")[36] Presumably upon having seen Bing's L'Art Nouveau pavilion at the Exposition, Steichen sought out one of its biggest draws, the Norwegian decorative landscapist Frits Thaulow.[37] Thaulow offered to introduce him to Rodin and probably also led him to another star in Bing's stable, Paul-Albert Besnard, a specialist in stylish portraits of the wealthy. Perhaps reasoning that Besnard's was not a bad branch of the art world for a photographer to know better, Steichen soon sought out and photographed three more leaders in the same line of business: John White Alexander, an extremely popular painter of swan-necked American women abroad;[38] the studio

photographer Otto Wegener (known professionally as "Otto"), another prominent exhibitor at the Exposition;[39] and Theobald Chartran, a dashing figure who had first made his name as a lithographic caricaturist for *Vanity Fair*. Steichen's other early art-world sitters included Alphons Mucha and the wife of Whistler's associate Walter Sickert. Whistler himself, ailing and bilious, proved unapproachable, as did Steichen's other principal idol, Claude Monet, whose self-made Eden at Giverny may have impressed the young man as ground too hallowed for intrusion.

Thaulow made it easy, though, to meet Rodin. One Saturday—the day the master received visitors—they cycled out to his home and studio in Meudon. Impressed with Steichen's growing portfolio of work, Rodin invited him to return on any and all Saturdays. Before finally photographing Rodin, Steichen later claimed, he rode out nearly every weekend for months to observe him at work. His method was a tip of the hat to his subject. Rodin employed people to circulate nude in his studios—not professional models, but sailors, shopgirls, and laborers, people whose bodies told life stories—and at any moment they could be asked to repeat an action or hold a pose while he sketched them. For Rodin, gesture constituted a facet of anatomy; optical impression, an element of physical truth: his portraits were intended as summaries of his sitters' life rhythms. The portrait of Rodin that Steichen finally made, however, in which Rodin's black profile looms up before the backdrop of his *Victor Hugo* monument (plate 6), is one which—given a few more years' practice, anyway—the photographer could have sketched out before even visiting Meudon. The portrait's intensity has nothing to do with capturing a living expression; it is a product of the economy of design in the poster-like layout. Steichen's *Rodin* is a stone monument to the sculptor's will: his cranium is muscular, a mountain being whispered to life by the ghostly muse of his *Hugo*. (Some months later, after working out how to craft a combination print from two enlarged negatives, Steichen would expand the portrait, putting Rodin into a face-to-face mental conversation with his *Thinker* [see fig. 13].)

The portrait, which Rodin loved on sight, clinched Steichen's position as the preferred photographic interpreter of the master's work. This role had been served by others before Steichen, as he knew from seeing Eugène Druet's photographs exhibited among the sculptures at Rodin's avenue de l'Alma pavilion. But neither Druet nor any other photographer was ever paid the rates Rodin offered Steichen.[40]

Two other portraits of artists from the Paris months transcend the series that gave rise to them. Like Rodin, the sculptor Albert Bartholomé (plate 5) and the Belgian playwright Maurice Maeterlinck (plate 12) are seen absorbed in contemplation of their work. Read allegorically, they are like the two halves of Man the Creator that contend in Rodin's *Thinker*: the Man of Labor, whose thoughts are manifest in the physical, and the Man of Intellect, whose life spirals inward around the mind.[41] Bartholomé is a dreamer with a mallet, gazing up at an ideal he has realized, greater than life-size, out of stone. In Maeterlinck one sees the far end of the "awakening of the soul" process depicted in *Keats*: the author, concentrating experience into art. His is not a portrait of effort but of grace; backlit, seated at his desk, Maeterlinck appears as impassive in his transmitting role as a photographic negative, the words on the page appearing as though products of sunlight passing through him. His disposition recalls the theme in Maeterlinck's writing that attracted Steichen (as an aesthetic theory, if not as a professional credo): wisdom is at large in the grand design, and man's task is simply to make himself receptive to the bounty that nature reserves for its humbler servants. Against the self-destructive competition of human society, Maeterlinck praised the cooperative intelligence of insects and, in the book that was to touch Steichen the deepest, the passive intelligence of flowers, whose wisdom is their creative reliance on the forces of sun, wind, and soil.[42]

In the fall of 1900 Steichen traveled to London to submit his photographs to the salons, and there he met the American pictorialist Fred Holland Day, who had come to hang an exhibition called *The New American School of Photography* in the rooms of the Royal Photographic Society. Steichen showed Day his work and was soon working by his side designing and hanging the show. As the exhibition's title suggested, Day was Stieglitz's principal rival for leadership among American pictorialists; the show was going on, in fact, despite Stieglitz's concerted efforts to foil it. (His letters did keep it out of the rooms of the Linked Ring, where Day and Stieglitz were both "Links.") The politics of the matter did not dawn on Steichen until the hanging was finished, when he saw that Stieglitz and his closest allies were the only major figures missing from the walls. All his life Steichen would recall the futility of Stieglitz's attempts to sabotage Day's show, a timely reminder that one should neither cross nor depend too exclusively upon Stieglitz's authority.[43]

Photography was only the latest endeavor to bring Day to England, where his ties were largely literary and bibliophilic. In the 1890s, the Boston firm of Copeland and Day had published fine editions of dozens of works that brought the spirit of fin-de-siècle London to American shores, notably the Beardsley-

illustrated *Salomé* and the serial *The Yellow Book*.[44] While it is intriguing to speculate on the many literary, artistic, and intellectual connections Day might have provided Steichen in London, from critics to poets to illustrators, in fact the most lasting relationship established during Steichen's stay seems to have been one of mild mutual enmity with Day's young cousin, Alvin Langdon Coburn. During the next decade, Coburn—with a domineering mother for his perpetual shadow—recurrently presented Steichen with the closest thing to competition as a photographer of public renown. Only the fact that Coburn settled in London, and upon a fairly narrow graphic idiom in which to express his talents, prevented the two men from developing a more poisonous rivalry than they did. Steichen liked to complain that whenever he made a discovery, Coburn appeared (mother in tow), figured out what Steichen had done within a percentile, and took his version to the public first. The chance that one day Coburn would improve on Steichen's methods, or come up with something better of his own, kept Steichen on his toes.

The *New American School* exhibition, held at the Royal Photographic Society's galleries in Russell Square and scheduled to compete with the Linked Ring salon, was a big hit, which meant being the butt of jokes. Many writers ridiculed Day's and Steichen's presentation of their work, which involved floating small prints on several nested colored papers (see plate 4)—"a wilderness of mount," as one critic put it, who concluded that "Mr. Steichen evidently has the free run of a brown paper store."[45] In an article in *Camera Notes* answering the "wholesale ridicule lavished by narrow and fettered minds" upon Day and himself in London, Steichen counterridiculed "the heavy creations of slabs of timber" that entombed prints at the Linked Ring and Royal salons.[46] Another dispute ushered in by the exhibition was one between London photographers' academic emphases on clarity, contrast, and line, and the American embrace of the ambiguities of "tone." Steichen's prints in particular were deemed "by turns excessively sombre or provokingly faint," and hazy inventions with titles like *The Vampire* won him the dubious distinction of "out-Heroding Herod," as another critic put it, in a jab at Day.[47]

The rancor of his first London visit seems to have set in Steichen's mind that the British pictorialists, on those occasions when they proved absolutely unavoidable, were best treated with insolence. The Ring struck him as a group in stasis; to linger in the previous decade meant, for Steichen, hanging onto the last century. He declined the membership offered him in 1901, and when offered it again the next year, told the Ring's secretary he was accepting "only out of consideration to Mr.

Stieglitz," who had engineered both invitations.[48] Another lesson of London was the importance of controlling the selection and hanging of one's work. Steichen's letters to Stieglitz over the next decade would often concern the minutiae of salon politics. From very early on, he was urging Stieglitz to spearhead an international group of the top "workers," who would operate independently, joining forces only for an annual group exhibition of their very best pieces. This liberal blockbuster game plan ran counter to Stieglitz's instincts, which told him to play a tighter game at the head of a more intimate team of artists, perhaps a national group. It was a matter for some thought, especially since politics within the Camera Club were coming to a breaking point.

When Day joined Steichen in Paris for several weeks that winter, the two often posed for one another, and Day doubtless preferred many insights on the psychology of portraiture.[49] An image depicting the London pictorialist Frederick H. Evans, his back turned as he contemplates one of Day's controversial self-portraits as Christ (plate 15), exemplifies the tropes of psychological immersion and visual indirection that were Day's hallmarks. But the platinum print in the Metropolitan Museum's collection has a life story as circuitous as the path of gazes it depicts. The print was a gift from Steichen to Evans, who mounted the print in his own highly distinctive manner, then inscribed the mount "Frederick H. Evans" and "by [?] E. J. Steichen." A palimpsest from concept to finish, the picture invites interpretation as a work by Day or by Steichen, or perhaps Steichen's print after Day's negative, or even Evans's.[50] Ambiguities of authorship, unimaginable at any other time in Steichen's career, seem quite to the point in the case of this image, suggesting as they do a season of mutual apprenticeship among photographers who had much to teach one another. Steichen, at least, spent much of the following year stockpiling new skills that would become a defining part of his artistic persona.

Steichen's and Day's first plan for showing *The New American School* in Paris was to accept an invitation to exhibit in the halls of a graphic arts exhibition society, the Salon des Cent. The group had fallen on hard times since the December 1899 death of its founder, Léon Deschamps, an impresario of lithographic and poster art—notably Mucha's—and the publisher of the graphics journal *La Plume*.[51] What might have come of the intriguing opportunity to present American pictorialist photography under the auspices of avant-garde French graphic art is unknown, for the two Americans soon found themselves talked into exhibiting in the rooms of the Photo-Club de Paris by the club's leader, Robert Demachy.[52]

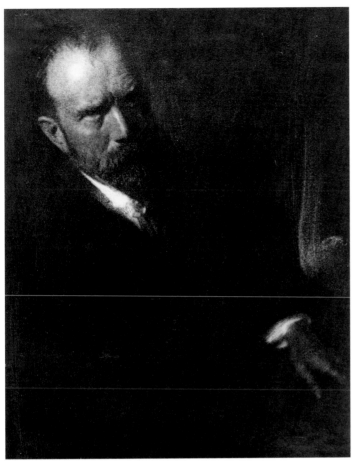

Fig. 11. Edward Steichen, *Carl Marr,* 1901. Direct carbon print. The Metropolitan Museum of Art, New York. Alfred Stieglitz Collection, 1933 (33.43.10)

Outwardly, Demachy had the makings of a Parisian Stieglitz, with wealth-given leisure time to divide between his club's darkroom and excursions in the expensive motorcars that were his passion. Steichen enjoyed the congenial banker's company and generosity but soon saw that Demachy lacked the inner need for daring and dominance that spurred Stieglitz's creativity, in business matters as in art.[53] Indeed, Demachy's technical preoccupation with brush-applied pigment printing techniques, and especially gum bichromate printing (see fig. 2), described the beginning and end of his curiosity about photography's artistic potential. This work-intensive process, favored since the mid-1890s by leading amateurs in France and Germany, gave photographers the power to produce prints in a wide variety of colors (a red tone reminiscent of chalk was popular), to devise vignette formats for their prints, and to highlight or obliterate selected details with brushwork during sensitizing or development. As utilized up to that time, gum bichromate printing presented both the most obvious and the narrowest means to "artistic" effects in photography.

At the Exposition Universelle, Steichen had seen some of Demachy's best efforts in gum, as well as huge chalk-drawing-like landscapes by the German amateurs who were beginning to dominate in the technique. At some point before Day departed Paris, Steichen undertook his first serious work in gum, making repeated experiments with the Rodin negative and with a portrait of himself as a vaguely eighteenth-century painter, outfitted in Day's foppish gear (see fig. 12). Meeting with some success by the autumn of 1901, when prints of both works were hung in the Linked Ring salon, Steichen began thinking out loud about the intertwined roles of "paintre and fotographer," as he spelled the words in his frequent promises to write Stieglitz an article.[54] Late that summer he had found a sympathetic ear, and perhaps a willing instructor, in Gertrude Käsebier, a professional New York portraitist, gum printer, and newly elected member of the Ring, who was then visiting Paris.[55] That fall, in Munich, the two Americans met Heinrich Kühn, a correspondent of Stieglitz's and one of the so-called *Kleeblat* (cloverleaf, or trio) of Austrian gum and carbon printers, who exhibited regularly as a team.[56]

After seeing an international art exhibition (including a Munich Secession wing) at the Glaspalast, Steichen presented himself to the Royal Munich Academy's director, Carl Marr (fig. 11), a Milwaukee-born muralist whose vast history painting *The Flagellants* had won a gold medal at the 1893 World's Columbian Exposition in Chicago.[57] Marr in turn probably expedited Steichen's access to the painters Franz Stuck and Franz von Lenbach, true art-stars of the day, whose dispensations included reconstructed Italian villas that were later to be converted into their personal memorial museums.[58] Each painter made considerable use of photography to help him meet a heavy backlog of portrait and figure-study orders, and each, to judge by the pictorialist annuals, posed in his richly outfitted studio for a parade of admiring photographers. They were not men to brook direction in the matter of poses: Stuck rarely deviated from the left-profile view, which he provided Steichen twice, while Lenbach was roused from his habitual frontal glare with brush and palette (plate 14) only by Steichen's explicit request for variation, which he got by loaning him a hat.

In an article published in Germany some months later, defending the principle of the painterly photograph, Steichen argued that it was sensible to hold specific processes like the platinum print or the lantern slide to specified technical limits, but that no photographic artist worth the name should give a thought to the notion of technical "purity," any more than Monet felt bound to a housepainter's repertoire of pigments

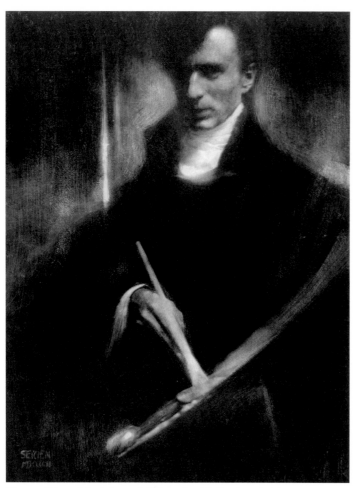

Fig. 12. Edward Steichen, *Self-Portrait with Brush and Palette*, 1902. Gum bichromate print. The Art Institute of Chicago. Alfred Stieglitz Collection, 1949.823 (photograph ©1999 The Art Institute of Chicago. All rights reserved)

and strokes.[59] The polemic is convincing, but practice did not yet bear it out. The brushstrokes worked into early figure studies like *The Black Vase*, *Languid Repose*, and *Figure with Iris* (plates 8–10) do little more than superimpose over the factualism of a photograph the implication of expressiveness (or more generically, stylishness) associated with visible hand movement. The pictures are really no more "painterly" than they are "hand-writerly," with brushstrokes supplying a substratum of un-representation out of which the picture's human content struggles, as Rodin's figures emerge out of uncarved stone or plaster ooze. Compared to the subtle, unified effects Steichen would soon be achieving, these are fairly primitive exercises in the hybrid art-form one critic called, with apposite awkwardness, the "paintograph."[60]

Steichen worked brushwork more evenly into his *Self-Portrait with Brush and Palette* (fig. 12), plausibly suggesting the joining of brush and lens in the very genetic material of the

image. The picture was instantly declared a masterpiece by Rodin, who considered purity as irrelevant a criterion in photographs as he did in the carved, dipped, molded, disassembled, and reconfigured plaster human forms produced in his shop, but who allowed that photographs were most effective when tangibly products of the action of light.[61] The sophisticated legerdemain by which this picture announces itself as a painter's camera self-portrait points ahead to the challenge finally, triumphantly met in *Rodin — The Thinker* (fig. 13): the joining of the camera's selectiveness and the brush's elaboration into a seamless pictorial language. Both pictures make a telling contrast to a portrait of the painter William Merritt Chase that Steichen had made in New York some eighteen months earlier (plate 7), in which he had smudged paint and scrawled chalk lines onto a straight print — clumsy reminders that an artist was both behind and before the camera. What Steichen had sought then, and had now begun to achieve, was an effect that brought the two realms together, suggesting that life and art were one — and that photography was both.

Steichen had been extraordinarily successful in getting his work before the public eye.[62] In the spring of 1901, his painted portrait of Day had been hung at the Salon du Champ de Mars, the "second," more liberal, non-prize-giving salon sponsored by the Société Nationale des Beaux-Arts. One year later, he mailed Käsebier a letter with still more exciting news, which she promptly forwarded to Stieglitz. Writing from Rome, to which he had treated himself to a joy excursion on the proceeds of a sold painting, Steichen announced that he had been accepted into the salon again, not only with drawings and a painting of a woman in white (the sitter, an American named Clara Smith, had just accepted his proposal of marriage) but with ten photographs, the first to be accepted into a salon of paintings and graphic art. It went without saying that these had passed the salon's jury as exponents of an expressive visual dialect: as art.[63]

Steichen literally left unsaid, however, that he had submitted his prints to the jury as works of "graphic art" rather than as photographs. By the time Stieglitz had read the letter, the camera origin of the images had been found out, and they were promptly dropped from the salon's list. Amid the flurry of indignation that Stieglitz stirred up in the photographic press, Demachy noted — with all due respect to Steichen — that the jury's decision was appropriate: no jury of photographers would have admitted drawings to their salon, either.[64] Stieglitz and Steichen did not share his bloodless equanimity. The issue, of course, was one of status: the manual arts had it, photography did not. Warming to a favorite theme, Stieglitz announced

that the salon had only exposed its own defensive hypocrisy, since Steichen's photographs had, on the grounds of aesthetic quality, already been conceded to belong amid paintings.

What really mattered was that an eminently publicizable event concerning photography had occurred on the stage of the fine arts world of Paris, and that Steichen's virtuosity as a "paintre-fotographer" was at the center of it. The principle of integrating the two callings was secondary. Before departing Paris, Steichen arranged a brief one-man show at the Maison des Artistes (the exhibition space of Otto, the high-society photographer), where he had an opportunity to hang his paintings and photographs side by side, but he appears to have kept them segregated. In fact, the gallery list even added a further division, breaking the photographs into two classes: unmanipulated prints and *peinture à la lumière* (painting with light).[65]

With the closing of his one-man show and with wedding plans to announce to his family, in the summer of 1902 Steichen returned to New York. Needing a few month's income before he could marry, he leased a studio space on the top floor of a brownstone at 291 Fifth Avenue, near Thirtieth Street. It put him just up the street from Käsebier's studio at number 273, seven blocks uptown from the newly completed

Flatiron Building at Madison Square, and around the corner from the Camera Club, on Twenty-ninth Street. It was a lively but affordable part of midtown, where a portion of society that was neither at leisure, nor of the growing office-working class, but "in trade," stepped into private social clubs and portrait studios to try on its public faces. Along with Steichen's other Fifth Avenue neighbors — suitmakers, furriers, fine candymakers, Chinese curio importers — were the city's premier art dealers, Duveen Brothers, Knoedler's, and Durand-Ruel. Their painting inventories were almost exclusively European and comfortably Old Master. In the few preceding years, successful New York exhibitions of American Tonalist painting had given a major public boost to the idiom in which Steichen worked, but the market for an unestablished American painter still pointed to photographic portraiture as a more likely paying prospect.

Late in the winter of 1902, around the time Steichen had been writing to Käsebier from Rome, Stieglitz had devised a name, "Photo-Secession," to bestow upon a group of American photographers he had decided to represent outside the confines of the Camera Club. Having recently shipped off a premium selection of prints to the Turin Decorative Arts

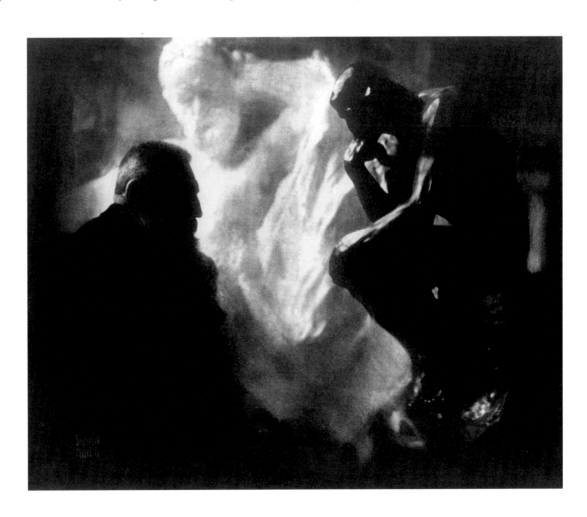

Fig. 13. Edward Steichen, *Rodin — The Thinker*, 1902. Gum bichromate print. Gilman Paper Company Collection

Exposition under the club's banner, Stieglitz quickly pulled together a second group of material (something, one suspects, a little like the grab bag of also-rans he had accused Day's show of being) and hung it at the nearby National Arts Club under the title *American Pictorial Photography Arranged by the "Photo-Secession."* Prominent among the thirty-two exhibitors were Steichen, White, Käsebier, Stieglitz's right-hand man Joseph Keiley, Stieglitz himself, and the Chicago photographic illustrator William B. Dyer.[66] The Photo-Secession had yet to be introduced to itself, and Stieglitz informed Steichen that it was to be served and represented by a new journal, *Camera Work*. Steichen set about designing the cover and layouts during a visit to his family in Wisconsin.

As has often been noted, Stieglitz's aversion to the Camera Club from which he was "seceding" did not extend to its darkroom facilities, which were the best-equipped on the continent, and for the sake of which he, Steichen, and all local members of the new group would continue to maintain costly club memberships.[67] Like the art-world Secessions of German-speaking Europe from which Stieglitz had adopted the title, the new group was the tactical opposite of a secession: it was a stepping-forward into public prominence, in this case not out of an academy but away from the Robert's Rules of Order demeanor of the Camera Club, in the uncharted direction of an American art movement. Although the group's goals and tenets would remain designedly half-enunciated, its clannishness was that of a former men's club, not the alchemists' secret society that the Linked Ring played at being.[68] Like the white suits Mark Twain favored, the Photo-Secession was conservative in cut but eccentric in tone. Twain explained that while he didn't want to be conspicuous, he naturally wished to be noticed—a distinction the neglect of which had dragged Oscar Wilde down to infamy and Whistler to self-parody. Stieglitz raised Twain's very American outlook on publicity to the level of a modus operandi—and Steichen dressed in white three-piece suits, which never suited a young man better.

Steichen understood immediately that the Photo-Secession was not to be an exercise in democracy but a public instrument of Stieglitz's personality. (The expression "Why not have the Photo-Secession decide…" appears more than once in his letters to Stieglitz.) That he quickly made himself indispensable to the success of Stieglitz's project expressed both Steichen's energy and his sense that, as he later wrote to Stieglitz, "the whole d—m business 'photo-pictorially' rest[s] between us two.…I don't think another single one of the whole movement big or little really grasps *what* you are driving at and *how*."[69] Secrecy between the two of them played a part in that cir-

cumstance, but more crucially, the two men's needs dovetailed so neatly in 1903 that others were simply left outside. Steichen needed comradeship and intelligent, well-produced publicity for his work. Stieglitz needed to equate the Photo-Secession with the most remarkable photography being made. The obvious step: an issue of *Camera Work* dedicated to the medium's *enfant terrible*.[70] After the January 1903 debut of the magazine, which—against Steichen's objections—fulfilled Stieglitz's promise to make Käsebier his first featured photographer, the first all-Steichen number of *Camera Work* came out in April 1903, with seven photogravures and four halftone reproductions after his photographs.

Steichen used his number of *Camera Work* to show potential clients his range of styles and formats. The ratio of genres of imagery in the issue suggests a balance between artist's portfolio and catalogue of wares, with two landscapes (from Wisconsin and the Bois de Boulogne), three nudes, an anonymous female "portrait study," and five portraits, all depicting artists: Rodin, Bartholomé, Lenbach, Besnard, and Steichen himself, brandishing brush, palette, and knowing smile. The ratio tipped further in favor of portraits in Steichen's section of the Photo-Secession's flagship loan exhibition, which opened in January 1904 at Washington's Corcoran Gallery (six portraits, three landscapes, and a nude), and again in an expanded version of the show at Pittsburgh's Carnegie Institute, where Steichen showed twelve portraits, four landscapes, and two nudes. By interspersing large, low-keyed, bravura exhibition prints like *The Little Round Mirror* (plate 30) among his portraits, Steichen emphasized the complementary decorative effects of his art as a whole. By repeatedly circling back to portraits, his exhibitions kept his claim staked in the most sociable and marketable field of work open to a photographic professional.

In the autumn between the Steichen *Camera Work* number and his major American exhibition debut, Steichen married Clara Smith in Manhattan's Trinity Church. The newlyweds spent several days alone at Oaklawn, Stieglitz's parents' home on the shore of upstate Lake George, then visited Clarence H. White (plate 23) at his home in Ohio. The busman's-holiday character of this photocentric honeymoon is significant; Steichen frankly told Stieglitz he had married in the hope that the experience of family life—as it were, the general *subject* of marriage and fatherhood—would serve his development as an artist, as it seemed to have done for two of his heroes, Jean-François Millet and Eugène Carrière.[71] The Victorian conventionality of his hopes characterizes Steichen at age twenty-four: that life's chaos would lend itself to artistic order, that the will of others might be willed into partnership with

his own, that to become a family man physically would naturally make him one in temperament. From Lake George he wrote Stieglitz a long description of lush, full-moon evenings, and commented, strikingly, that he "would like to share some of it with you good friend.—you and my mother."[72]

Autumn air, giddy hopes, the raw openness of fantasy, and the push and pull that would characterize the marriage come through in the mesmerizing *Portraits—Evening* (plate 22), made outdoors at the lake. What makes the picture heartbreaking is the distance separating what must have seemed an irreducibly simple setup—let's embrace and look straight into the camera—and the complexity of the result, which is a love triangle. Edward's eyes lock on the camera, either seeking or certain of confirmation, of just the kind that Clara tangibly holds in reserve. It doesn't quite matter whether the camera absorbing these looks is Stieglitz, or Steichen's mother, or the child that has just been conceived; trouble is ahead. Through a dozen punishing years, until the family blew apart during the war, the escalating pain and misunderstanding of an ill-matched marriage was to constitute Steichen's harshest emotional schooling, a test for his faith in human nature and idealized notions about love and women, and—not incidentally—a spur to his pursuit of intimate friendships among the wealthy, engaging patrons who became his true extended family.

· · · ·

Steichen's first years away from home are a story of energies tested, connections half-made, ideas seized upon and hammered at, and activity so quicksilver that the accomplished photographs floating to the surface come as something of a miracle, like a legible sentence wrested from one of his more excited letters. Settling down, in any real sense, was not in the cards—he would remain the fastest-moving person in the room for the next six decades—but when he touched down in New York City in late 1902, with familial responsibilities before him and Stieglitz's flattering demands laid at his door, Steichen focused his considerable energy on the task of forging his rich patois of aesthetic intuitions, Continental affectations, and technical tricks into a cohesive pictorial vision. The Camera Club's darkrooms gave him space to work out all of the practical problems associated with the large-scale, technically complex pictures that alone could meet his standards (and billed expectations) as a painter-designer. More, he pushed his skills to the point that each print became a fresh adventure, a live performance, in which darkroom hours are far more vividly present than the moment of exposure recorded in the image. While using strong contrasts and elemental composi-

tions to craft a visual style that would carry across a room, Steichen also wanted prints that demanded close attention and rewarded immersion. From this time onward, whenever one walked into his section at a salon, opened an issue of *Camera Work* devoted to his work (double Steichen numbers appeared in 1906 and 1913), or stepped off the elevator at 291 Fifth Avenue to commission a portrait, one entered a place where landscapes, figure studies, and portraits represented glimpses into the unified otherworld of an artist's imagination.

Of all of Steichen's photographs, it was his views of spaces—landscapes, cityscapes, nightscapes—that were transformed the most dramatically by leaps in technical sophistication. In multiple gum and platinum-gum printing, overlaid "pulls" of pigment from a negative simulate the additive effect of watercolor washes or translucent layers of lithographic ink. Even in very skilled hands, gum is kindest to subjects that are full of shadows and low on details that might go wrong when a negative is misaligned. Most pictorialists deciding whether to employ the technique were in effect choosing whether they wanted an image rich in tone and color, or one that was graphically clean and suggestive of the edges, textures, rhythms, and voids of inhabitable space. Steichen wanted to get past the need to choose, and, especially in the astonishing case of *The Flatiron,* he got there.

In an important sense, however, Steichen's new landscapes hewed to the model of his early pictures of Milwaukee woodlots: he continued to favor views into semienclosed spaces, hemmed in by scrims and shadows that hint at the limits of perception. To this proclivity he added a new, complementary one. Three compositional points of reference among the Photo-Secessionists were Japanese woodblock prints, Whistler's elemental "nocturne" paintings, and the graphic exercises of the design instructor Arthur Wesley Dow (fig. 14).[73] Like these, the best of Steichen's landscapes are defined by a taut balancing of masses within the picture's four edges, rather than by implied reference to a world beyond the frame (fig. 15, plate 27). An emphatic sense of containment combines with color effects generally suggestive of nightfall, and with a physical scale that invites imaginative entry, to lend his landscapes the psychological status of interiors: portraits, in effect, in which the sitter is oneself, relocated into an atmospheric stage setting.[74]

In Steichen's series of views of the Flatiron Building (plates 18–20), one is transported to a taxi stand on Madison Square, where the evening lamps have just been lit. Or have they? Widely varying states of murk and glimmer in three prints from the negative alert us that all of the light here has been at least touched by painterly fantasy, and atmospheric sensations

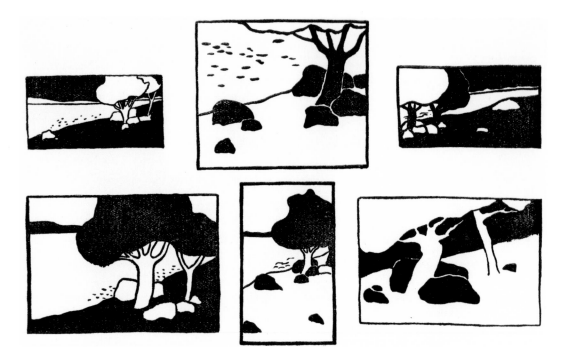

Fig. 14. Arthur Wesley Dow, *Dark-and-Light Composition*, from Dow's *Composition: A Series of Exercises Selected from a New System of Art Education* (New York: Baker and Taylor, 1905)

imported or suppressed for effect. The symphonic tone poetry of each image plays with the Flatiron's status as a prismatic slab in the sky, cumulatively lending it the character of a mirage: the specter of a future unanticipated by the trees and cabmen on the ground. The baroque splendor of Steichen's vision makes a vivid contrast with the stripped-down formal perfection of Stieglitz's platinum rendering (fig. 16) and Coburn's dramatic variations, which alternately imaged the building as a rough-faced urban El Capitan and as an eruptive expression of side-walk energy (fig. 17). After voting Coburn's earliest effort out of the American selections being shipped to the Linked Ring salon in the summer of 1904, Steichen explained to Stieglitz that Coburn's Flatiron was "good if you want to show it to someone that knows it but in London it is simply a black mass—meaningless + badly composed."[75] If Steichen's own version—made that winter, and a showstopper the next fall both in London and at the inaugural group exhibit in the Little Galleries of the Photo-Secession—was motivated in part by a desire to show up Coburn and give "the Britishers…a good *thrashing*," on a deeper level it was inspired by the problem Coburn's picture had raised: how to show *this*, a massive new principle of civilization that was America's alone, to those who did not "know it"? In aesthetic and in allegorical terms, Steichen's is the cosmopolitan Flatiron: London and Venice (a silhouetted horse and cab, adrift on the wide wet canal of Broadway) face the coming of night, oblivious to the astonish-ing prow of a skyscraper breaking its way over the horizon.[76]

A moment more private and more cosmic is suggested in *The Pond—Moonrise* (plate 26), which was photographed at the Mamaroneck home of the art critic Charles H. Caffin, the Steichens' host for some weeks after their daughter Mary's dif-ficult birth in the summer of 1904. Grateful for the peace of the countryside, Steichen nonetheless was disappointed to find there, as he wrote to Stieglitz, "nothing paintable."[77] He may have convinced himself otherwise with his own photograph, in which the landscape becomes a frame, or framing, of mind. The

Fig. 15. Sketch for *The Big Cloud* in a letter from Edward Steichen to Alfred Stieglitz, July 1904. Yale Collection of American Literature, Beinecke Rare Book and Manuscript Library, New Haven, Conn.

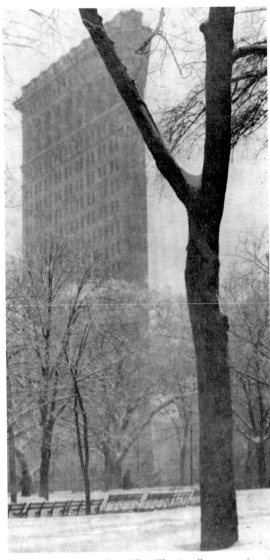

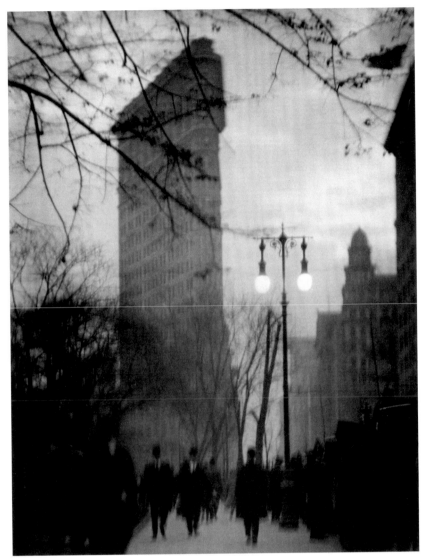

Fig. 16. Alfred Stieglitz, *The "Flat-iron,"* 1902, printed ca. 1913. Photogravure. The Metropolitan Museum of Art, New York. Alfred Stieglitz Collection, 1949 (49.55.16)

Fig. 17. Alvin Langdon Coburn, *Flatiron Building,* 1912. Platinum print. Courtesy George Eastman House, Rochester, N.Y.

print's drifting skeins of tone recall Maeterlinck's evocations of the enfolding realms of nature—we see moss, soil, water, wood, air, algae, moonlight—and the ceaseless exchange of vitality among them. The image was sometimes exhibited under the title *Solitude;* the pictured moment of lunar dawning both prompts and mirrors a moment of contemplation, with the pool suggesting a primal site of self-reflection that was not to be found (or was not being sought) by a teenager in the muddy Wisconsin woods a few years earlier.[78] Steichen would use the parklands around Caffin's home again on return visits as a setting for studies of his wife and daughter (plate 24). He had found something worth depicting there after all: an idyll of fecundity.

For some, the metaphysics of Steichen's pictures were a poor replacement for physics. Frederick H. Evans questioned the unlikely suspension of a sunlit cloud over a black horizon in *The Big Cloud, Lake George* (plate 27).[79] The scene is built, of course, on that uncanny juxtaposition: with the sun's activity suppressed in the scene generally, the cloud becomes its own miraculous light source. The blackening of shadows and intensifying of highlights to coax life from an unremarkable subject was nothing new, but Steichen stretched this strategy beyond its usual bounds in landscape, rearranging the natural order with the flair of a studio portraitist, whose implicit task is never to record what comes through the viewfinder, but to render it wonderful.

When applied to conventionally pretty, "paintable" landscape subjects, the technique could lapse into the saccharine, as when perfume-heavy blossoms commence to glow (plate 25). Steichen's talents were better matched in the scenes he encountered on a 1906 trip to the American west, where one form of the uncanny met another. He wrote to Stieglitz that he had felt himself unequal to the view east from the Rockies, looking over the plains "far—far—and on to, say, the Flatiron."[80] His solution was to focus on more localized expressions of the light and space of the west. His *Storm in the Garden of the Gods* (plate 28) could almost be a scene back east, near the Flatiron or the Battery. A "Garden of Gods" is something very like what a great city, New York or Paris, meant to Steichen, and he described the urge to get back to civilization and his "*desire* for work" as a "barometer foretelling storm" inside him.[81] The upright form in nature, the Flatiron brushed by fog or a stone spire in the sun, had become a significant subject for him. Its human correlative, as seen in the poster Steichen designed for the Little Galleries of the Photo-Secession (p. 160), was the male hero facing a moonlit vista and sublimating it in his art.[82] It was a subject awaiting its climactic treatment.

Steichen had gained some renown at the end of his time in Paris in 1902 for a series of nudes, a subject in vogue on the Continent but under close watch in the Anglo-American world, and especially in New York, where Anthony Comstock's Committee for the Suppression of Vice was at the height of its powers.[83] The nudes Steichen had exhibited in Europe (plates 9, 10) were studio views of a slim model with her face averted (a necessary concession in getting the most attractive models to shed their clothes), attended by a meager list of props: pussy willow, iris, and narcissus in Arts and Crafts vessels, a Bacchus mask, a curtain, and Steichen's cat Minimum. In New York, even the most "painterly" of these unassuming little nude studies were far from matching Steichen's paintings in commercial appeal, a factor having less to do with the subject of lovely women than with their colorful and decorative treatment. The enlarged, intensified, colorful versions of his nudes that Steichen began printing in New York (plates 30, 31) can be understood equally well as "Tonalized" versions of the Paris nudes or, conversely, as eroticized versions of Tonalist formulas, as though the stilted world of Thomas Wilmer Dewing, for example, had been stage-managed by Rodin, shifting one's attention, compellingly, to the psychological state of his women.

The spiritual elegance of Steichen's nudes is very much like that of the elementally "slight" figure studies by Whistler from

which they descend (fig. 18). It is the elegance of a visual imagination skirting the outer edges of allegory, assuming but not belaboring the doubleness of phenomena: a subject's isolation and connection to the world; the specific and the generic in a flower or a pose; a name's literal and poetic resonance. Whistler's idiom—and in Aestheticism's wake, the idiom of pictorialism—had been an essentially theatrical one, in which a figure and its "properties" (in the stage manager's sense) are conspicuously separate entities, joined by a directorial gesture that is the artist's creative contribution. The gesture is at once underlined and dismissed in pictorialist titles that brush lightly past the woman to go straight for her prop, such as Steichen's *The Brass Bowl* and *The Little Round Mirror* (plates 29, 30).

Some of Steichen's other figural works, however, give an early hint of a new idiom: that of cinema, in which an actress's "properties" are of the psychological kind, an aura emanating from a face translated into shadows on a screen. His visual style, in all genres, is one of artful occlusion: dominant shadows make an equally momentous event of any light that breaks through them, whether it is the sparkle in an eye, a glimmering vest button, or a distant streetlamp on Fifth Avenue. His proto-cinematic intuition was to see that art draws us most irresistibly to that which we are led to infer but prevented from seeing, compelling us to imagine it into life for ourselves. To lift his subjects into a condition of mesmeric attraction, Steichen needed a fulcrum, an intensely concentrated form of the diffuse elegance that was everywhere and nowhere in Whistler. In a word, he was inventing glamour, by its nature an unavailable quality, specific to its possessor. Steichen's task was given a boost when his subject was famous, powerful, enchanting, or wise. (*Glamour* and *grammar*, joined at the root, both refer to the wielding of occult knowledge.) But if a subject defied glamorization, it had Steichen's resourcefulness to contend with.

Whistler had used his titular props and discrete stylizations as a matrix in which to dissolve the real presence of his female sitters. Steichen wanted style and props alike to read as outward expressions of his women's personalities. To provide a decorous and decorative representation of her station in the world was every elegant woman's task; to make her occupation of the role appear inevitable was Steichen's. The titles of his 1904 pictures *Melpomene—Landon Rives* and *Profile* (also called *Mercedes de C., Profile, Miss de C.,* and so on) have a half-identifying, half-concealing function that neatly fits the images (plates 32, 33). Steichen poured his sitters (an aspiring actress and a magazine illustrator, respectively) into roles that effectively occupied them: the muse of Tragedy, for whom performance was the

closest thing to self-revelation, and a profiled (and therefore precisely half-hidden) *femme fatale*.[84]

Women who were publicly known, or known to Steichen personally, warranted more acutely calibrated relationships to their settings; a heightened quality of self-possession more properly earns their pictures the name of "portraits." He depicted Mrs. Philip Lydig, a stylish and wealthy New Yorker famously fond of flowers, as the most exotic blossom in a swirling bouquet of the cyclamen she adored (plate 55). Agnes Ernst, a cultural reporter at the *New York Sun* and an intimate of Steichen and Stieglitz, rises more majestically, but no less florally, from a vase, of the kind she took to collecting seriously with her husband-to-be, financier Eugene Meyer, who commissioned this portrait of his fiancée (plate 52). The beauty that Steichen pictured literally glowing from her face and dress (he and Stieglitz called Ernst "the Sun Girl") does not soften the vivid flash of her eyes, which give notice of an attentive mind not to be deflected. Steichen placed another paying sitter—Lady Ian Hamilton, the wife of a British military officer—at what might be called a respectful distance from the camera, an arrangement he later used as a photographer for *Vanity Fair* when depicting costumed stage and screen performers in set pieces (plate 37). Lady Hamilton's set piece is one about stature and stateliness (a later period eye may see only their deflated descendant, "status"), qualities that her setting equates both with architectural grandeur and with the buoyancy and propulsion of the sea.[85]

With his portraits of public figures, Steichen's cinematic notions found their true calling. One definition of realism in opera suggests that the question to ask is not whether the stories told in *The Magic Flute* or *Turandot* are plausible, but whether, in a world where such events occurred, people would communicate by means of the composer's music.[86] Steichen's best celebrity portraits are realistic in this sense: when his sitters live up to the style in which they have been presented, one is convinced that their personal magnetism inspired the photographer's vision of them, rather than the other way around. Set among Steichen's other pictures, which frankly employ reality only as a conduit to ideals and dreams, Steichen's portraits appear strikingly rooted in the physical details of their subjects, and they convincingly worked their way into the public's understanding of the notables he depicted.

A photographic portrait, unlike its painted counterpart, must succeed in convincing us that the sitter was in an important sense a coauthor of the image—that is, that the photograph depicts a persona that was making itself available to view. With regard to portraits of the famous, this calculation had a

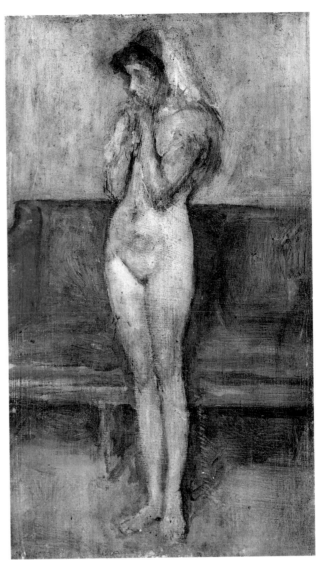

Fig. 18. James Abbott McNeill Whistler, *Rose and Brown: La Cigale,* 1899. Oil on wood panel. Courtesy of the Freer Gallery of Art, Smithsonian Institution, Washington, D.C. (02.110)

sharper edge to it in an era before the movies, which made celebrities constantly available to their public in the form of moving, speaking images. Viewers could not help trying to incorporate Steichen's *Richard Strauss, J. Pierpont Morgan,* and *George Bernard Shaw* into preestablished ideas about who these people were. But an average viewer's notion of Shaw, for example, would have been a pastiche of fragmentary reports about the playwright's wry demeanor, political opinions gleaned from his essays, and sundry impressions of his appearance taken from earlier portraits.[87] Steichen's sprightly likeness of the author (plate 51) served to incarnate these scattered abstractions into the kind of whole, vivid personality one sees when looking at a close friend.

The portraits Steichen exhibited during his first months back in the United States in 1903 were still thick with Symbolist provocation, and they served, as had his self-portrait in suspenders, as something like a manifesto, dividing friends from foes. A highlight of the early Photo-Secession group exhibitions was Steichen's portrait of Sadakichi Hartmann (plate 34), Stieglitz's handpicked reviewer for the Corcoran and Carnegie exhibitions and a notorious aesthete.[88] James Moser, a painter living in Washington, recounted to Stieglitz an amusing meeting of the Capital Camera Club, where a young man, "thin as a match with a hint of Van Dyke beard," had interrupted a senior club member's denunciation of the Hartmann portrait to insist that "Steichen was a great artist." Asked to arbitrate, Moser had declared, "with some emphasis and much deliberation and distinction, 'that is a *great* work of art.'…I am not at all sure of the 'greatness' of that ugly print," Moser admitted to Stieglitz, "but I could not miss such a chance [any] more than that more famous 'Jimmie' (Whistler) could."[89]

The portrait had done its work. Hartmann, sinking into charcoal-black darkness and unabashedly affected in his dress and posture, is a kind of poster-boy for Secessionism, and the very embodiment of blasé decadence. His image takes on extra humor if seen as a mirror image of Johann Tischbein's portrait of Goethe among temple ruins in the Campagna (Städelsches Kunstinstitut, Frankfurt-am-Main), the archetypal Romantic vision of a humanist contemplating the antique past. The half-German, half-Japanese Hartmann was exactly the man to catch such a reference and, in the same light, to appreciate the facile brushwork whereby Steichen converted a standing cloaked statuette behind his sitter—a somber Rodin figure or a pious church saint—into Ho-Tei, the obese Japanese god of worldly good fortune.[90]

The classic portrait of J. Pierpont Morgan that Steichen made in early 1903 (plate 35), in which the banker's fierce grip on his chair's arm lends him the appearance of a knife-wielding fanatic, has become difficult to see through its own myths and those attached to its sitter.[91] Steichen was commissioned to photograph Morgan at the studio of Fedor Encke, a portrait-painter friend of the Stieglitzes, who was anxious to spare his impatient client hours of posing. By rehearsing the job with a janitor in the chair before Morgan arrived, Steichen shaved seconds from the procedure. He was after two views of Morgan, one for the painter's use and one for himself. When asked to adopt the second pose, Morgan stiffened and glared, and Steichen got his exposure; upon being told, a moment later, that the session was done, Morgan paid five hundred dol-

lars to the fine young man who had taken such care not to waste his time.

At this point, fact and legend get tangled. Steichen later claimed that for Encke's print he did extensive negative retouching to reduce Morgan's disease-ravaged nose to presentable proportions, while to his own negative he "did very little retouching, except to make the nose a little more vague and remove spots that were repulsive."[92] Steichen's story of the portrait centered upon his subject's reaction to proofs of these two variants: Morgan ordered a dozen prints of the "retouched" painter's working-aid but shredded Steichen's less doctored variant, pronouncing it "terrible." Yet a few years later, Steichen claimed, Morgan saw and admired an enlargement of the latter version, by then a well-known image, and the photographer derived "childish" pleasure from taking his time about filling the banker's order for a set of prints.

The biggest problem with Steichen's story—if it intends to mean that photographic truth beats flattery, even in the eyes of the flattered—is that Morgan's nose is equally retouched in both portraits; in this respect neither of Steichen's images differs much from the respectful file photographs that were published with Morgan's obituaries in 1913. Steichen's reworking of the nose, however contrary to his later sense of honesty as a photographer, in fact makes perfect sense when appreciated as an integral part of the picture's purpose, which was not to portray Morgan as a grotesque but to suggest the vehemence of his grasp on power.[93]

The briefest flash of irritation had given his sitter the demeanor Steichen was looking for; in the darkroom, he amplified the mood by playing upon the happy accident of Morgan's grip on his chair. In terms of work method, the three-minute session with Morgan represented quite a change from watching Rodin every Saturday for months, followed by months of intricate combination printing. As a picture, Morgan's image adds up to less than Rodin's, but a tangible air of urgency makes it incontestably the more vivid portrait. "If some moment of reality in the personality of the sitter did not happen, you had to provoke it," Steichen had learned. "The essential thing was to awaken a genuine response."[94] The operatic analogy cited above may provide the best reference for the meaning of his key word, *genuine*: a genuine glimpse of Morgan was one that intensified a mental image of him in which the world devoutly believed, whatever its relation to the truth. Morgan was of course fully aware of his authority, and non-verbal beyond abruptness, but he was no wild-eyed beast. Indeed, many of his executives felt stifled under a regimen of endless "conference, consultation, and compromise."[95] But the

story conveyed by Steichen's picture, like the story he told about it, was one he knew spoke to a public reality greater than one man's private character.

Directly upon leaving Encke's studio, Steichen took a hansom crosstown to photograph the elegant stage star Eleanora Duse at her hotel. Intoxicated with the story-ready, beauty-and-the-beast contrast of the morning's work, he left a cryptic card at Stieglitz's home. "I have 'sneezed,'" he announced, and told Stieglitz to meet him at the Camera Club for details.[96] The reference to a sudden yet anticipated release suggests that the two had already discussed the imminence of his public triumph. Steichen was a celebrity photographer, in both senses of the phrase, from this day on.

Richard Strauss came to the city in February 1904 to conduct his *Symphonia Domestica* at Carnegie Hall. Probably introduced through the hall's orchestra director, Hermann Hans Wetzler, a friend of Stieglitz's, Steichen found an ideal subject in the mild-mannered composer, who clearly recognized the sitting as an opportunity to heighten his Luciferian public image (plate 36).[97] Strauss's wife and friends gently mocked him as a hopeless bourgeois, but Steichen elected to show him as the unrivaled high priest of the cult of difficult genius. That Steichen chose to photograph his subject as the composer of *Ein Heldenleben* and *Also Sprach Zarathustra* is all the more striking given the affinities of the *Symphonia Domestica* with Steichen's own notions about the quiet life of the family as a likely topic for deeply moving art. The voice of public greatness in Steichen's ears, as a subject and as a future, was drowning out the charming clatter of home.

· · · ·

Life centered at 291 Fifth Avenue was enormously productive for Steichen's photography and bankbook, but his ambitions as a painter suffered under the demands of his business and of his annual determination to outshine Coburn and "make the roast beef sizzle" at the Linked Ring salon. By 1905, it was time for the kind of "kick in the pants" that Steichen gave himself whenever his life settled into complacency.[98] In one of the informal evenings at Stieglitz's home that passed for Photo-Secession meetings, Steichen announced his plans to close his studio and return to Paris to paint. But a year's work remained before he could make good on the plan.

Steichen had come to see Stieglitz as brilliant in all he did but helpless to do anything new on his own. He needed what Steichen called a "spark," and Steichen was it. Stieglitz had already negotiated an arrangement whereby the Photo-Secession decided which American photographs went on the

walls in London and at other international salons. What was still needed, Steichen felt, was an exhibition venue in New York, under Stieglitz's direction. As Stieglitz was unopposed to the idea, Steichen relocated himself into a larger space across the hall at 293 and passed the rental contract for 291 to Stieglitz. He then undertook his former studio's makeover into a gallery after the latest European fashion, hanging the walls with burlap while Clara put floor-length skirts over the shelving that ran around the rooms up to waist height. Between November 1905 and May 1906, Steichen designed and hung seven exhibitions in the rooms, establishing the subtle, compelling voice of the Little Galleries of the Photo-Secession.

The first issue of *Camera Work* had featured an article by Sadakichi Hartmann on photography and interior decoration that favored Japanese "harmony" over cluttered American "museum style" as the ideal setting for portraits by Steichen and Käsebier. "We have outgrown the bourgeois beauty of Rogers statuettes, and are tired of seeing Romney backgrounds in our portraits and photographs," Hartmann wrote. The delicate balance between something and nothing in Steichen's pictures made a worthy model for the rooms in which they could best be viewed, and for the lives that were to be led there.[99]

The space inside the Little Galleries was, both literally and effectively, the space inside Steichen's portraits: a space designed for self-reinvention, for imagining the conversion of life into art. In the years ahead at 291 Fifth Avenue, the stylish adventure of "being done by Steichen" was replaced by new, more abstruse aesthetic adventures, but no ritual of consecration divided the address's two phases; they were stages in a continuum. The numerical nickname "291," which like a Picasso drawing called for speculative interpretation, and for that reason appealed strongly to a select group of New Yorkers a few years later—this, too, was the invention of an impatient young entrepreneur, too busy to write out his studio's full return address in his letters to Stieglitz.

Stieglitz's paradoxically hungry and distant attitude toward the world outside what now became his rooms might be described as one of "abstraction"—a word that implies at once conceptualization, intricacy, and removal. The salon that was 291, its mood and energy abstracted from the smoking-room at the Camera Club, organized itself around the unique combination of flexibility and fixation in Stieglitz's habits of thought. The Little Galleries became the real home Stieglitz had needed: life with his family was as crowded with alien spirits as any sidewalk, but 291 was an annex of his mind.

In the autumn of 1906, Steichen packed up his family and returned to Paris, eager to get back to painting and to begin

Figs. 19, 20. Edward Steichen, views of his studio at 103, boulevard du Montparnasse, Paris, 1906. Gelatin silver prints. Yale Collection of American Literature, Beinecke Rare Book and Manuscript Library, New Haven, Conn.

providing Stieglitz with exhibitions of Paris art that would shift the Photo-Secession's public role, once and for all, away from that of a parochial photographic club. The two men's shared desire to provoke, to inspire, and to wave what they called the "red rags" of Paris art before the bull of American taste at first served to minimize, and indeed to eclipse, their differences. But the activity that joined them—Steichen's gathering, and Stieglitz's presiding over, exhibits of the latest developments in art—was from the beginning made possible by the very differences that would ultimately split them apart: Steichen's eye for visual spectacles that would attract the public, and Stieglitz's knack for spinning conundrums and complications to confound it.

· · · ·

Under pressure to get his family settled after a difficult ocean crossing, Steichen took an expensive, newly built studio and apartment at 103, boulevard du Montparnasse. Into its design he poured the store of experience and ideas he had accumulated during the conversion of 291. The apartment was luxuriously bright and modern, including even hot-water facilities adaptable to darkroom purposes. Its studio area, which Steichen showed off to Stieglitz in a group of photographs accompanied by meticulous color notes (figs. 19, 20), provided a space in which to show paintings to prospective buyers, and also to make the occasional camera portrait, for which Steichen devised an adjustable set of overlapping scrims over a high bank of skylights.

The furnishings of the room provided visitors with the artist's legible table of contents, blending intimacy and heroism, the current and the classic. Objects throughout the room advertised an astute range of affinities: a Rodin figurine, Arts and Crafts furniture, vases of fresh flowers. A kind of altar was erected against one wall—potted trees flanking a life mask of Beethoven, the peace-invoking, common god of the warring Strauss and Wagner cults—and at the center of the room stood an altar of another kind: a magazine stand bearing three issues of *Camera Work* dedicated to Stieglitz, White, and Steichen himself.[100] Amid paintings on easels, a select group of photographs bodied forth the painter's cherished personal loyalties. Besides his self-portrait with Clara and two variants on *Mother and Child—Sunlight Patches*, these included one of several portraits of Stieglitz with his daughter Kitty that Steichen had made the year before (plate 38).

The latter image is a little jarring in this context, since it is one in which familial intimacy silently struggles with a sense of depthless detachment. The warmth is a testament to Steichen's skill in directing his sitters; the distance says something truer about the strained relations in the Stieglitz household. (In two other pictures from the sitting [fig. 21], both father and daughter wear their coats indoors, as though a chill haunts any room they both inhabit.) The portrait earned its place on Steichen's mantel, one senses, not as a variant on the theme of parental love seen in *Sunlight Patches*, but as an emblem of the roles that had made Steichen himself an adoptive member of the Stieglitz clan: he was Kitty's dashing young

uncle, the kindest of the photographic crowd toward Emmy, and, at Lake George, a *plein-air* painting partner to Alfred's father Edward, a taskmaster whom the younger Edward affectionately called "Rex." Steichen's portrait of Alfred and Kitty could almost be a snapshot of his siblings, older and younger, whose awkwardness toward one another was less apparent to the photographer than their common bond to himself.

Notably absent from the artist's Paris decor were portraits made in the New York studio, which represented the high-profile commercial photographer's identity Steichen had come to France to undo. Painting was the vocation for which he had recrossed the ocean, and in a broader sense, color was the dimension of picture-making around which his motives would organize themselves during his next several years of work, in all media. In painting as in photography, a portion of Steichen's sales would come from portrait commissions, but landscapes expressed his dearest artistic aspirations, and these comprised the greater part of the winter exhibitions of his paintings that he lined up at 291 and other Manhattan galleries. The exhibitions—landscapes and all—often sold out, more than once paying his family's expenses for the following year in France.

Previously, Steichen's photographic eye had guided his painter's palette, with a single dominant tone modulating the basically dualistic, light-and-dark nocturnal scenes he favored.

Fig. 21. Edward Steichen, *Alfred Stieglitz and His Daughter Katherine,* 1904, printed 1905. Platinum print. The Metropolitan Museum of Art, New York. Alfred Stieglitz Collection, 1949 (49.55.228)

The sight of Van Gogh's paintings had intrigued but startled him a few years earlier, and he told Stieglitz that the Salon d'Automne of 1906, featuring a roomful of Gauguin's Tahiti paintings and several dozen Russian moderns, likewise "gave me a stomach ache."[101] But over the next few years, Steichen's repeated exposure to Henri Matisse's paintings in Leo and Gertrude Stein's apartment, to the work of other young American painters in Paris like Arthur Carles and Alfred Maurer, and to the works of Cézanne and lesser figures at the Salons d'Automne (Kees van Dongen was an early favorite) nudged his vision toward a world irreducibly made of color, in which black shadows were only a fiction.

If Steichen recognized the contemporary Parisian painters' "red rag" potential immediately, he did not apply the lessons of their work to his own until 1908, when the Steichens began spending their time at a rented farmhouse in the village of Voulangis, a few miles northeast of Paris. There he began breeding flowers, a painting subject that defied treatment in the low end of the spectrum, and a pastime that soon followed a characteristic curve into obsession and mastery. Within a few years, Steichen's life and thinking would be centered around the arcana of delphinium genetics and the spectacular gardens surrounding his house at Voulangis.

In selecting representative examples of the art he was seeing to send to New York, Steichen ran up against a problem: 291's scale. The Little Galleries, with their narrow clearance between rail and ceiling, were spacious enough for any show of photographs, but they could not accommodate more than a few oil paintings of even moderate size. Of necessity, much of what Steichen shipped to Stieglitz consisted of works on paper.[102] Between Paris and New York there was in effect a filter, winnowing out much of what beguiled Steichen's eye in contemporary art—the saturated color intensities of oil paint—from the shows that went on the walls at 291. Stieglitz unpacked and put before his public a compelling, but in substance quite different and more difficult, vision of the Modern—a vision having largely to do with form and its permutations—than the one Steichen ideally would have shown. This effect was exacerbated in the historical record, since *Camera Work,* the gallery's visual logbook, was for the most part illustrated with black-and-white reproductions of the works exhibited there.[103]

Steichen's ongoing efforts to get color into his photographs, expressed in the preceding years in his use of multiple-pigment printing techniques and imperfect double- and triple-negative processes, soon met with a technological boost of quite another order.[104] In June 1907 the Lumière brothers of

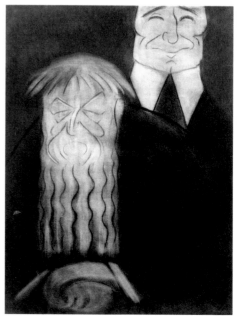

Fig. 22. Postcard from Edward Steichen to Alfred Stieglitz, 28 Aug. 1909. Yale Collection of American Literature, Beinecke Rare Book and Manuscript Library, New Haven, Conn.

Fig. 23. Marius de Zayas, *Rodin and Eduard J. Steichen*. Photogravure in *Camera Work* 46 (Apr. 1914). The Metropolitan Museum of Art, New York. Alfred Stieglitz Collection, 1953 (53.701.466 [4])

Paris publicly presented their newest invention, the auto-chrome. When placed in a camera, the double-coated glass plate filtered light onto a photosensitive emulsion through a matrix of potato starch grains infused with secondary-color dyes (red-orange, blue-violet, and green). A tantalizingly error-prone process of development and redevelopment yielded a unique full-color image, which, held up to the light or, more problematically, projected onto a screen, represented the world as a mist of pointillist color specks.[105] For Steichen and many others, the autochrome seemed to confirm that color and the evocation of atmosphere pointed toward a future in which the means of photography and of painting converged.[106]

The autochrome's novelty drew many of its enthusiasts into artless exercises, much as the wonder of the daguerreotype had done in 1839; but Steichen, though more taken than anyone with the latest vehicle of color vision, kept his balance better than most. He made still-lifes and landscapes in addition to portraits (plates 39–42), produced both larger and smaller plates, and offered his autochromes at a wide range of prices, as he did his prints on paper.[107] In all these ways, he signaled that the process was, for him, contiguous with the rest of his art, not a new province of activity defined by the price structure of the Lumières' stock. After months of research, he even devised a way to produce color prints from autochromes by way of a four-color process, although after a confidential announce-ment to Stieglitz the breakthrough was not heard of again. More than likely the time- and cash-intensiveness of the method rendered it impractical.[108] Strapped for cash after months of costly experimentation, Steichen drafted an exhaus-tive technical how-to text on the autochrome and proposed that Stieglitz publish it as a moneymaking pamphlet. But as the lingering impracticalities of the process became clearer, he finally opted simply to print the essay in *Camera Work*.[109] If the autochrome did not quite, in the end, give cause for throwing over painting, or even black-and-white photography, for sheer joy it continued to provide Steichen a lift comparable only to that of aviation, the leading Franco-American diversion of the moment (fig. 22).[110]

Two strikingly fresh photographs Steichen made at the Longchamps racetrack during his first year as a "color-mad" autochromist find him treating light (even in the absence of color) as an array of vibrant, unique fields of tone, rather than as a matter of the presence or absence of illumination (plates 44, 45). The effect is a product of the spatial complexity of the scenes, as rare a characteristic in Steichen's photography as the social intricacy and the candid, high-speed exposures of these images. Bodies of matching brightness and texture (white silk dresses, for example) are seen from a wide range of distances and amid varying surroundings, differentiating them from one another as distinctly as the sound of a high C played on a clari-

net, a trumpet, and a piano. Steichen achieved this sense of "color," in the musical arranger's sense, by placing himself amid the motion of the crowd rather than at a point apart from it (say, across the track or atop the bleachers), from which the spatial arrangement of the site would have reduced itself to a map, and the dresses in the crowd would have resolved into matching motifs in its unified surface.

Steichen later described his racetrack pictures as "my first serious attempt at documentary reportage."[111] But if actively immersing oneself and one's seeing in one's subject was a tactic that sensationalist news photographers of later decades embraced, in 1907 the pictorial chaos it risked was too much like that of the pictorialists' bugbear, the Kodak "snapshot," and too little like the authoritative, commanding view that newspaper and journal illustrators were expected to provide. It was, in short, no procedure for anyone with a specified end in mind. Steichen's eye, however, was free: he had no need to concern himself with what "news" was occurring at the racetrack — who was in attendance, what horses won, or (the only potentially momentous fact preserved in his images) how a poor flower girl fit in among the leisured classes at Longchamps. A more plausible perceptual precedent for his dramatic prints are the drunk-on-absinthe posters of Henri de Toulouse-Lautrec, or even the paintings of Matisse and other "wild animal" painters that Steichen had seen at the Salon d'Automne, in which every face, limb, tree, and rock represented a fresh challenge to the artist's eyes and brush, every subject a new beginning in the process of representation, and each inch of canvas the occasion for a new adventure in color.

Amid all his painting, autochroming, assembling shows for 291, attending air shows, and breeding flowers, Steichen spent little time adding to his store of new negatives to print. Stieglitz too, apart from autochrome jaunts in Germany with Steichen and others in the summers of 1907 and 1909, was scarcely photographing at all during these years, but his thinking was undergoing a gradual overhaul under the influence of the art Steichen was sending him, and the new cast of "sparks" that it drew into his presence at the gallery. The most important of his new associates was a dashing Mexican emigré cartoonist named Marius de Zayas, who shared Stieglitz's fascination with the aesthetic and rhetorical beauties of the world as seen in black and white. De Zayas's brash and playful theories helped Stieglitz convince himself that photography's role lay in an unexplored border zone where painting, science, and modern thought had not quite met.[112]

For Steichen, painting and photography were knotted together at their adjoining loose ends: the search for beauty and the love of one's subject justified any number and manner of rope bridges between the one procedure and the other. De Zayas, and after him Stieglitz, was more intrigued by those aspects of the two media, as sign systems and as modes of thought, which led in divergent directions. By temperament as by profession, de Zayas was a caricaturist: one who approaches the physical features of the world piecemeal, converting each facet of his subject into a graphic sign, then exaggerating the signs until a new kind of likeness results, based in equal parts upon scrupulous observation and wit without scruple (fig. 23).[113] De Zayas saw straight photographs like Stieglitz's, on the other hand, as unique self-portraits of nature's bald facts. A "negation of all representative systems,"[114] uniquely untouched by the prejudices of artistic convention, the photograph freed painters to pursue conceptual and subjective problems that were more naturally the province of a handcrafted medium. Even a visually uninteresting photograph commands attention as a physical index to facts in the world; but only a rather sophisticated, counterintuitive effort on the part of a viewer can force the typical photograph to reveal itself as a consciously

Fig. 24. Alfred Stieglitz, *The Steerage,* 1907, printed 1915. Photogravure on vellum. The Metropolitan Museum of Art, New York. Alfred Stieglitz Collection, 1933 (33.43.419)

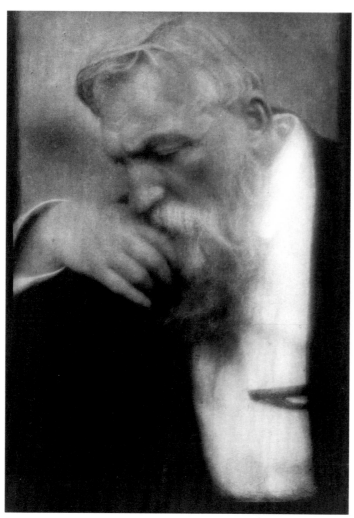

Fig. 25. Edward Steichen, *Auguste Rodin*, 1908. Photogravure in *Camera Work* 34–35 (Apr./July 1911). The Metropolitan Museum of Art, New York. Alfred Stieglitz Collection, 1953 (53.701.454 [1])

photographs that frankly made centerpieces of their subjects. He plainly enjoyed wrestling with the varieties of personal magnetism, which forced a portraitist to find visual languages appropriate to egotism and self-surrender, spirituality and pragmatism, revolutionary verve and institutional might. When Steichen referred to George Bernard Shaw, whom he photographed in the summer of 1907, as "the photographers' best model," he was making a little dig at Coburn, who had recently derived enormous publicity from the photogenic playwright. (Among other poses, Coburn had photographed him nude as *The Thinker*.) But he was also saluting a man with a rare sense for how to play to the camera.[115] In Steichen's portraits, Shaw's alertness to the encounter with the picture frame emblematizes his conversational wit and suggests a certain commonality of purpose with the cameraman, as though to say an author is always, and first, the author of himself and his settings. A few weeks later, photographing thirty-two delegates to a Socialist congress in Stuttgart, Steichen found himself struck with the "force and power of men," a quality he expressed visually, along with the group's unity of motive and a certain austere purity, by the use of simple, light-toned backdrops. (He thanked Stieglitz for forwarding him a copy of *Camera Work* to show to the Socialists, as "I hate to be taken as just an 'ordinary photographer.'")[116]

Following an especially lucrative winter of gallery shows in New York, in April of 1908 Steichen traveled to Washington to photograph President Theodore Roosevelt and Secretary of War William Howard Taft for five hundred dollars per portrait, an extraordinary rate that had been negotiated for him by Stieglitz.[117] The portraits, along with a view of the White House captioned *The Goal*, were used to illustrate Lincoln Steffens's profiles of the year's presidential candidates in *Everybody's Magazine*.[118] Steichen's portraits met the contrasting purposes of Steffens's article by evoking two distinct modes of authority: retention and expansiveness. Roosevelt's phlegmatic pose recalls the portrait of Morgan, although this time the soft-spoken man of power held, appropriately enough, a big stick. The jovial Taft, on the other hand (plate 54), is enhaloed by a globe behind his head, echoing the generosity of his body's profile and making the optically reasonable implication that to resemble the world is a useful quality in ruling it.

If Steichen was nagged by thoughts of reversion to the soulless professionalism that had inspired his flight from New York, October of 1908 brought an opportunity to undertake a project with deeper personal relevance. Rodin invited him to Meudon to photograph the *Balzac*, still uncast but now mounted atop a high pedestal, which had been wheeled onto

constructed array of signs. Stieglitz came to look upon *The Steerage* (fig. 24), which de Zayas discovered for him among his negatives, as his greatest picture, because it did not only what de Zayas had said art did (it looked like shapes and signs in the mind of a thinker working things out) but also what de Zayas said photographs did: it preserved in perpetuity the complexity of a moment of vision. Stieglitz amended de Zayas's theory by relating the complexity of the moment preserved in a photograph to the complexities inside the photographer who had felt moved to record it. He began entertaining the notion that the relationship between these two—the meeting of the "I" and the "not I" in the moment of exposure—was in some way uniquely the subject of a photograph.

While Stieglitz was starting to think of photography as a form of self-portraiture, centered around the photographer's act of selection, Steichen grew ever more expert in making

a terrace overlooking Paris. Following the sculptor's suggestion to photograph by the light of the full moon, Steichen worked through the night, producing several moonlight exposures of greatly varying lengths, as well as one view made with a flash and two by the light of early dawn. The resulting images represent the sculpture variously as a featureless silhouette, a rough outcrop of stone, and an uncannily human presence (plates 47–49). Rodin identified the elegiac function of the prints Steichen brought him several days later by remarking, "You will make the world understand my Balzac through these pictures. They are like Christ walking in the desert."[119] Steichen knew, having seen the robed and unrobed studies for the sculpture in Rodin's studio, that in the course of his work Rodin had sought to go beyond likeness and tribute toward true physical, even autoerotic, oneness with his subject. Like Michelangelo's *Moses*, another sage lost in thought, the *Balzac* suggested its maker's identification with a great man suffering public trials and internal conflicts. Now a decade old, and never to be cast in the artist's lifetime, the maquette had become Rodin's self-portrait by proxy.[120] Rodin's appearance lent itself to Old Testament treatments—Steichen had earlier pictured him as Adam or God to his own sculpture of Eve (plate 41), and now he portrayed him as Moses deep in concentration (fig. 25)—but Steichen's images of the *Balzac*, as the sculptor suggested, put the photographer in the role of an Evangelist, beautifying an isolated, defiant moral critic in such a way as to "make the world understand," inviting awe and love regardless of what viewers might have thought of the sculpture itself, and whether or not they had read Balzac.

After providing Rodin with prints, Steichen produced a set to send to New York in early 1909. "They are the only things I have done of recent that I myself can feel enthusiastic over," he told Stieglitz. "I hope you can give them a show to themselves if only for a week.—The three big ones are a series and

Fig. 26. Sketch of the *Balzac* sequence in a letter from Edward Steichen to Alfred Stieglitz, Mar. 1909. Yale Collection of American Literature, Beinecke Rare Book and Manuscript Library, New Haven, Conn.

should be hung on one wall—the rest any way you choose." In a sketch accompanying the letter (fig. 26), he showed Stieglitz the sequence he had in mind for the trio: the vertical frontal study titled *The Open Sky* should stand at center, flanked by horizontal profile views, so that the figure would be looking up to, and even in a sense illuminated by, itself. (To soften the effect, he requested that Stieglitz "give the three a big separation so that each counts individually.")[121]

The *Balzac* photographs spoke as suggestively to Stieglitz's evolving notions about the aims of art and photography as they did to Steichen. The three big prints, which Stieglitz bought for himself, were hard-focused, consummate "straight" exposures from moonlight, but the romantic notion (and virtuosic feat) of an all-night lunar portrait session, with a magical sculpture for a sitter, came straight from the dreamworld in Steichen's paintings. The very essence of "slightness" and "intensity" in the treatment of their subject, Steichen's prints were nonetheless complex and sumptuous enough that customs officials failed to classify them, or tax them, as photographs.[122] Elemental shape studies, the silhouette views smooth the sculpture's blistered edges, heightening its human feeling even while playing up its character as a priapic trophy. Taken together, the *Balzac* photographs constitute a new genre, equal parts portrait and landscape: the Garden of the Gods and the Flatiron blooming into human form. And as studies in greatness—Steichen's most heartfelt preoccupation as a portraitist—the *Balzac*s are great in their universality: one might say, in their abstraction. Portraits-once-removed of Rodin and, of course, of Balzac, they surely spoke to Stieglitz of himself, too, a perpetually wronged genius staring down the void, feeling kinship with the moon but gazing in troubled love at civilization slumbering below.

·　　·　　·　　·

Strikingly, the exhibition of eight *Balzac* images in April 1909 marked the last time Steichen's prints appeared on the walls at 291. (He was represented in two consecutive exhibitions there early the next year: first as a painter, in the nine-artist *Younger American Painters* show, then in a show of autochromes, timed to coincide with a one-man exhibition of his photographs and paintings at the Montross Gallery.)[123] This is not to say that Steichen ceased being the Photo-Secession's most prominent exhibitor. On the contrary, a large new group of his prints anchored the American presence at a major photographic fair in Dresden in 1909, and a similar group of Steichen's prints figured prominently at the Albright Art Gallery's *International Exhibition of Pictorial Photography*, the sixty-five-artist, six-

Fig. 27. Edward Steichen, Fourth of July picnic at the Meyer estate, Mount Kisco, N.Y., 1915. *Clockwise from left:* Agnes Ernst Meyer, Paul Haviland, Abraham Walkowitz, Marion Beckett, Francis Picabia, John Marin, Eugene Meyer, Jr., Katharine Rhoades, J. B. Kerfoot, Emmy Stieglitz, Marius de Zayas, Alfred Stieglitz. Yale Collection of American Literature, Beinecke Rare Book and Manuscript Library, New Haven, Conn.

Fig. 28. Katharine Rhoades or Marion Beckett (?), Edward Steichen at a Fourth of July picnic at the Meyer estate, Mount Kisco, N.Y., 1915. Yale Collection of American Literature, Beinecke Rare Book and Manuscript Library, New Haven, Conn.

hundred-print blockbuster that Stieglitz curated in Buffalo at the end of 1910.[124]

What the statistic really indicates is the degree to which those events coincided with the exhaustion of Stieglitz's interest in pictorialism. The last London salon occurred in 1909, a circumstance that was in itself partly a product of Stieglitz's and Steichen's success in diverting foreign participants from Linked Ring events. The disappearance of his chief competition on the international photographic exhibition scene left Stieglitz with no motivation to organize annual shows for members of the Photo-Secession, whose work in any case had ceased to address artistic problems that engaged him. The gallery's exhibition program and the content of *Camera Work* turned increasingly in non-photographic directions that had proceeded from Steichen's inspiration, but that were now being more rigorously explored by de Zayas and others around Stieglitz.

Steichen "lives now in the country and it seems that he comes to Paris very seldom," de Zayas reported to Stieglitz during a scouting trip to France in 1911.[125] When Stieglitz traveled to Paris later in the year, Steichen did come to town to be his guide; the oil paintings by Cézanne, Renoir, and Van Gogh that he showed him reenergized Stieglitz, and another year's

exhibitions (including watercolors by Cézanne) were excitedly worked out. But if Stieglitz's mind was already in New York, Steichen's was in Voulangis. Putting almost all other work aside, Steichen had recently undertaken a four-year, $15,000 commission to paint a suite of decorative oil paintings that were to be installed as murals in Agnes and Eugene Meyer's townhouse under the collective title *In Exaltation of Flowers*.[126] His subject was the colorful splendor of a garden, in various metaphorical permutations staffed by his friends: a party of beautiful people, the treasures in a sculptor's studio, the objects in an art collector's sitting room. The paintings, finished in 1915 but never installed, are a celebration of the decorative (among flowers, Maeterlinck would point out, this means the sexual) as the unifying force of life. The sincerity of the concept was one that could be appreciated by all who knew Steichen: snapshots of a picnic at the Meyers' Mount Kisco estate in the summer of 1915 (figs. 27, 28) suggest Steichen's gifts as a social pollinator and his infectious joy and stamina among others at the top of their game.

On the other hand, no subject or ethic of representation could have lain further from the questions that fired Stieglitz's imagination. In 1912, when Stieglitz devoted an issue of *Camera*

Work to Gertrude Stein's word portraits of Picasso and Matisse, Steichen wrote that in his opinion a Cézanne number "would have seemed more logical" first.[127] In his way, Steichen was right; by the logic of "red rags" as successive educational encounters with the public, and learning as the mastering of seeds and germinations, Cézanne deserved an issue, since it was that painter's efforts that had made Picasso's and Matisse's work conceivable. But according to Stieglitz's game—that of keeping 291 afloat on the swiftest currents available—Picasso, Matisse, and (most of all) Stein had unquestionably been the way to go. Steichen continued making his winter trips to New York, but without business to transact and plans to concoct, his bond with Stieglitz naturally weakened. His flowers, his friends, his increasingly troubled marriage, and the darkening clouds over Europe made greater claims on his attention than the philosophical disputes that by 1913 had made 291 a storm center of radicalism in the arts.

Steichen learned just how separated his orbit and Stieglitz's had become when, early in that year, he came to New York and saw the epoch-making exhibition at the Sixty-ninth Regiment Armory that introduced modern art to the American public at large. Very little of the foreign work on view at the Armory Show could have been entirely unfamiliar to Steichen—the organizers' agents, some working at Stieglitz's direction, had done much of their hunting in Paris—but the sight of New York crowds taking it in, and the seriousness with which a now unfamiliar group at 291 discussed all the "isms" that Steichen had already decided were not for him—these were new, and hard to take. In a long, extraordinarily probing letter to

Stieglitz, written as he sailed back to France onboard the *Mauretania*, Steichen declared his relief to be heading home to the proven, quietly self-sufficient wisdom of his flowers and away from the strange mixture of analysis and revolutionism that seemed to have become, willy-nilly, the party line of modernism. "Because we see the beginnings of a chemical creation of life—does not make us give up our instincts of father + mother—not just *yet.*...Picasso in inventing cubism invented a new tendency.—but it will take *Genius* somewhere to make it or what comes out of it a living work of art, and this will _not_ spell death to any thing that has been produced by genius before.—that is not one of the ways of evolution."[128] As for the years ahead, Steichen gladly conceded, "I have no idea whether my work will look more like Bouguereaus than Picassos. Nor do I care"; he knew only that "I must have this force driving me before I can get anything—thinking about it makes me sleepy.—! Meanwhile it is great to know you are captain of a greater ship than this one."[129]

·　·　·　·

It has become customary to think of Steichen's and Stieglitz's association as coming to an end with World War I, when Stieglitz (out of disgust with American propaganda, and through his general affinity for the underdog) vaguely supported the Germans, while Steichen—having evacuated his family to the United States in 1914—directed aerial reconnaissance missions for the Army Signal Corps over France. Certainly the war exacerbated a division between the two men, but the split had been long in coming. In 1917, when

Fig. 29. Paul Strand, *Geometric Backyards, New York,* 1917. Platinum print. The Metropolitan Museum of Art, New York. Ford Motor Company Collection, Gift of Ford Motor Company and John C. Waddell, 1987 (1987.1100.12)

Fig. 30. Alfred Stieglitz, *Equivalent,* 1926–27. Gelatin silver print. The Metropolitan Museum of Art, New York. Alfred Stieglitz Collection, 1949 (49.55.29)

define his subsequent work, Stieglitz announced that his sharply focused, horizonless renderings of the clouds above Lake George (fig. 30) were immaculate expressions — *Equivalents* he called them — of his inner state. In the same year, Steichen returned to New York from his self-imposed postwar exile in Europe. Hired by the publisher Condé Nast, he instantly assumed leadership in the lucrative fields of fashion, celebrity, and advertising photography, a position he would maintain for the next two decades (fig. 31). "Photographic prints are too slow and don't reach far, but the printed page goes all over the world," he later explained.[130] "I wanted to reach into the world, to participate and communicate."[131] Regular full-page features in *Vanity Fair* and *Vogue* and syndicated work for the J. Walter Thompson advertising agency at last supplied him with a forum that satisfied his hunger for circulation. In Stieglitz's aesthetics of "Equivalence" and Steichen's aesthetics of glamour — centered upon the self and celebrity, respectively — the American Century found two of its defining photographic dialects.

But if the war spelled an explicit ending to Stieglitz's and Steichen's bond, in a quieter and deeper sense Steichen's letter

Stieglitz folded Camera Work and shut down 291, each ending underscored the distance separating him from his former partner. The journal closed with a double issue illustrated by the work of Paul Strand, a New York photographer whose rigorously straight pictures (he had never handled a brush) spoke of the medium's future as forcibly as, years before, Steichen's diametrically different efforts had. And the final show to hang in the gallery was one of abstract drawings and watercolors by Georgia O'Keeffe, a Wisconsin-born painter some nine years Steichen's junior for whom Stieglitz soon left Emmy, and who was pointedly indifferent to the idea of traveling abroad to expose her eye to foreign influences. The "paintable" had come home.

Strand and O'Keeffe, as it turned out, were pioneers in the joining of formalist rigor and native subject matter that was to characterize American art of the 1920s (fig. 29). Their influence played into a line of Stieglitz's thinking that had started with *The Steerage*. In 1923, arriving at the idiom that would

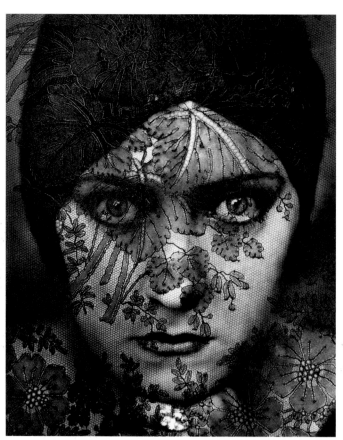

Fig. 31. Edward Steichen, *Gloria Swanson,* 1924, printed 1960s. Gelatin silver print. The Metropolitan Museum of Art, New York. Gift of Grace M. Mayer, 1989 (1989.1056)

of early 1913 had already recorded the coming of the end of the spiritual pact through which the two men's fundamental differences had previously been overcome. Under the force of time, diverted affections, and the internal compasses of two very different men, something truly ended at the Armory Show, and each of them recognized it. They were, in some simple functional sense, done with each other. Their mutual gaze had become the quizzical, wary one recorded in a portrait Steichen made of Stieglitz at 291 in 1915 (plate 56). Steichen's farewell from the *Mauretania*—the first, most intimate sounding of the widening gap between them—seems a sadder and truer ending than the later, merely political differences brought by the war, because it so forcibly describes, symptom by symptom, the death of a decade in modern culture when energy and analysis, color and form, ornament and abstraction, "paintre and fotographer," had joined hands and flown toward a future that would never happen.

NOTES

First, my sincere thanks to Maria Morris Hambourg, Curator in Charge of the Department of Photographs at the Metropolitan Museum of Art, for the gift of confidence in bringing this project my way. The conscientious and always resourceful efforts of the department's Research Associate, Laura Muir, have been indispensable at all stages of my work. For close readings of the text, for judgments regarding the sequencing of ideas and images, and for spot-on questions and advice, I am indebted to them both, as well as to Malcolm Daniel at the Metropolitan Museum of Art and Douglas Nickel at the San Francisco Museum of Modern Art. Credit for this essay's every remaining error, whether of fact or of judgment, is, of course, jealously guarded by the author. For various admixtures of hospitality, practical assistance, and thoughtful interrogation during the research phase, I am grateful to Peter Barberie, Michael Cole, and Douglas Eklund. For more than a bit of all of the above, and for her sustaining energy and patience, I thank Laurie V. Dahlberg.

Thanks also to the librarians and staff at the Beinecke Library, Yale University, and to Toby Jurovics, Assistant Curator of Photography at the Art Museum, Princeton University, for his help with materials in the Clarence H. White Collection. Professor Peter C. Bunnell of the Department of Art and Archaeology, Princeton University, was typically generous with time, encouragement, and access to files that reflect his decades of research; as always, he has my deepest gratitude. At Princeton University Press, I would like to thank my editor, Patricia Fidler, for tactical (and tactful) support of every kind, and the book's production editor, Curtis Scott, whose alertness, persistence, and understanding have been an inspiration and an education.

For the book as a visual work, credit goes to Bruce Campbell for his design; production manager Ken Wong; Susanne Cardone and Eileen Travell, who made the transparencies; and Martin Senn, whose separations would have earned Edward Steichen's grateful handshake.

1. On hobby club pictorialism's role in the American Progressive and Aesthetic movements, see Christian Peterson, "American Arts and Crafts: The Photograph Beautiful, 1895–1915," *History of Photography* 16, no. 3 (Autumn 1992): 189–232.

2. See Margaret Harker, *The Linked Ring: The Secession Movement in Great Britain* (London: Heinemann, 1979).

3. See Mary Panzer, *Philadelphia Naturalistic Photography*, exh. cat. (New Haven: Yale University Art Gallery, 1982), and Sarah Greenough, "'Of Charming Glens, Graceful Glades, and Frowning Cliffs': The Economic Incentives, Social Inducements, and Aesthetic Issues of American Pictorial Photography, 1880–1902," in *Photography in Nineteenth-Century America*, exh. cat., ed. Martha A. Sandweiss (Fort Worth: Amon Carter Museum; New York: Harry N. Abrams, 1991), 258–81.

4. For Steichen's account of the event, see his autobiography, *A Life in Photography* (Garden City, N.Y.: Doubleday, 1963), 1.5–6. My page references to this unpaginated book refer to chapter number and page within the chapter.

5. Stieglitz later said that Steichen told him he had never before received more than fifty cents for a photograph. Stieglitz's offer was, in any case, several times the typical prices listed by beginning amateurs at American photographic salons. See Dorothy Norman, *Alfred Stieglitz: An American Seer* (New York: Random House, 1973; reprint, Millerton, N.Y.: Aperture, 1990), 47.

6. Quoted in "View Pictures by Amateurs," a review of the Chicago Photographic Salon from an unidentified newspaper, 1900. This and many other early press notices of Steichen's work are preserved in a scrapbook kept by his mother, now in the Edward Steichen Archive, The Museum of Modern Art, New York (henceforth cited as "Maternal scrapbook, MoMA"). The *Photo-Beacon Souvenir*, a partial visual catalogue of the salon, is preserved in the Clarence H. White Collection at The Art Museum, Princeton University.

 In 1962, Steichen revised the title of the photograph to its current form. The shift from allusiveness to literalness is characteristic of Steichen's attempt, in late life, to erase the tracks of his early (Aestheticist, Symbolist) sensibility.

7. Elba Johnson, ed., *Handbook of Arts and Crafts: [Fifth] Milwaukee Biennial, Public Library and Museum Building, June 4–June 8* (N.p.: King-Cramer Publishing, 1900).

8. On the Philadelphia salons of 1898–1902, see Greenough, "'Of Charming Glens,'" 276–77.

9. The Layton Gallery, opened in 1888, went on to form the core of the collections of the Milwaukee Art Museum. See *1888: Frederick Layton and His World*, exh. cat. (Milwaukee: Milwaukee Art Museum, 1988). My thanks to Jennifer L. Van Schmus of the Milwaukee Art Museum for her help in dating Layton Gallery acquisitions.

10. Steichen implied firsthand familiarity with Inness's paintings in "British Photography from an American Point of View," *Amateur Photographer* (London), Nov. 1900 (reprinted in *Camera Notes* 4, no. 4 [Jan. 1901]: 175–76, 179–81), in which he called one landscape "at its best a very poor imitation of the technique of George Innes [*sic*], however, contrary to his canvases: it is heavy with pigment instead of the atmosphere that hangs over a landscape shadowed with…clouds."

 Steichen later stated that the only art journal he saw regularly in his teens was one illustrated with chromolithographs after works by the genre painter J. G. Brown, the forerunners to Norman Rockwell's *Saturday Evening Post* covers of later decades. But Steichen's earliest works leave no question that he was familiar with the pictures in more sophisticated, lithograph-illustrated journals like *The Chap Book, The Studio, Die Kunst, Kunst für Alle*, and *Jugend*—more likely candidates for subscription at a German-run commercial lithographer's shop.

11. Joseph Keiley, in "The Salon (Philadelphia, Oct. 21–Nov. 18): Its Purpose, Character and Lesson," *Camera Notes* 3, no. 3 (Jan. 1900): 145, called Steichen's self-portrait "somewhat suggestive of certain of the Chap-Book portraits of some time back," while another writer saw in the picture "all the ear-marks of modern poster composition" (Sadakichi Hartmann [Sidney Allan, pseud.], "Eduard Steichen: Painter-Photographer," *Camera Notes* 4, no. 1 [July 1902]: 16).

 The artist's niece Margaret Sandburg stated that in 1900, when filing his naturalization papers, Steichen (christened Eduard Jean) spelled his first name "Edward," although he did not adopt the Americanized spelling in practice until his enlistment in the Signal Corps in World War I. See Penelope Niven, *Steichen: A Biography* (New York: Clarkson Potter, 1997), 66, 709 n. 35.

12. R. Child Bayley wrote in *Photography* (London), "'Self-Portrait!' We do earnestly hope that the phrase will not become current over

here. Imagine half a young man, clothed only in shirt and trousers, standing before a light wall, quite bare, save for a black picture frame that he could easily swallow at a gulp, and you have a self-portrait. It is probable that his missing half is at the next door neighbor's, for we notice that his address is 342½ Seventh Street, Milwaukee" (quoted in "The English Exhibitions and the 'American Invasion,'" *Camera Notes* 4, no. 3 [Jan. 1901]: 173). When the self-portrait was reproduced in *Camera Notes* 4, no. 1 (Jan. 1901), Steichen complained to Stieglitz that the journal's printer, understanding the spirit of the image all too well, had added a smirk to his face. Steichen to Stieglitz, [Jan. 1901], Stieglitz Papers, Yale Collection of American Literature, Beinecke Rare Book and Manuscript Library, Yale University, New Haven, Conn. (henceforth cited as "Stieglitz Papers"). Steichen seldom dated his correspondence; on those occasions where a letter's date is estimated, it appears in brackets.

13. Weston Naef, *The Collection of Alfred Stieglitz: Fifty Pioneers of Modern Photography* (New York: Metropolitan Museum of Art, 1978), 444, cites this inscription on a print of *Woods Twilight* in the Alfred Stieglitz Collection, Art Institute of Chicago.

14. Henry G. Abbott, "The Chicago Photographic Salon," *Photo-Era* (Boston), May 1900. Steichen evidently did not see the review until after his visit. In his first letter to Stieglitz, en route to Paris, he gleefully asked whether Stieglitz had seen it, and noted that Abbott "must have [acquired] his knowledge of impressionism from a member of some ladies' 'art club'" (Steichen to Stieglitz, 17 May 1900, Stieglitz Papers).

15. Two early reports to American readers are Arthur Symons, "The Decadent Movement in Literature," *Harper's New Monthly Magazine*, Nov. 1893, 858–67, and Frans von Schéele, "What is Modern Art-Symbolism?" *Literary Digest* (New York) 7, no. 6 (10 June 1893): 148.

16. Steichen to Stieglitz, 19 Oct. 1900, Stieglitz Papers.

17. In 1908, when the still-unknown poet Carl Sandburg proposed to Lilian Steichen, he remarked that financially they stood "about where [Eduard] was the day before he sauntered into Stieglitz [*sic*] office the first time." See Margaret Sandburg, ed., *The Poet and the Dream-Girl: The Love Letters of Carl Sandburg and Lilian Steichen* (Urbana: University of Illinois Press, 1987), 165.

18. Steichen, *A Life in Photography*, 1.6.

19. Ibid., 1.2.

20. Cabanel's *Birth of Venus* (Musée d'Orsay, Paris) had been a star attraction at the Salon of 1863. Acquired by Napoleon III, it became widely known even in the United States. In the 1870s, two Americans—John Wolfe of New York and Henry Gibson of Philadelphia—commissioned copies of the work from Cabanel for their private art collections; Gibson's copy was bequeathed to the Pennsylvania Academy of the Fine Arts in 1892, Wolfe's to the Metropolitan Museum of Art in 1893.

21. Less successful than Steichen's growing exhibition record were his efforts to sell photographic illustrations to the mass-market magazines *Scribner's* and *The Century* during his visit to New York. Comments in letters suggest that Stieglitz took up these causes for Steichen, as he was soon to do for Clarence H. White. See Maynard White, "Clarence H. White: A Personal Portrait" (Ph.D. diss., University of Delaware), 1975, 79ff.

22. Robert Demachy, "The American New School [*sic*] of Photography in Paris," *Camera Notes* 5, no. 1 (July 1901): 40.

23. "The Salon Exhibition," *Photography* (London) 14, no. 724 (25 Sept. 1902): 668. A writer in the *London Morning Post*, 26 Apr. 1902, remarked of a twelve-print Steichen portfolio printed in that month's *Photographic Art Journal*: "That the prints are unconventional, that they are 'unphotographic' in character, and that they are by turns excessively sombre or provokingly faint, are the chief impressions they leave" (Maternal scrapbook, MoMA).

24. If seen as an illustration of Tennyson's 1850 poem of the same name, Steichen's picture evokes the central sections (55–56), in which the thought of evolution-driven "Nature, red in tooth and claw" leads the speaker to fall "with my weight of cares / Upon the great world's altar-stairs / That slope thro' darkness up to God." Embodying as it does Tennyson's general themes of loss and despair, this passage was frequently employed by illustrators to emblematize the poem as a whole.

This reading of the photograph, and of its title, suggests input from Fred Holland Day (see below), who might have seen the picture at an early date in Steichen's studio. In 1894, Day had published the American edition of George Somes Layard's *Tennyson and His Pre-Raphaelite Illustrators*. In the fall of 1900, possibly through Day's introduction, Steichen photographed Tennyson's longtime friend, the artist G. F. Watts (plate 13), whose memorial statue of the poet laureate was to be erected near the Chapter House, Lincoln Cathedral, in July of 1905.

25. Alfred Horsley Hinton to Stieglitz, 4 Aug. 1904, Stieglitz Papers.

26. "A Master of Photography," *Milwaukee Journal*, 29 Aug. 1902, 5 (Maternal scrapbook, MoMA).

27. Regarding Constant's role at the Académie Julian, see John Milner, *The Studios of Paris: The Capital of Art in the Late Nineteenth Century* (New Haven: Yale University Press, 1988), 22–23.

28. Steichen to Stieglitz, [Aug. 1901], Stieglitz Papers.

29. On the effects of foreign competition, nationalism, and ensemble exhibition methods on the French applied arts, see Nancy J. Troy, *Modernism and the Decorative Arts in France: Art Nouveau to Le Corbusier* (New Haven: Yale University Press, 1991), introduction and chaps. 1–2. On Bing and his artists, see Gabriel Weisberg, *Art Nouveau Bing: Paris Style 1900* (New York: Harry N. Abrams, 1986). My thanks to Amy Ogata for her early advice concerning Steichen and the decorative arts.

30. On the challenges faced by painters in the changing decorative context, see C. I. Holmes, "Gustave Moreau: The Modern Mind in Classical Art," *Contemporary Review* 74 (Sept. 1898): 403–10. On the comparative role of Symbolist poetics in photography and in the decorative arts, see Rosalind Pepall, "Cette Enchantresse Matière: Symbolism and the Decorative Arts," in *Lost Paradise: Symbolist Europe*, exh. cat. (Montreal: Montreal Museum of Fine Arts, 1995), 406–16, and Ulrich Pohlmann, "The Dream of Beauty, or Truth is Beauty, Beauty Truth: Photography and Symbolism, 1890–1914," in ibid., 428–47.

31. Arthur Symons, "Impressionistic Writing," collected in his *Dramatis Personae* (Indianapolis: Bobbs-Merrill, 1923), 346.

32. See Catherine Lampert, "Auguste Rodin," *Grove Dictionary of Art* (New York: Grove, 1998), 26:508–15, and the texts cited in note 40 below.

33. The Jewish army captain Alfred Dreyfus was court-martialed and convicted of treason by the French military in 1894. The reopening of his case in 1898 brought to light forged documents employed by the prosecution. Retried in 1899, Dreyfus was found guilty "with

extenuating circumstances" and sentenced to ten years in prison; a civilian court would finally exonerate him in 1906. "L'Affaire Dreyfus" established the battle lines of early twentieth-century French public life, pitting the army, the Catholic Church, and forces of ethnic chauvinism against leftist intellectual opponents of the *raison d'Etat*. To the occasional embarrassment of Rodin, who took no public stance on the case, Dreyfusards including Emile Zola and Anatole France figured prominently in the subscription drive for the *Balzac*. The cast of a female figure that occupies the foreground of Steichen's 1909 portrait of France at his desk (plate 50) may have been Rodin's token of gratitude for the writer's support. See Musée Rodin, *Rodin sculpteur: Oeuvres méconnues* (Paris: Musée Rodin, 1992), 84–85.

34. On Hollyer's portraits at the Exposition, see A. Davanne, Maurice Bucquet, and C. Klary, *La Photographie d'Art à L'Exposition Universelle de 1900* (Paris, 1900), reprinted in *The Universal Exposition of 1900: Two Catalogues* (New York: Arno Press, 1979). For his presence at the London salon of that year, see *Photograms of the Year 1900* (London: The Photogram, 1900). See also Horace Townsend, "Art in Photography: An Interview with Mr. Frederick Hollyer," *The Studio* 1, no. 5 (Aug. 1893): 193–96.

 Steichen's essay "The American School," in *The Photogram* (London) 8, no. 85 (Jan. 1901): 4–9, points to another model for his own work: portraits of French men of letters by the painter-lithographer Eugène Carrière, a friend of Rodin's and a grand prize winner in the graphic arts section of the Exposition. Steichen praised Carrière's pictures for their low-key atmospheric effects, and called his portraits a "pantheon of our time." By translating Carrière's aesthetic effects into photographic terms, Steichen transformed Hollyer's trademark subject into a project all his own. On Carrière, see Robert J. Bantens, *Eugene Carrière: The Symbol of Creation* (New York: Kent, 1990).

35. In his "British Photography" article, p. 179, Steichen remarked, "How much pleasure such a portrait as the 'George Frederick Watts,' by Hollyer, gives us! The corner with that wondrously fine hand alone might be cut out and hung as a worthy tribute to the greatest poet among modern British painters." In a variant Watts portrait (Art Institute of Chicago, Alfred Stieglitz Collection; reproduced in Steichen, *A Life in Photography*, plate 13), Steichen cast the painter's deeply wrinkled hand in a quasi-facial role as an expression of character, covering his cheek at the center of the image.

 Hollyer's profile portrait of Ruskin, a mourned cultural hero who had died earlier in 1900, was one of his signature exhibition pieces, shown at several photographic salons and at the Decorative Arts Exposition in Turin in 1902. Clearly referring to it, a writer in *The World* (London), 11 June 1901, compared Steichen's profile portrait of Rodin (plate 6) to "one of the last portraits of Ruskin, sitting at his study table" (Maternal scrapbook, MoMA).

36. On Whistler's rise to prominence in American culture of the late nineteenth century—first as a figure of controversy in London, later as a painter known by his visual style—see Sarah Burns, *Inventing the Modern Artist: Art and Culture in Gilded Age America* (New Haven: Yale University Press, 1996), chap. 7, and Nicolai Cikovsky, Jr., with Charles Brock, "Whistler in America," in *James McNeill Whistler*, ed. Richard Dorment and Margaret F. Macdonald (New York: Harry N. Abrams, 1994), 29–38.

37. Steichen proposed photographing Thaulow's daughter for an upcoming competition of children's portrait photography. He may

have seen her in a painted portrait of Thaulow's family by Jacques-Emile Blanche (1895, Musée d'Orsay; reproduced in Milner, *Studios of Paris*, fig. 243), which Bing exhibited at the Exposition.

38. Steichen to Stieglitz, 12 Aug. 1900, Stieglitz Papers. Alexander's portraits were praised for combining the stylistic traits of Whistler, Sargent, and Gibson, while skimming off their respective excesses. "Thrillingly aware of composition, we never suffer from its predominance," an anonymous appreciator wrote in "The Pictures of John White Alexander," *Harper's Weekly*, 20 Dec. 1902, 1970.

39. Two portraits by Otto exhibited at the Exposition are reproduced in Davanne, Bucquet, and Klary, *La Photographie d'Art à L'Exposition*, 26, 51. On Otto, see Maria Morris Hambourg et al., *The Waking Dream: Photography's First Century*, exh. cat. (New York: Metropolitan Museum of Art, 1993), 338–39. Steichen's portrait of Otto (Metropolitan Museum of Art; reproduced in Naef, *Collection of Alfred Stieglitz*, 451) was reproduced in Sadakichi Hartmann, "The Photo-Secession, a New Pictorial Movement," *The Craftsman* 6, no. 4 (Apr. 1904): 33. Back in Paris again in 1907, Steichen would supplement his income by working two days a week at Otto's studio, "showing him," as he told Stieglitz, "how to do it" (Steichen to Stieglitz, [May 1907], Stieglitz Papers). See also note 65 below.

40. Rodin paid Steichen fifty to one hundred dollars for prints at a time when Steichen's standard portrait fee was ten dollars per print (Steichen to Stieglitz, [early 1902], Stieglitz Papers). See Kirk Varnedoe, "Rodin and Photography," in *Rodin Rediscovered*, ed. Albert Elsen, exh. cat. (Washington, D.C.: National Gallery of Art, 1981), 203–47, and Hélène Pinet, *Les Photographes de Rodin: Jacques-Ernest Bulloz, Eugène Druet, Stephen Haweis et Henry Coles, Jean-François Limet, Eduard Steichen*, exh. cat. (Paris: Musée Rodin, 1986).

41. The "toilworn Craftsman" and "inspired Thinker" are complementary halves of the heroic Christ type described in Thomas Carlyle's 1833 work *Sartor Resartus*, "Helotage," section beginning "Two men I honour, and no third" (Boston: Ginn; New York: Athenaeum Press, 1896), 206–7.

42. Works by Maeterlinck that Steichen cited for influence and inspiration were *The Treasure of the Humble* (1896), *Wisdom and Destiny* (1898), and *The Intelligence of the Flowers* (1907).

43. Despite Stieglitz's conviction to the contrary, Steichen maintained that Day had obtained excellent prints for the exhibition. Steichen, *A Life in Photography*, 2.2. On the the pivotal role of the *New American School* exhibition in the development of pictorialism, see Jan Van Nimmen, "F. Holland Day and the Display of a New Art: 'Behold, It Is I,'" *History of Photography* 18, no. 4 (Winter 1994): 368–82.

44. See Stephen Maxfield Parrish, *Currents of the Nineties in Boston: F. Holland Day, Louise Imogen Guiney, and their Circle* (New York: Garland, 1987).

45. Bayley, "The English Exhibitions," 173–74.

46. Steichen, "British Photography," 176.

47. *Photographic News* (London), [Aug. 1902] (Maternal scrapbook, MoMA).

48. Alfred Horsley Hinton, citing Steichen's written comments to Reginald Craigie on Stieglitz, "'whom he regards as the only person who has ever done anything useful in the photographic world.' Look you, does a man's artistic genius absolve him from being decently courteous…? However Steichen is a Member, and perhaps for the prosperity of The Ring it is as well that we are likely to have more of his pictures than his presence" (Hinton to Stieglitz, 29 Sept. 1903, Stieglitz Papers).

49. Steichen to Stieglitz, [Jan. 1901], Stieglitz Papers. See F. Holland Day, "Portraiture and the Camera," *The American Annual of Photography* 13 (1899): 19–25. On Day's aesthetic ideas generally, see James Crump, *F. Holland Day: Suffering the Ideal* (Santa Fe: Twin Palms, 1995).

50. Crump, *Suffering the Ideal*, plate 36, attributes the Royal Photographic Society's print of this image to Day and dates it 1908, while the RPS classifies it as Steichen's. The RPS print is signed "FHD" by Day at its bottom edge, in vertical alignment with Day's self-portrait as Christ. The print was mounted, like the Metropolitan Museum's, by Evans, and its mount inscribed by Evans "FHE" and "EJ Steichen." Among the Steichen photographs lent by Gertrude Käsebier and shown in the first Photo-Secession show at the National Arts Club, New York, in Mar. 1902 was an image, perhaps this one, dated 1901 and titled *The Critic*.

51. Steichen to Stieglitz, [Jan. 1901], Stieglitz Papers. On the Salon des Cent, see Phillip Dennis Cate, "'La Plume' and Its 'Salon des cent': Promoters of Posters and Prints in the 1890's," *Print Review* 8 (New York: Pratt Graphics Center, 1978), 61–68. The group's assets, including its graphic art collection, were liquidated by early 1901, but in the summer of 1900 Steichen could have seen a final sale of prints and posters at the offices of *La Plume* at 31, rue Bonaparte. The magazine also sponsored a *History of the French Poster* exhibition at the Exposition.

52. Steichen to Stieglitz, [Jan. 1901], Stieglitz Papers. Holdings in the Clarence H. White Collection at The Art Museum, Princeton University, include, among other European art periodicals dated 1900–1902, an unbound, uncut signature from the June 1900 number of *La Plume* with Steichen's framed "S" mark on its cover. This evidence seems to suggest that Steichen both visited *La Plume*'s offices and tried to publicize its work to American photographers.

53. Steichen later called Demachy "a man of no buisness [*sic*] energy" (Steichen to Stieglitz, [early 1907], Stieglitz Papers).

54. Steichen to Stieglitz, 19 Oct. 1900, Stieglitz Papers.

55. Barbara Michaels, *Gertrude Käsebier: The Photographer and Her Photographs* (New York: Harry N. Abrams, 1992), 86, notes that Käsebier, who had been working in gum since the spring of 1898, had not yet attained mastery in the technique in 1901, and suggests that Steichen, a quick study, might have had things to teach her by the time of her visit.

56. Postcard to Stieglitz signed "GK," "HK," and "ES," postmarked Munich, 1 Sept. 1901, Stieglitz Papers. The *Kleeblat*'s other two members were Hans Watzek, who died in 1903, and Hugo Henneberg.

57. See Thomas D. Lidtke, "Carl Marr: Leben und Werk," in *Vice Versa: Deutsche Maler in Amerika, Amerikanische Maler im Deutschland, 1813–1913,* ed. Katharina and Gerhard Bott (Munich: Hirmer, 1996), 127–35.

58. See Jo-Anne Birnie Danzker, Ulrich Pohlmann, and J. A. Schmoll [Eisenwerth], eds., *Franz von Stuck und die Photographie* (Munich and New York: Prestel, 1996), and Sonja von Baranow, "Franz von Lenbach und die Fotografie," *Kunst für Alle: Malerei, Plastik, Graphik, Architektur* (Dec. 1986): 912–17.

59. Eduard J. Steichen, "Grenzen" (Boundaries), published in *Camera-Kunst* (Berlin, 1903), 12–15. An incomplete typescript English translation of the article, with (Steichen's?) penciled notes, is in the Edward Steichen Archive, MoMA. See also Eduard J. Steichen, "Ye Fakers," *Camera Work* 1 (Jan. 1903), and "Painting and Photography," *Camera Work* 23 (July 1908).

60. Sadakichi Hartmann, "A Monologue," *Camera Work* 6 (Apr. 1904). Hartmann's satirical soliloquy is written in the voice of "Hamlet-Steichen," asking himself "To paint or photograph—that is the question," and unable to choose between "paintographs" and "photopaints."

61. Rodin's views on photography appear in George Besson, "Pictorial Photography: A Series of Interviews," *Camera Work* 24 (Oct. 1908).

62. Stieglitz had secured the admission of five Steichen prints to the *Glasgow International Exhibition*, summer 1900; three to the Third Philadelphia Salon, Nov.–Dec. 1900, one of which was reproduced in the catalogue; and four to the Newark (Ohio) Camera Club exhibit, Nov.–Dec. 1900. He included two of Steichen's prints in the Camera Club of New York's section of the Turin Decorative Arts Exposition, spring 1902, and fourteen in *American Pictorial Photography Arranged by the "Photo-Secession,"* National Arts Club, New York, Mar. 1902. Stieglitz also published reproductions of five of Steichen's photographs in *Camera Notes* 4, no. 3 (Jan. 1901).

63. The photographs Steichen submitted to the salon were a nude, his *Self-Portrait with Brush and Palette*, and portraits of Alexander, Besnard, Lenbach, Marr, Maeterlinck, Rodin, Stuck, and Thaulow (Steichen to Gertrude Käsebier, 27 Mar. 1902, Stieglitz Papers).

64. Unidentified press clipping (Maternal scrapbook, MoMA).

65. Copies of the gallery list of the exhibition, held 3–24 June 1902, are preserved in the Stieglitz Papers and in the Edward Steichen Archive, MoMA. The address of Otto's exhibition space appears on his stationery, sheets of which Steichen used in 1901 and in 1907 to send notes to Stieglitz.

66. Stieglitz to General Louis Palma di Cesnola, 8 Nov. 1902, Stieglitz Papers. The events behind the formation of the Photo-Secession are reconstructed in different ways in Norman, *Alfred Stieglitz*, 48–49, and in Whelan, *Alfred Stieglitz*, 178–80. On photography at Turin, where Steichen's two prints were Wisconsin woodscapes owned by Stieglitz, see Rossana Bossaglia et al., eds., *Torino 1902: Le Arti Decorative Internazionali del Nuovo Secolo* (Turin: Fabbri Editori, 1994).

67. See Whelan, *Alfred Stieglitz*, 182.

68. Members of the Ring adopted code names, such as "Psychologist" (Day), "Hustler" (Coburn), and "Sergeant at Mace" (Hollyer). See Appendix 2 in Harker, *The Linked Ring*, 179–88. Ring secretary Alfred Maskell ("Scribe") wrote to Stieglitz (who, like most American Links, took no pseudonym): "I think it is useful to mention the Linked Ring sometimes in the press, but only in a sort of general mysterious way" (17 July 1895, Stieglitz Papers). The thirteen-point mission of the Camera Club, which ranged from "weekly test-nights for lantern-slides" to "jolly 'smokers' and dinners," was outlined on a full page of each number of *Camera Notes*. The Photo-Secession's blunt and highly variable statement of purpose tended, on those occasions it appeared in *Camera Work*, to take with one hand what it gave with the other, announcing such aims as "to hold from time to time exhibitions...not necessarily limited to the productions of the Photo-Secession or to American work." See William Innes Homer, *Alfred Stieglitz and the Photo-Secession* (Boston: Little, Brown and Company, 1983), 56, 111–14.

69. Steichen to Stieglitz, [Summer 1906], Stieglitz Papers.

70. Steichen's cover design for *Camera Work*, with the title in a large cartouche above a smaller one bearing the editor's name and address,

followed the lead of German art journals like Alex Koch's *Deutsche Kunst und Dekoration* and F. Matthies-Masuren's annual, *Die Photographische Kunst im Jahr*, in effect making the journal's editor its "author," regardless of the content of each issue.

71. Steichen to Stieglitz, 19 Sept. 1904, Stieglitz Papers.

72. Steichen to Stieglitz, [Oct. 1903], Stieglitz Papers.

73. See Peterson, "The Photograph Beautiful." On Dow's influence on two photographers as an artist, teacher, and writer, see Mike Weaver, *Alvin Langdon Coburn, Symbolist Photographer, 1882–1966: Beyond the Craft* (New York: Aperture, 1986), and Michaels, *Gertrude Käsebier*, passim.

74. On the "psychologized" landscape as a defining trope of Symbolist poetics, see Jean Clair, "The Self Beyond Recovery," in *Lost Paradise*, 125–36 (see note 30 above).

75. Steichen to Stieglitz, [late July 1904], Stieglitz Papers. Coburn dated his two known photographs of the Flatiron—one published in his 1910 monograph *New York*, the other (fig. 17) in his *Autobiography* 1909 and 1912, respectively. Steichen's description of the print he was rejecting in 1904 suggests something much like the 1912 version. Halfhearted printing—the source of Steichen's dissatisfaction with Coburn's picture—would have rendered this dynamic image all but illegible. My thanks to Dell Zogg, senior cataloguer at the International Museum of Photography at George Eastman House, Rochester, and Pam Roberts of the Royal Photographic Society, Bath, for their assistance.

76. In comparing the trio of large Flatiron prints to the four-year series of Rouen Cathedral paintings (1891–95) by one of Steichen's idols, Claude Monet, an important distinction stands out. Monet's pictures chronicle subtle changes in ambient light, while Steichen's, when seen together, instantly reveal themselves as departures from a single moment of exposure. They are the design improvisations of a printmaker, not studies in atmospheric optics. Accordingly, Steichen never exhibited *The Flatiron* in more than a single variant at once. The imputation of the Metropolitan Museum's three large prints—one dating from 1905, two from 1909—as a coherent unit, and their preservation as such, is the work of Stieglitz, who by the latter date was deeply interested in sequence and serialism as common concerns of photography and modernist art. Having acquired and saved four Steichen *Flatiron*s (including an eight-by-ten-inch proof of a view from a few steps out in the street [plate 17]), Stieglitz included them in his major gift to the museum in 1933.

77. Steichen to Stieglitz, 7 Aug. 1904, Stieglitz Papers.

78. See F. Matthies-Masuren, *Photographische Kunst im Jahr 1904*, where *The Pond—Moonrise* is reproduced with the title *Solitude*. Ralph Waldo Emerson's poem "Waldeinsamkeit" (forest solitude) of 1857 provides a plausible spiritual archaeology for Steichen's woodscapes, relating American Transcendentalism to German Romanticism in a way that both Edward and Lilian would have been inclined to appreciate.

79. Frederick H. Evans, "The Photographic Salon, London, 1904. As Seen Through English Eyes," *Camera Work* 9 (Jan. 1905): 38–39.

80. Steichen to Stieglitz, [Summer 1906], Stieglitz Papers.

81. Ibid.

82. The boxed Vienna Secession-style "E.S" monogram with which Steichen signed his poster, and which graced his stationery beginning in 1906, is itself a tightly framed picture of a landscape beneath a moon. Tracing the Dow-based design of the poster to its Ukiyo-e origins, one may read Steichen's decorative signature as a pictorial caption commenting on the larger scene, and see the device as a rendering of the view that Steichen's wandering Secessionist is seeing through the viewfinder of his camera.

On the photographic source of Steichen's poster design—an anonymous daylight snapshot of Stieglitz standing on the angled girder of a bridge and doubtless preparing to photograph a city view—see Hambourg et al., *The Waking Dream*, 344–45.

83. On French and English responses to nudes in photographs, see Robert Demachy, "Photography in France," *Photograms of the Year 1903* (London: The Photogram, 1903), 7–17. A "clever nude" by Steichen was praised by the salon reviewer A. C. R. Carter in *Photograms of the Year 1901* (London: The Photogram, 1901), 122, but in the installation views of the gallery accompanying Carter's review, that nude, alone of all images in the salon, was decorously blacked out by the printer (p. 109, no. 283). Steichen later recalled noticing that in New York homes, including Stieglitz's, "[pictures of] nudes were usually hung in the bedroom" (Steichen, *A Life in Photography*, 3.1).

84. In 1904, Steichen introduced Mercedes de Cordoba, a favorite model of the New York Secessionists, to his painter friend Arthur B. Carles; in 1909 the two, intimate members of Steichen's circle in France, were married. Landon Rives, daughter of the popular novelist Amélie Rives, was also a model of Coburn's and briefly, in this period, an exhibiting photographer at the London salon. On the Melpomene role as a trope in the portrayal of actresses, see Joel Weinsheimer, "Mrs. Siddons, the Tragic Muse, and the Problem of As," *Journal of Aesthetics and Art Criticism* 36, no. 3 (Spring 1978): 317–28.

85. Steichen included Lady Hamilton's portrait among his prints in the Photo-Secession's Members' Show in 1907, the London Salon of 1908, the Dresden exposition of 1909, and the 1910 *International Exhibition of Pictorial Photography* in Buffalo.

86. See, for example, Herbert Lindenberger, *Opera: The Extravagant Art* (Ithaca, N.Y.: Cornell University Press, 1984), 25, for George Bernard Shaw's comments in an 1894 theater review, contrasting Eleanora Duse's dramatic performance in *Cavalleria Rusticana* to Emma Calvé's operatic turn in the same role. My thanks to Philip Kennicott for pointing me to Lindenberger's book.

87. A fan of Shaw's, Steichen had surely taken note of the July 1905 issue of *The Bookman* (London), which featured several pages of caricatures and character studies of the author as well as full-page halftones and tipped-in duotones from a series of portraits of Shaw by Frederick H. Evans.

88. On Hartmann, see the "Editors' Introduction" in Sadakichi Hartmann, *The Valiant Knights of Daguerre*, ed. Harry W. Lawton and George Knox (Berkeley: University of California Press, 1978), 1–31.

89. James Moser to Stieglitz, 25 Apr. 1905, Stieglitz Papers.

90. The object at left, sometimes referred to as a "laughing Buddha," varies greatly in different prints of the portrait, but when seen most clearly, as for example in the catalogue reproduction for the 1904 Corcoran exhibition, it appears to be a plaster study for one of Rodin's *Burghers of Calais*, or another robed, bearded figurine, standing on a mantel before an upright plate. In an article on Steichen's studio a year earlier, Hartmann had referred to "a little plaster fragment of one of Rodin's statues hang[ing] in proud isolation over the mantelpiece" (Sadakichi Hartmann [Sidney Allan, pseud.], "A Visit to Steichen's Studio," *Camera Work* 2 [Apr. 1903]:

17–18, 21; reprinted in Hartmann, *Valiant Knights*, 202–9). The conjuration of Ho-Tei out of a Rodin sculpture (and his bag of worldly goods out of the plate behind it) might indicate an intention to use the portrait in connection with the publication of Hartmann's book *Japanese Art* (Boston: L. C. Page and Company, 1903).

91. For two analyses of the Morgan portrait, see Robert McCracken Peck, "Influential Image: Edward Steichen's J. P. Morgan," *Image* (Rochester, N.Y.) 20, no. 2 (June 1977): 32–36, and Eric Homberger, "J. P. Morgan's Nose: Photographer and Subject in American Portrait Photography," in *The Portrait in Photography*, ed. Graham Clarke (London: Reaktion Books; Seattle: University of Washington Press, 1992), 115–31.

92. Steichen, *A Life in Photography*, 3.2.

93. A label note by Stieglitz on the Metropolitan Museum print's original mount, written in January 1912, describes the print as an "exchange for an older print which had faded (bromide print) and was destroyed." Steichen inscribed the date 1904 on Morgan's chair arm in the museum's print. Correspondence suggests a date of 1909 or 1910 for this "exchange" print, but nothing indicates that it differs in pose, facial detail, or scale from the original print, which had been exhibited as early as January 1904, when it led off Steichen's section at the Corcoran exhibition.

Stieglitz, who in Steichen's absence fielded requests for copy prints, did not actually keep Morgan waiting for his order, although whether Stieglitz told Steichen this is unclear. On 30 Oct. 1909, responding to a query from Morgan's librarian Belle Greene earlier that month, Stieglitz priced a new "very large" print of the Morgan portrait at one hundred dollars, photogravure proofs of it at seventy-five dollars for two dozen, and regular and deluxe copies of the 1906 "Steichen Supplement" of *Camera Work* containing the portrait at fifteen to twenty-five dollars each. Greene ordered twelve photogravures and two copies of the Supplement; on 4 Apr. 1910, she thanked Stieglitz for having sent her these. In June 1912, Stieglitz loaned Greene the large print of the portrait, and in thanking him she remarked, good-naturedly, "If only I could make Steichen send me some!—Isn't he hopeless!" (Greene-Stieglitz correspondence, Stieglitz Papers).

94. Steichen, *A Life in Photography*, 3.3.

95. Burns, *Inventing the Modern Artist,* 203, quoting former House of Morgan executive George W. Perkins. Burns discusses the prevalent Gilded Age image of Morgan "as something extra-human, not quite man," armed, as Horace Traubel put it, with "tooth and claw, not forgiveness and reciprocity." In the face of a public perception that their cabals ran the American market, financiers used Morgan's brutish public image to help portray Wall Street as an arena of fierce competition.

96. To the calling card bearing Steichen's message, Stieglitz added the explanation: "Jan 8/03 Had photo'd Duse + Morgan within 2 hours. AS" (Steichen to Stieglitz, 8 Jan. 1903, Stieglitz Papers).

97. The general "W" correspondence file, Stieglitz Papers, includes vacation postcards from Wetzler to Stieglitz, discussing holidays and demonstrating familiarity with Stieglitz's photographs.

On the *Symphonia Domestica* and Strauss's visit to New York in 1904, see Michael Kennedy, *Richard Strauss* (New York: Schirmer, 1996), 40–42.

98. "Make the roast beef sizzle": Steichen to Stieglitz, [July 1904], Stieglitz Papers. "Kick in the pants": Steichen prescribes his cure-

all in Matthew Josephson, "Commander with a Camera," *New Yorker*, 3 July 1944.

99. Sadakichi Hartmann [Sidney Allan, pseud.], "The Influence of Artistic Photography on Interior Decoration," *Camera Work* 2 (Apr. 1903); reprinted in Hartmann, *Valiant Knights*, 91–93.

100. Soon after sending these photographs, Steichen wrote to Stieglitz, regarding the Photo-Secession's future, that "if everything else fails we have always an American *Kleeblat*," and offered sketches for an "SWS" (Stieglitz, White, Steichen) monogram (Steichen to Stieglitz, [18 Dec. 1906], Stieglitz Papers)

101. Steichen to Stieglitz, [Nov. 1906], Stieglitz Papers.

102. Exhibitions that Steichen sent to 291 included drawings by Rodin (two exhibitions), drawings and watercolors by Matisse and Cézanne, drawings by Picasso, lithographs by Toulouse-Lautrec, Cézanne, Renoir, and Manet, watercolors by John Marin, and etchings and drawings by the theatrical designer Edward Gordon Craig (plate 53).

103. Notably, many of the exceptions to this rule reflect Steichen's contributions to *Camera Work*, including experimental two- and three-color halftones from his photographs, tipped-in full-color reproductions of his paintings and those of John Marin, whose watercolors he discovered in Paris, and duotone halftones of Rodin's nude sketches.

104. The exhibition *Photographs by Eduard J. Steichen*, at the Little Galleries of the Photo-Secession, 17 Mar.–5 Apr. 1906, included an unknown number of multiple-pigment prints produced from selectively filtered, three-negative exposures. *Camera Work* 15 (July 1906) featured a three-color halftone reproduction of one of these, and each copy of *Camera Work* 19 (July 1907) included a hand-tinted photogravure of his photograph *Pastoral—Moonlight*. The Steichen Supplement (1906) included a two-color halftone of a landscape and a hand-tinted photogravure, *Road into the Valley—Moonrise*. Steichen colored the sheets himself during a stay at his parents' farmhouse in Wisconsin (Steichen to Stieglitz, [Summer 1906], Stieglitz Papers).

On Steichen's early color work and autochromes, see Catherine T. Tuggle, "Eduard Steichen and the Autochrome, 1907–1909," *History of Photography* 18, no. 2 (Summer 1994): 145–47.

105. Steichen discussed and diagrammed solutions to the problem of autochrome projection that he had worked out in the projection room of the Photo-Club de Paris. Steichen to Stieglitz, [Feb. 1909], Stieglitz Papers.

106. Charles H. Caffin, "Is Herzog Also Among the Prophets?" *Camera Work* 17 (Jan. 1907), associated painters who laid emphasis on form ("the formal, artificial building-up of 'ideal' compositions") with moribund academicism; he named color and "atmosphere" as the principal concerns of "modernism," a tendency he summarized as the artist's attempt to find a bridge between "sensations in himself and…suggestions in the world about him." Caffin's equation between color and modernism is implicitly brought to bear upon Steichen's photographs in J. Nilsen Laurvik, "The New Color Photography," *The Century*, Jan. 1908, 323–30, and Charles H. Caffin, "Progress in Photography, with Special Reference to the Work of Eduard J. Steichen," *The Century*, Feb. 1908, 483–98. See also Anne Hammond, "Impressionist Theory and the Autochrome," *History of Photography* 15, no. 2 (Summer 1991): 96–100.

107. In a typical instance, the main gallery list in the catalogue of the Linked Ring salon of 1908 is followed by a separate listing of

autochromes by J. Craig Annan (2), Alvin Langdon Coburn (11), Adolph De Meyer (20), George Bernard Shaw (1), Steichen (29), and J. C. Warburg (3). Steichen's plates are offered at three prices, the others at a single price or not at all.

108. Steichen to Stieglitz, [Autumn 1907], Stieglitz Papers. Making a multiple-pigment print from an autochrome meant coordinating two processes that were expensive, labor-intensive, and unpredictable. A faint and seemingly single-toned enlargement from *Rodin — The Eve* (plate 41) is, at time of writing, the only confirmed print from a Steichen autochrome to have surfaced (Sotheby's, New York, sale 6973, 18 Apr. 1997, lot 100).

Like *Rodin — The Eve*, Steichen's portrait *Edmond Joseph Charles Meunier* (signed and dated 1907, Metropolitan Museum of Art; reproduced in Naef, *Collection of Alfred Stieglitz*, 463) depicts a figure standing before a plaster sculpture that occupies most of the composition. This hand-coated (?) gelatin silver print might itself be an undocumented print from an autochrome, though no such autochrome is currently known. If (as Steichen's letters suggest) the translation of an autochrome's mingled secondary colors into a single gray scale presented a major practical challenge, then images like these, in which white predominated, would have offered strategic advantages in Steichen's printing experiments. Technical novelty, then, may explain why this poorly rendered (and evidently never exhibited) print maintained a place in Stieglitz's collection.

109. Eduard J. Steichen, "Color Photography," *Camera Work* 22 (Apr. 1908).

110. Steichen's postcard was mailed from Reims, where he had presumably spent the past week at the airfield watching world records broken in the "Grande Semaine de l'Aviation." The card reached Stieglitz at Tutzing, Bavaria, where he and Secessionist Frank Eugene were awaiting Steichen's arrival for an autochrome klatsch. An autochrome genre-portrait of Eugene at table, attributed to Stieglitz, includes a newspaper in which a headline may be read, "RECORDS AT RHEIMS / SIX MILES IN GUSTY WEATHER," presumably referring to Georges Legagneaux's nine-minute, fifty-six-second flight of 22 Aug. 1909 (Box 130, object 2527, Stieglitz Papers). See Richard Ferriss, *How It Flies* (New York: Thomas Nelson and Sons, 1910), 427.

111. Steichen, *A Life in Photography*, 4.1.

112. See Marius de Zayas, *How, When, and Why Modern Art Came to New York,* ed. Francis M. Naumann (Cambridge: MIT Press, 1996).

113. See Willard Bohn, "The Abstract Vision of Marius de Zayas," *Art Bulletin* 62, no. 3 (Sept. 1980): 434–52.

114. Marius de Zayas, "Photography and Artistic-Photography," *Camera Work* 42–43 (Apr./Nov. 1913).

115. During Steichen's visit, Shaw showed him his personal collection of other photographers' Shaw portraits — in their shared opinion, an unimpressive brief for photographic portraiture. Steichen's title for his own effort alludes to Shaw's collection, and, in its comical light, to Shaw's wry warning to Steichen that Coburn "considers me his special property" (Steichen to Stieglitz, 13 July 1907, Stieglitz Papers).

116. Steichen to Stieglitz, [22 or 23] Aug. 1907, Stieglitz Papers. Steichen's portraits of August Bebel, Jules Guesde, Jean Jaurès, and H. M. Hyndman were published as illustrations in Robert Hunter, *Socialists at Work* (New York: Macmillan, 1908).

117. By comparison, five hundred dollars was the cost of the three-year lease renewal just signed for 291.

Steichen to Stieglitz, 26 Mar. 1908, Stieglitz Papers; Stieglitz to *The Century*, transcripts in the Edward Steichen Archive, Museum of Modern Art, New York, from correspondence in the New York Public Library, Manuscripts Division, and the Archives of American Art, N8: 501–13.

118. Lincoln Steffens, "What the Matter Is in America and What to Do About It," *Everybody's Magazine*, June 1908, 723–36 et seq.

119. Steichen, *A Life in Photography*, 4.2.

120. Citing Rodin's fetishistic research on Balzac and enumerating his "twenty-two studies for the head, seven for the nude body, two of the figure in dressing gown, and at least sixteen for the clothed statue," one writer calls the *Balzac* not a portrait but "a stretch of autobiography" (Leo Steinberg, "Rodin," in *Other Criteria: Confrontations with Twentieth-Century Art* [Oxford and New York: Oxford University Press, 1972], 395). In *Contemporary Portraits* (1925), the sexual-liberationist journalist Frank Harris described Rodin's *Balzac*, under "the old monastic robe with its empty sleeves…grasping his virility" (quoted in Albert Elsen, *Rodin* [New York: Museum of Modern Art, 1963], 96). A headless nude study of the figure, confirming Harris's account, is illustrated on p. 97 of Elsen's book.

121. Steichen to Stieglitz, Mar. 1909, Stieglitz Papers.

122. Ibid.

123. The gallery list for Steichen's 1910 exhibition at the Montross Gallery is preserved in the Edward Steichen Archive, MoMA.

124. As late as 1913, too, a double issue of *Camera Work* (nos. 42–43) was devoted to Steichen's work.

125. Marius de Zayas to Stieglitz, 6 Apr. 1911, Stieglitz Papers (published in de Zayas, *How, When, and Why*, 163).

126. See Anne Cohen DePietro, *The Paintings of Eduard Steichen*, exh. cat. (Huntington, N.Y.: Heckscher Museum, 1985). Nothing seems to have come of Steichen's commission to paint a series of New York City scenes for the Luxembourg Galleries, as reported in a brief feature upon Steichen's arrival in the city ("Will Paint New York for France as Typical of American Spirit," *New York Herald*, 23 Apr. 1910, Steichen clipping file, Stieglitz Papers).

127. Steichen to Stieglitz, [late Nov. 1912], Stieglitz Papers.

128. Steichen to Stieglitz, Mar. 1913, Stieglitz Papers. Steichen's conviction with regard to the genius-preserving character of evolution describes the theme treated in Tennyson's *In Memoriam* and relates to his methods as a plant breeder. See Ronald J. Gedrim, "Edward Steichen's Exhibition of Delphiniums," *History of Photography* 17, no. 4 (Winter 1993): 369–76.

129. Steichen to Stieglitz, Mar. 1913, Stieglitz Papers.

130. Edward Steichen, interview by A. D. Coleman, 7 July 1969, published in *Photograph* (New York) 1, no. 2 (1976): 33.

131. Steichen, *A Life in Photography*, 5.4.

PLATES

I

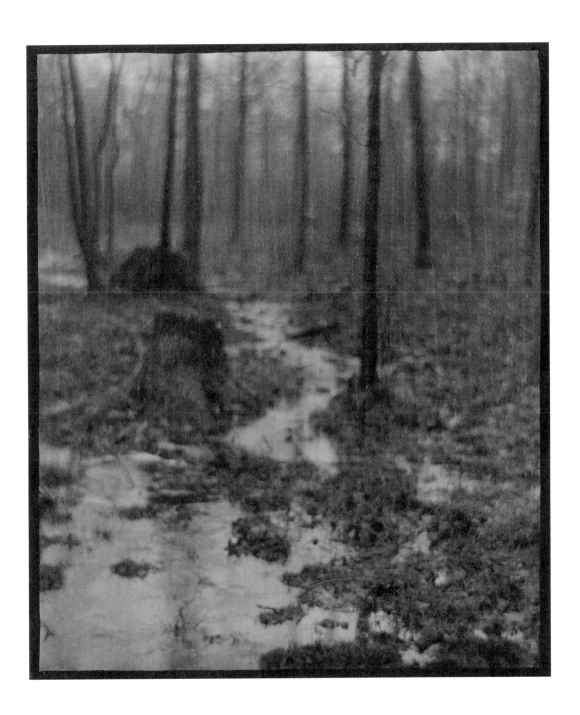

2

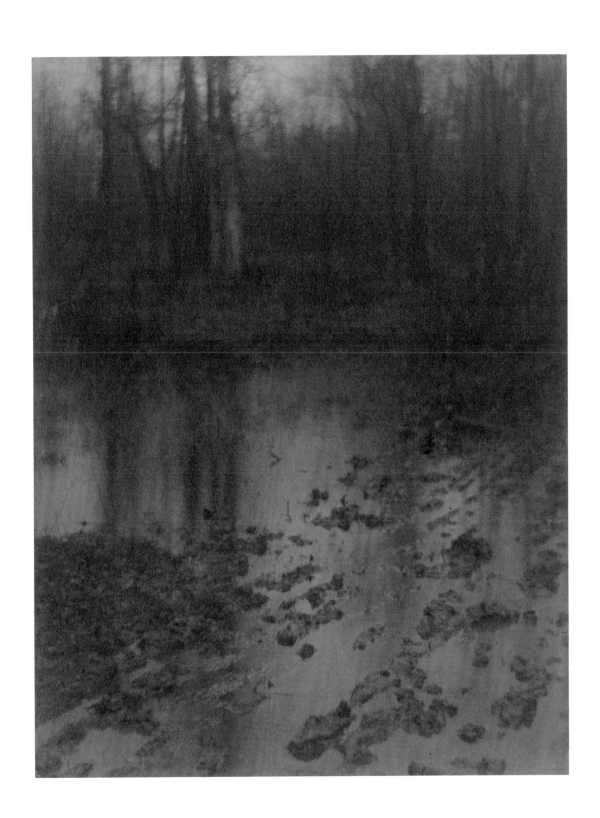

3

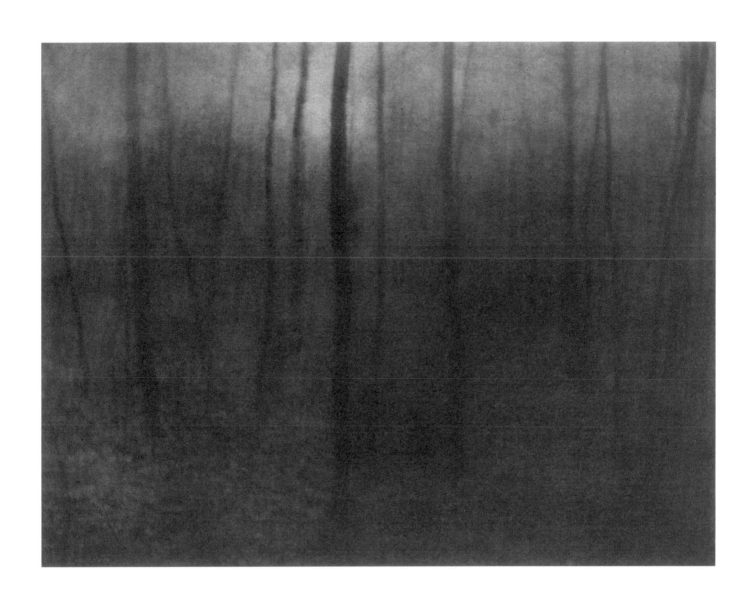

4

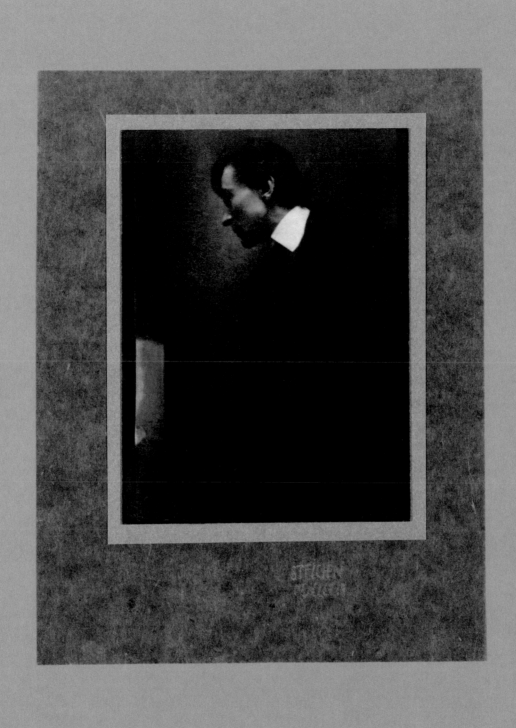

5

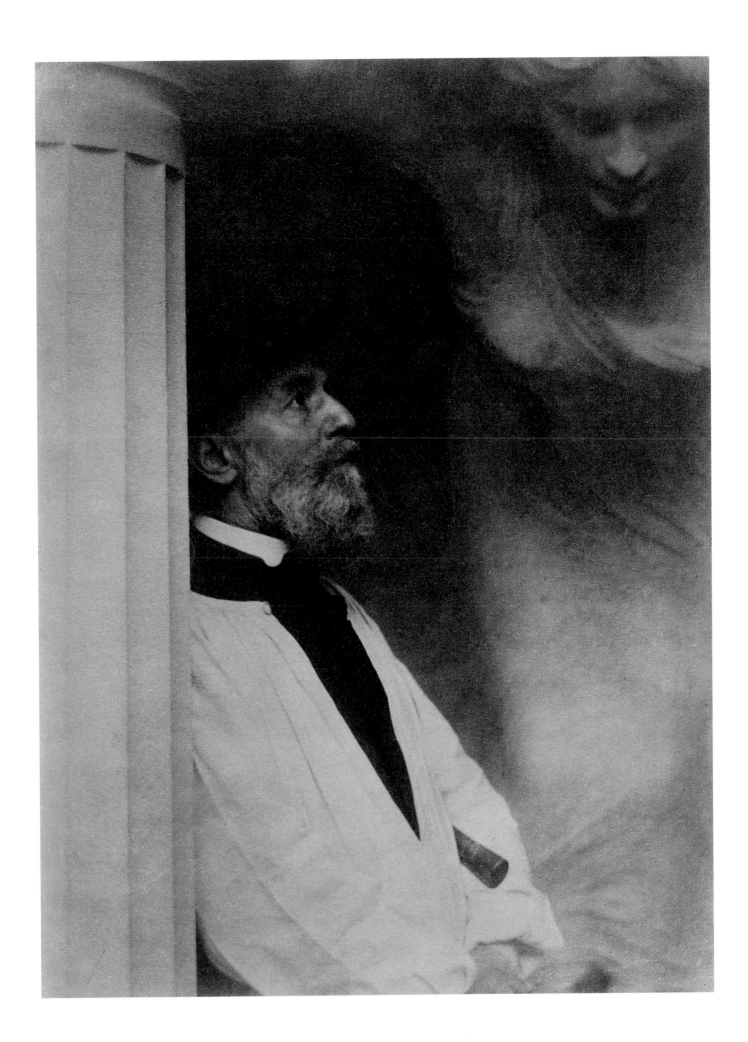

6

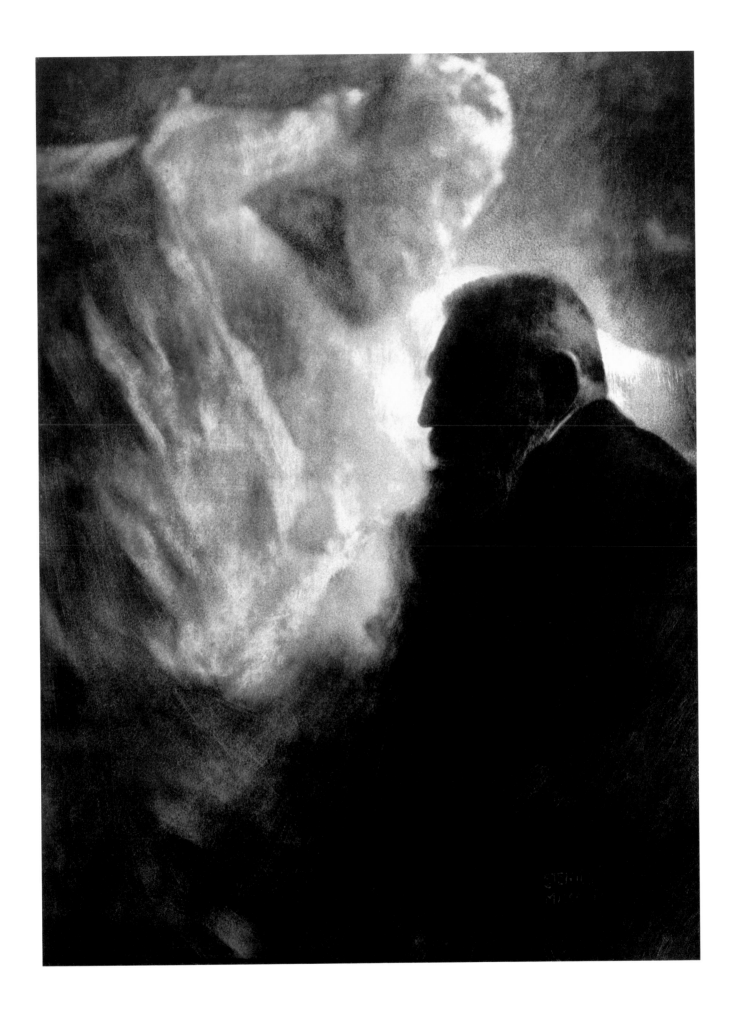

7

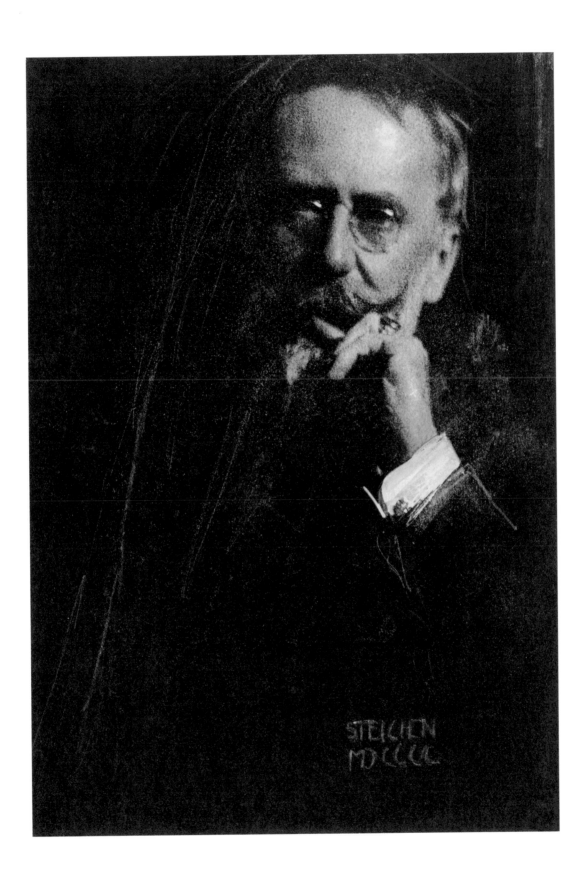

8

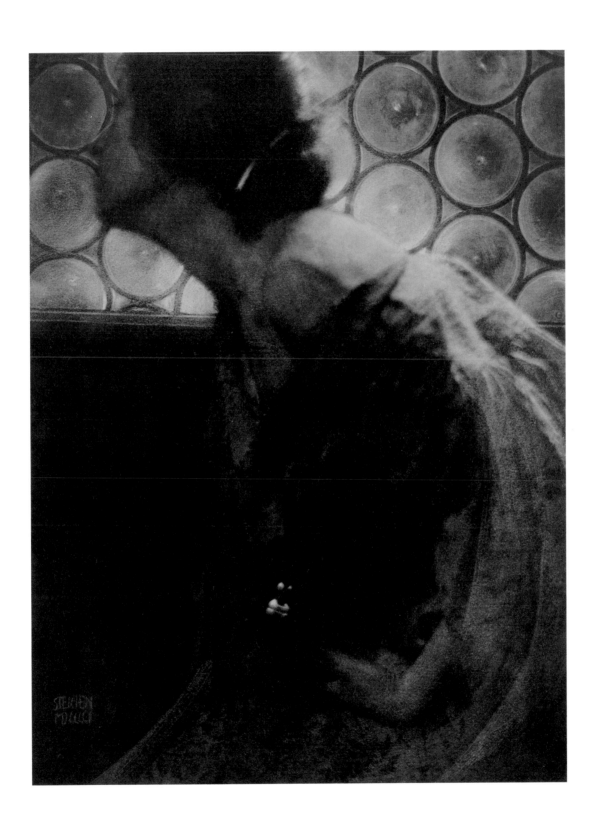

9

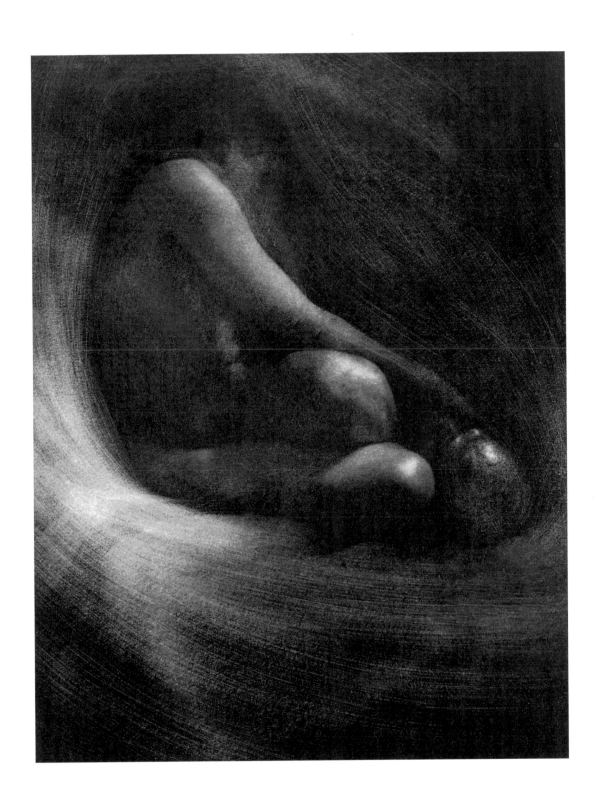

10

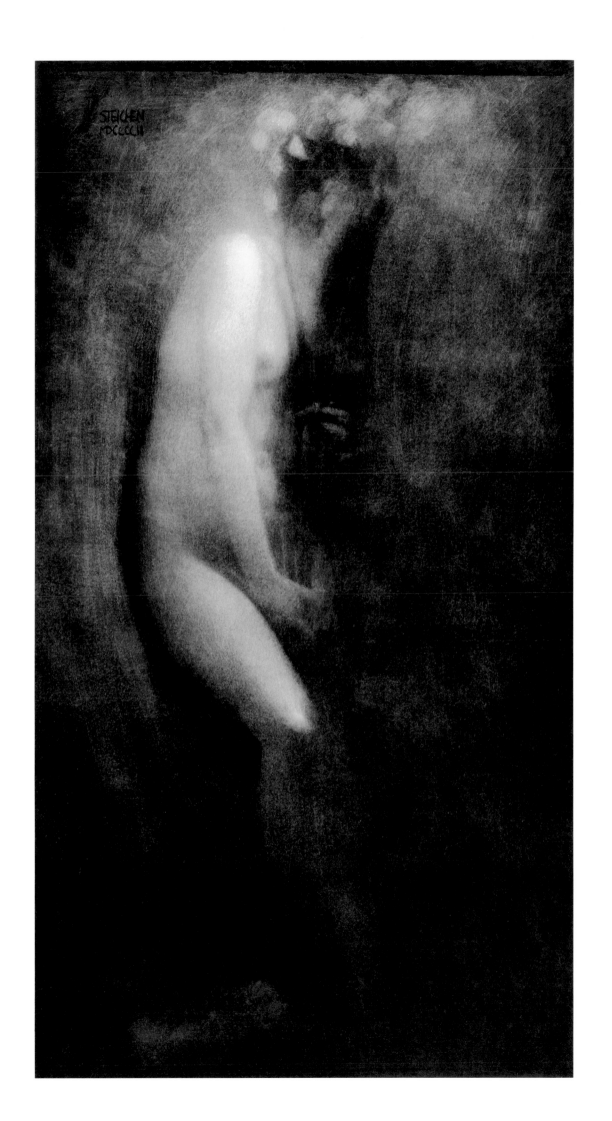

II

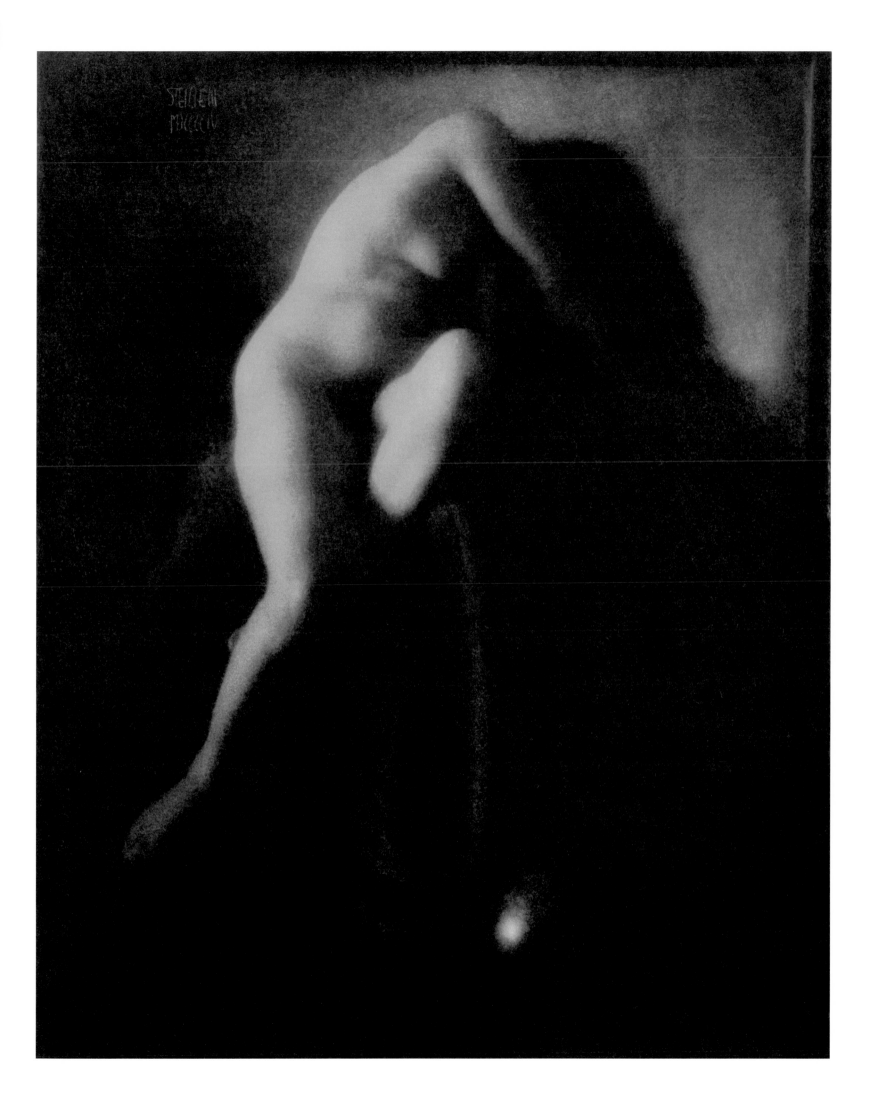

12

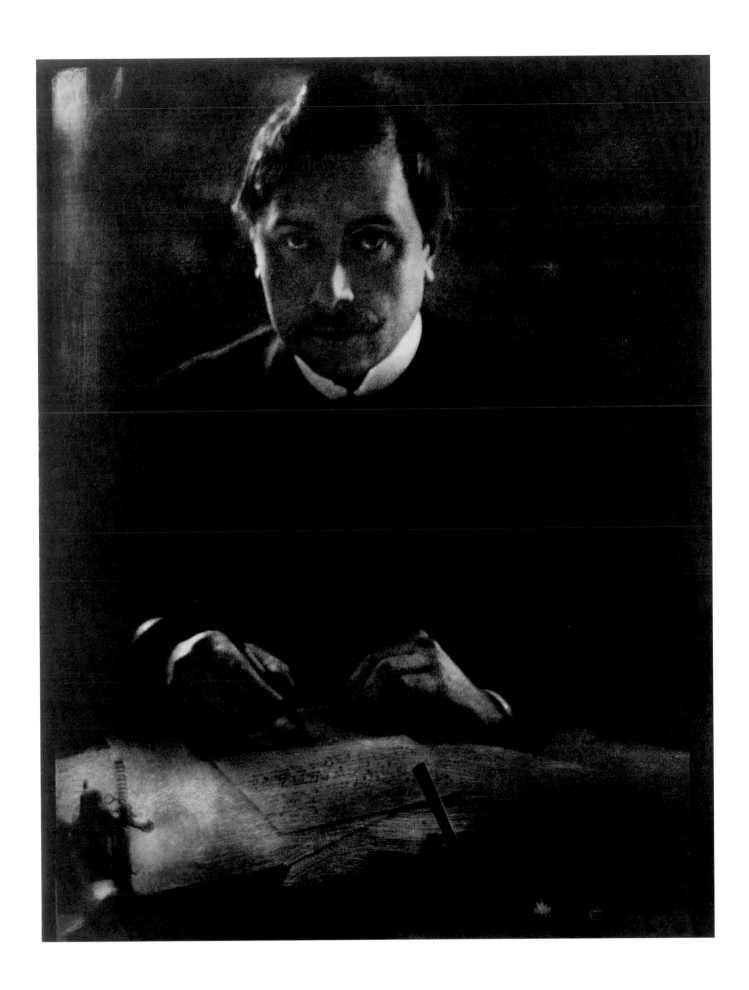

13

GEORGE FREDRICK WATTS

14

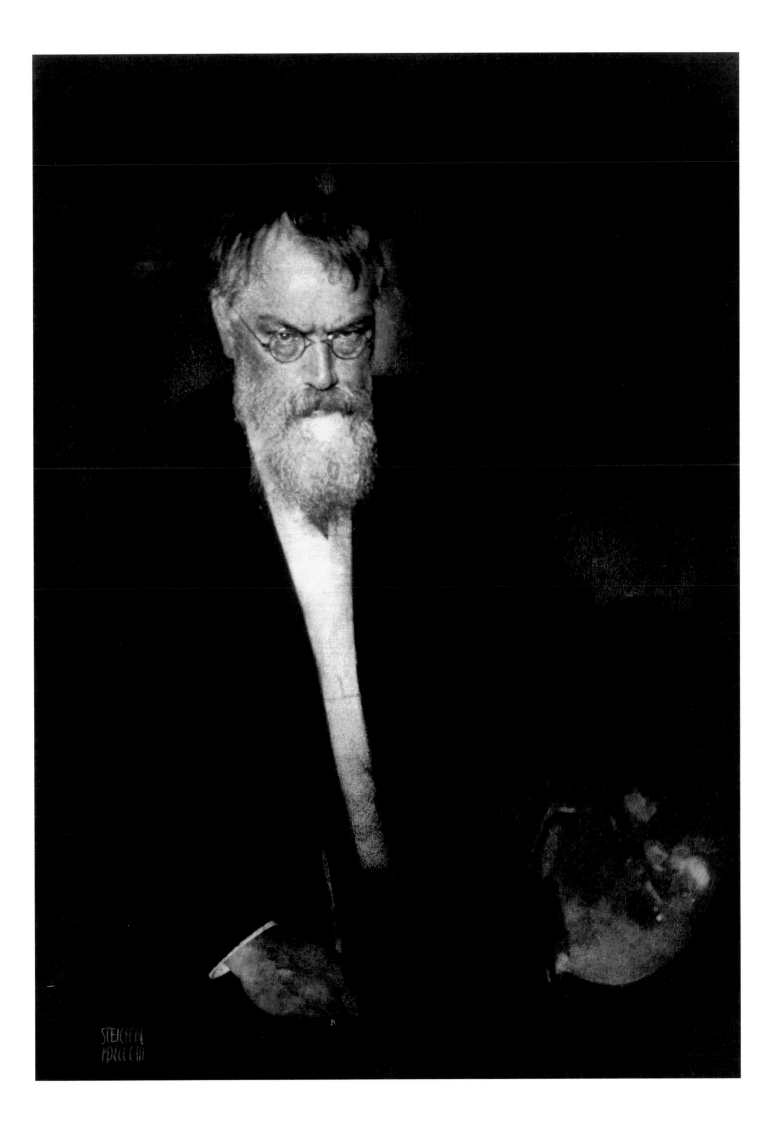

15

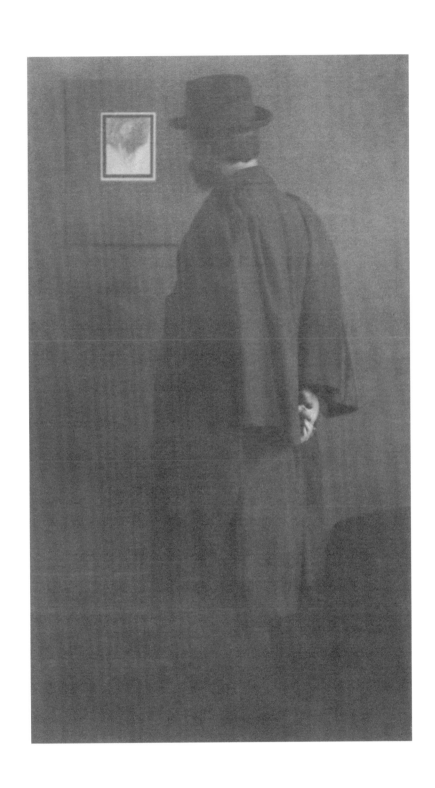

16

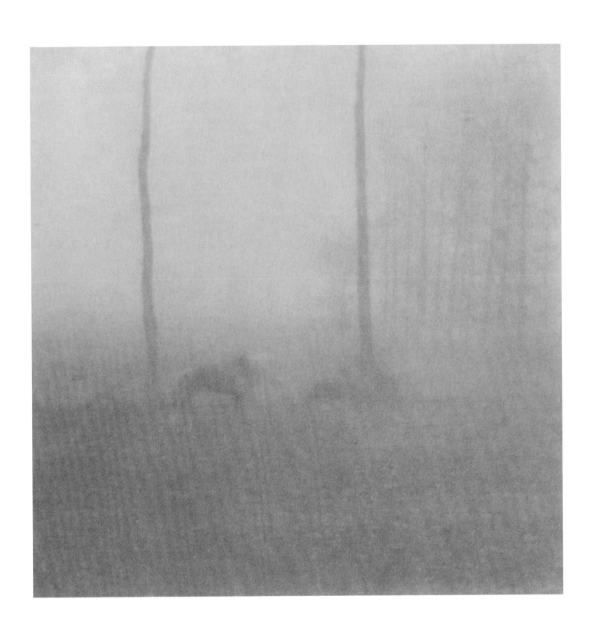

17

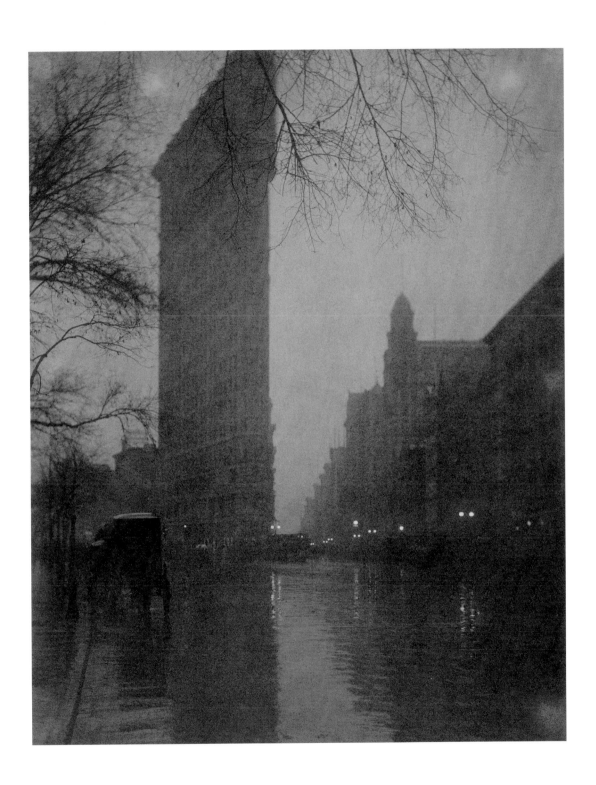

18

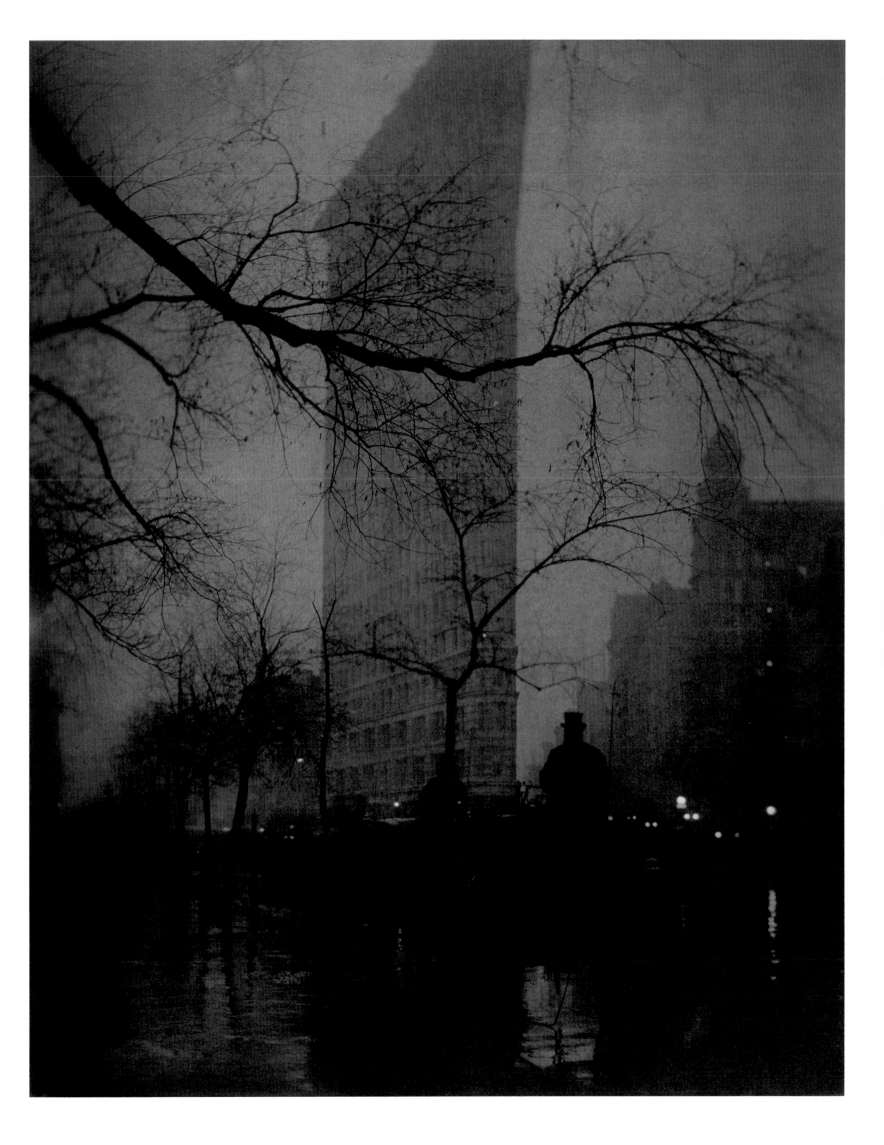

19

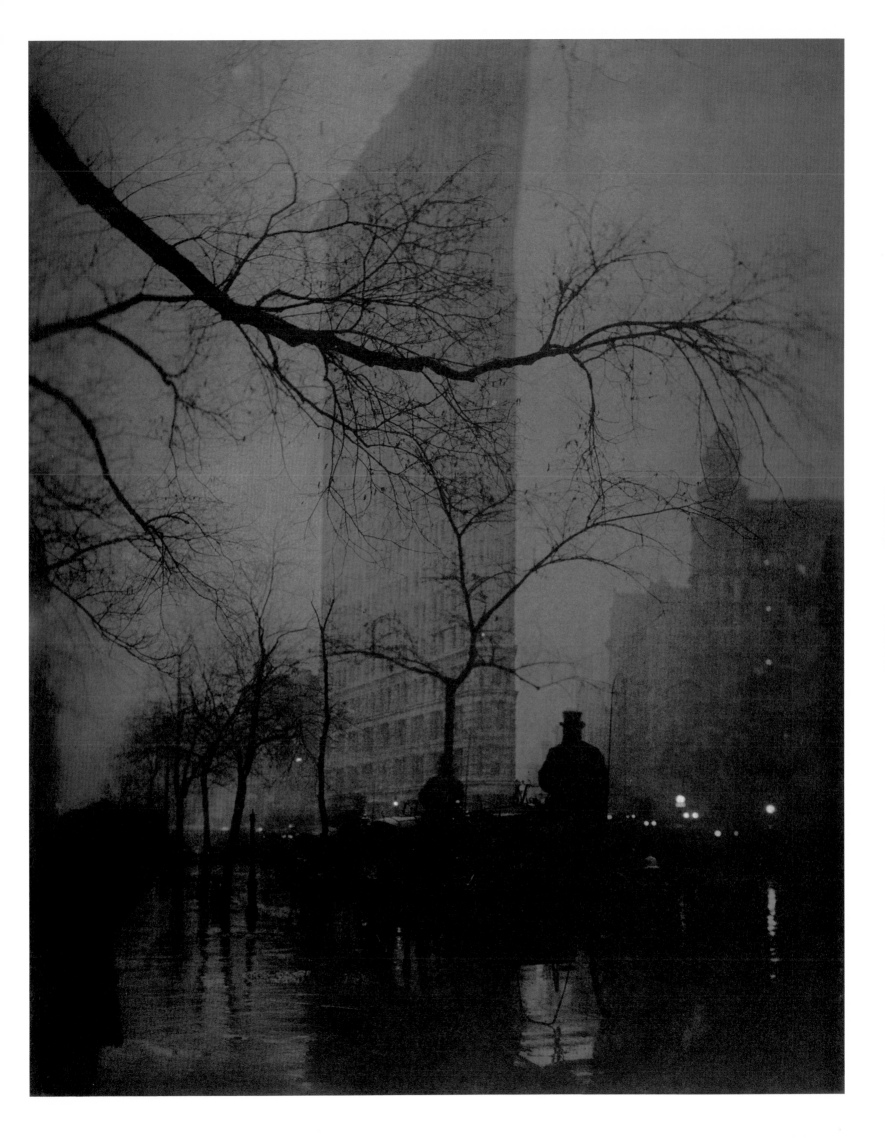

20

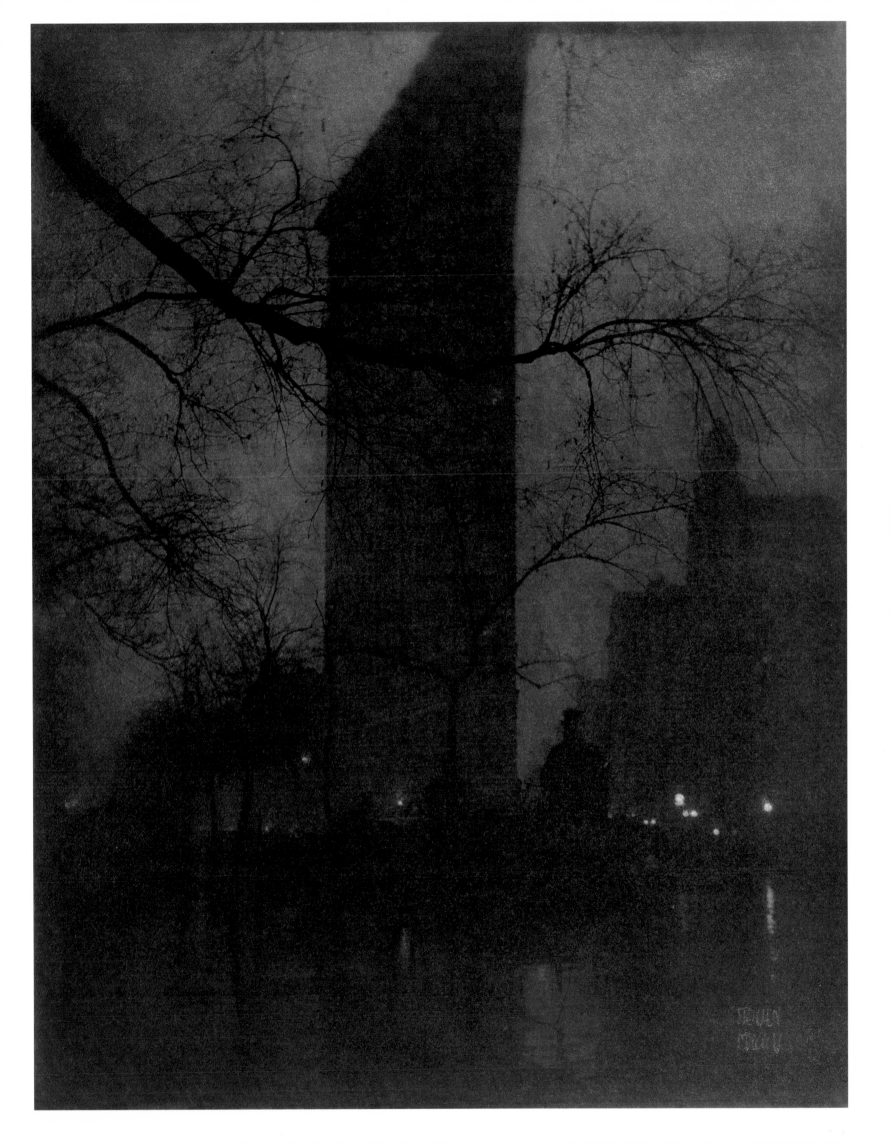

21

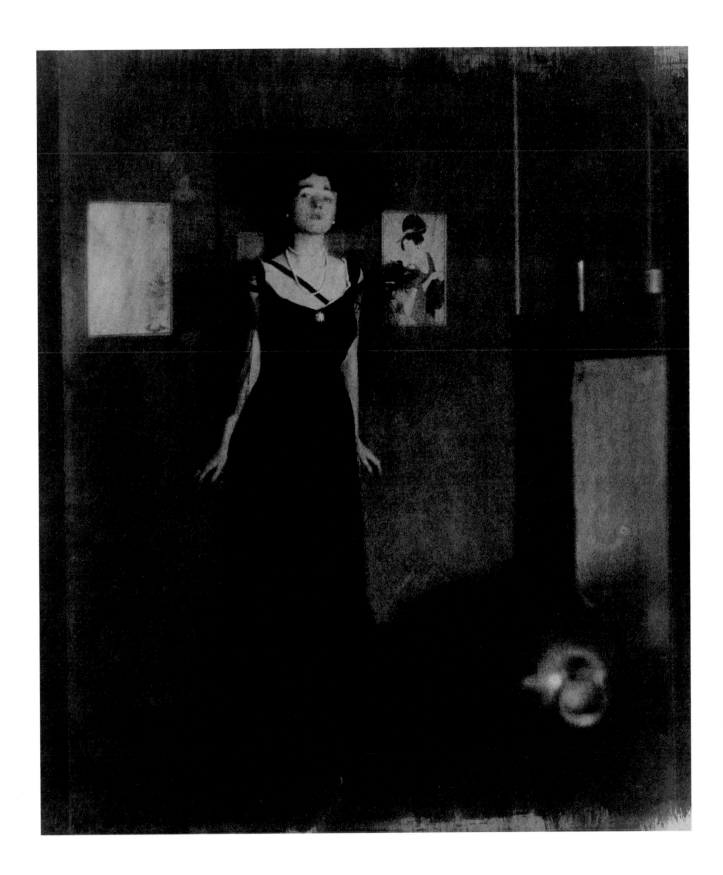

22

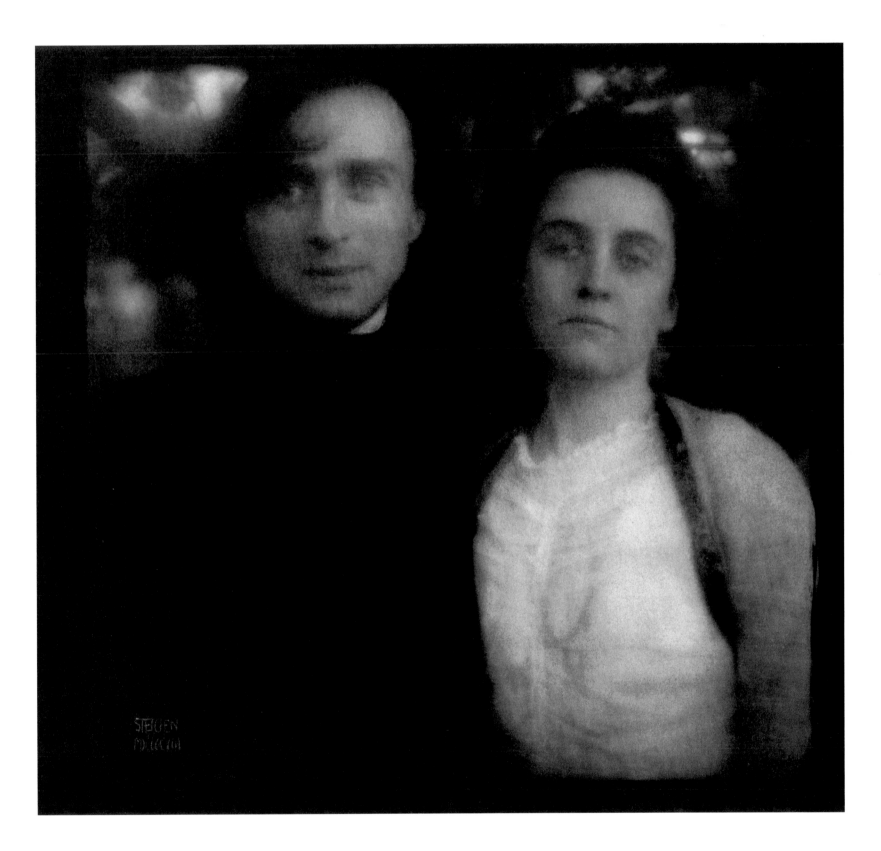

23

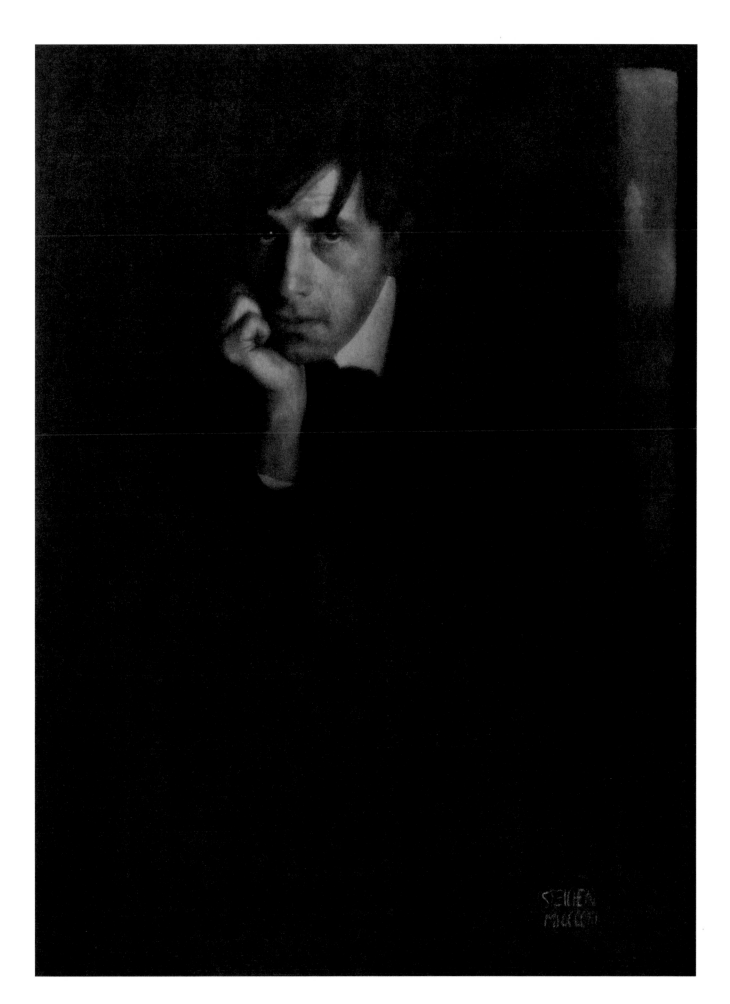

24

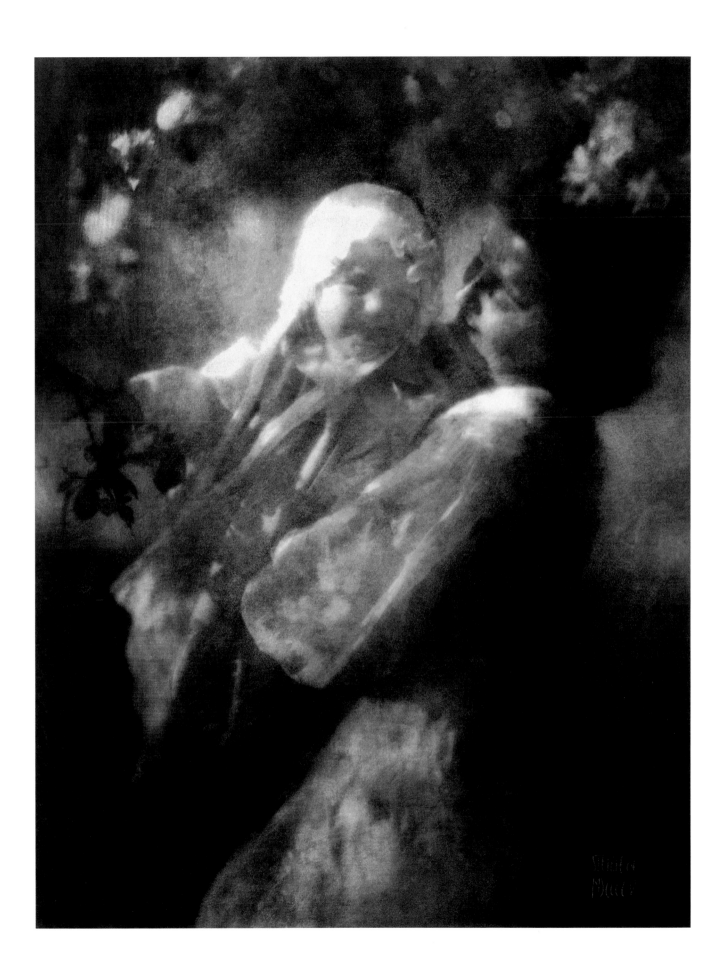

25

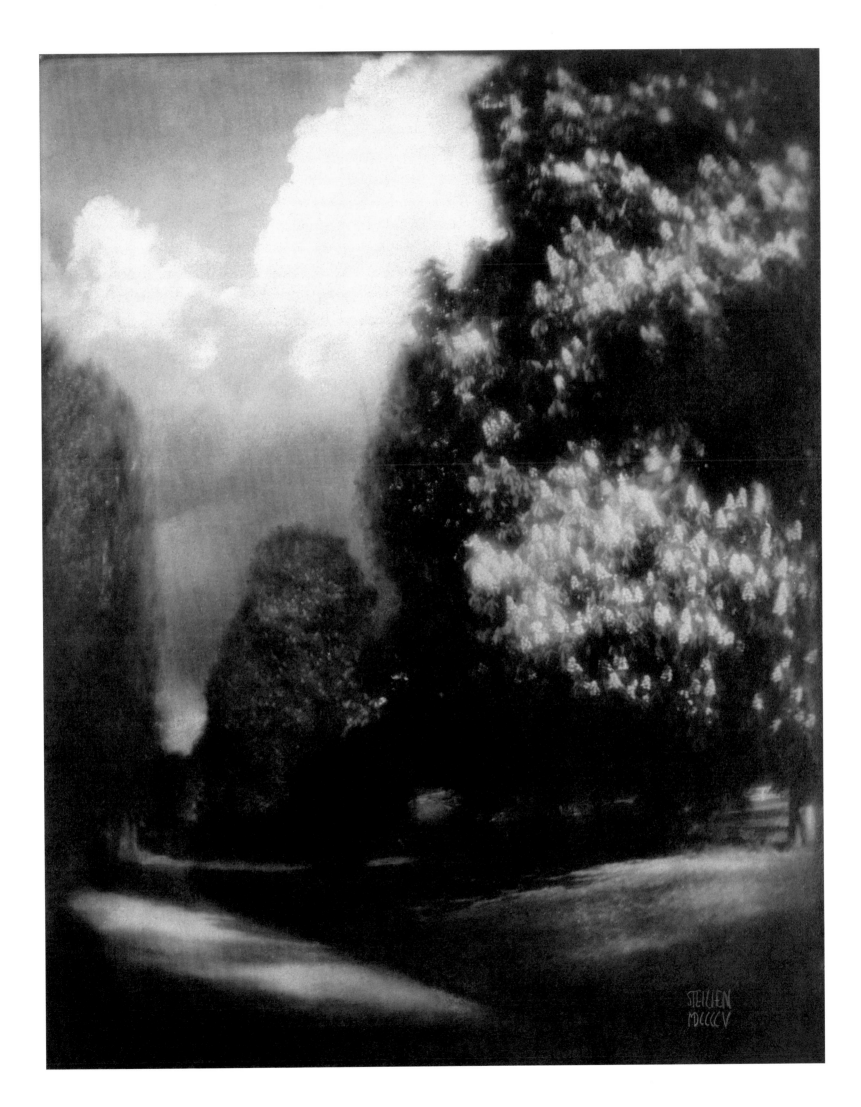

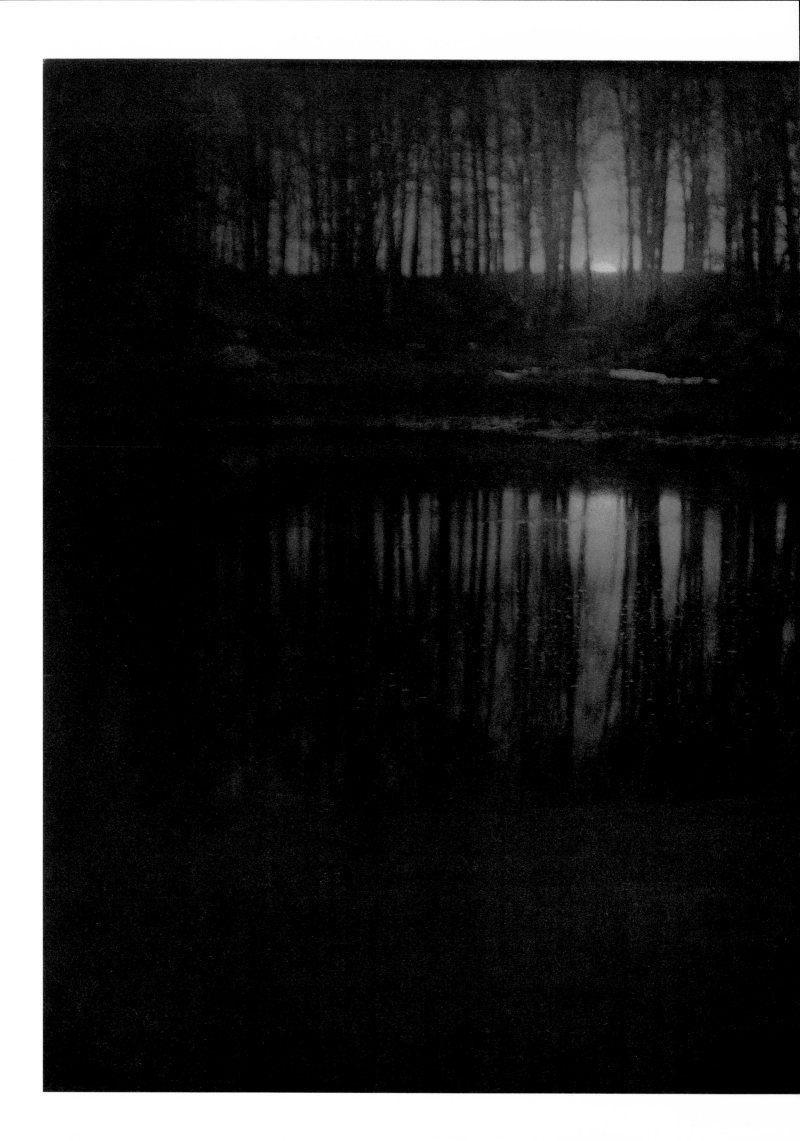

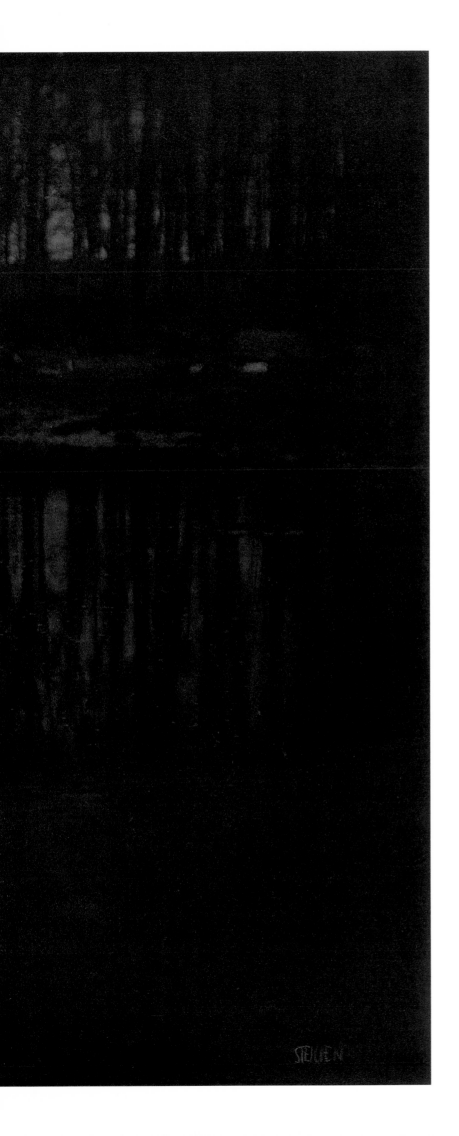

27

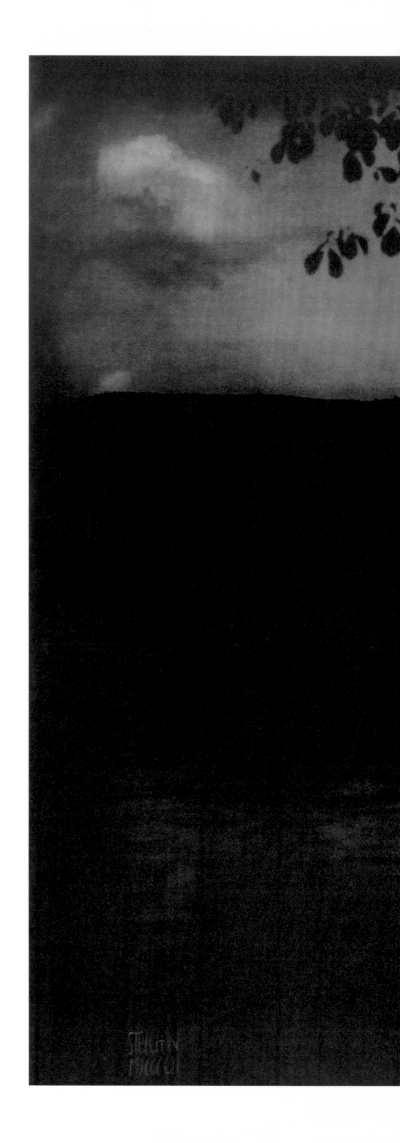

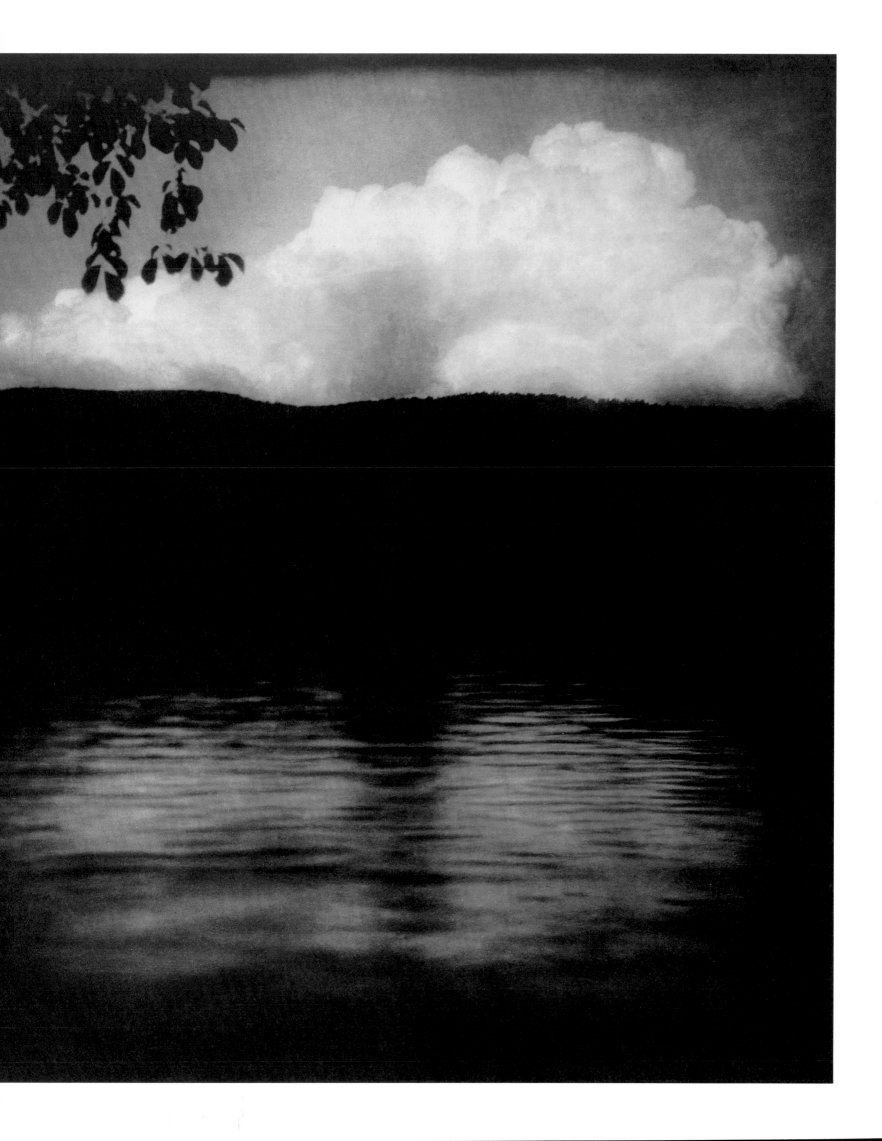

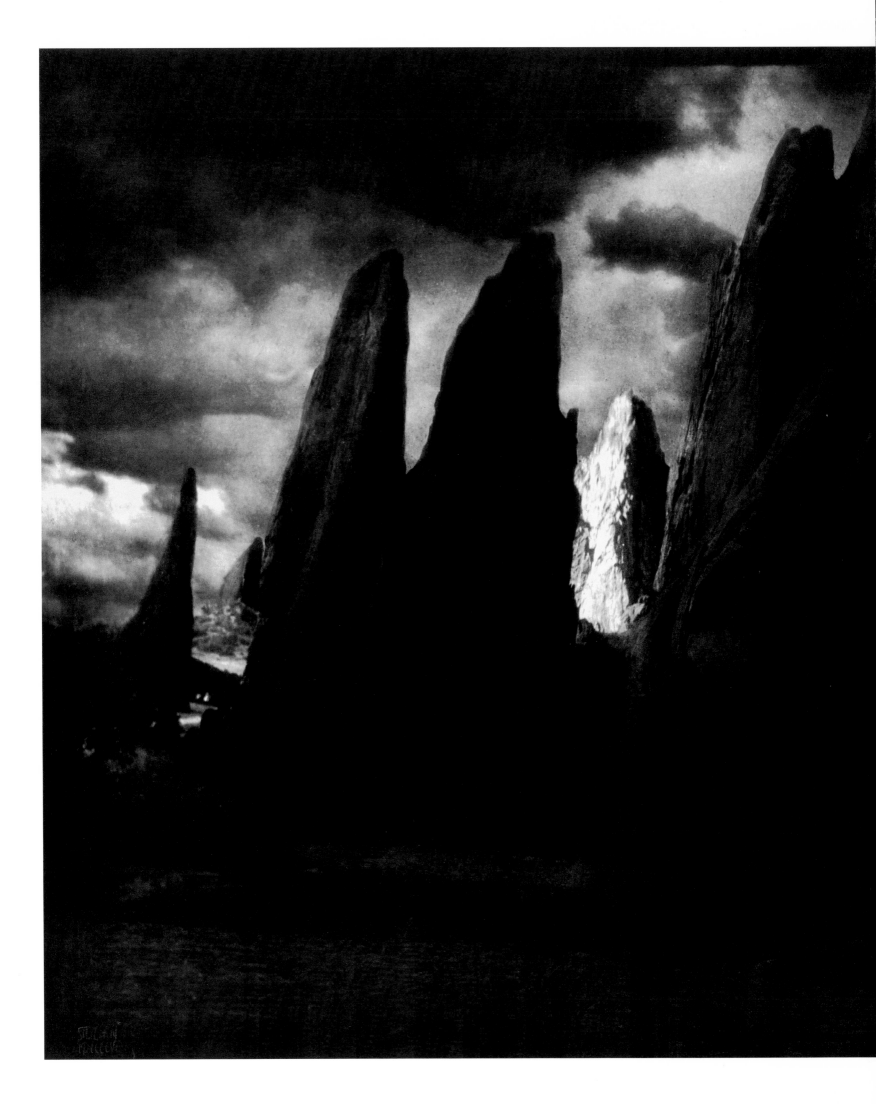

28

29

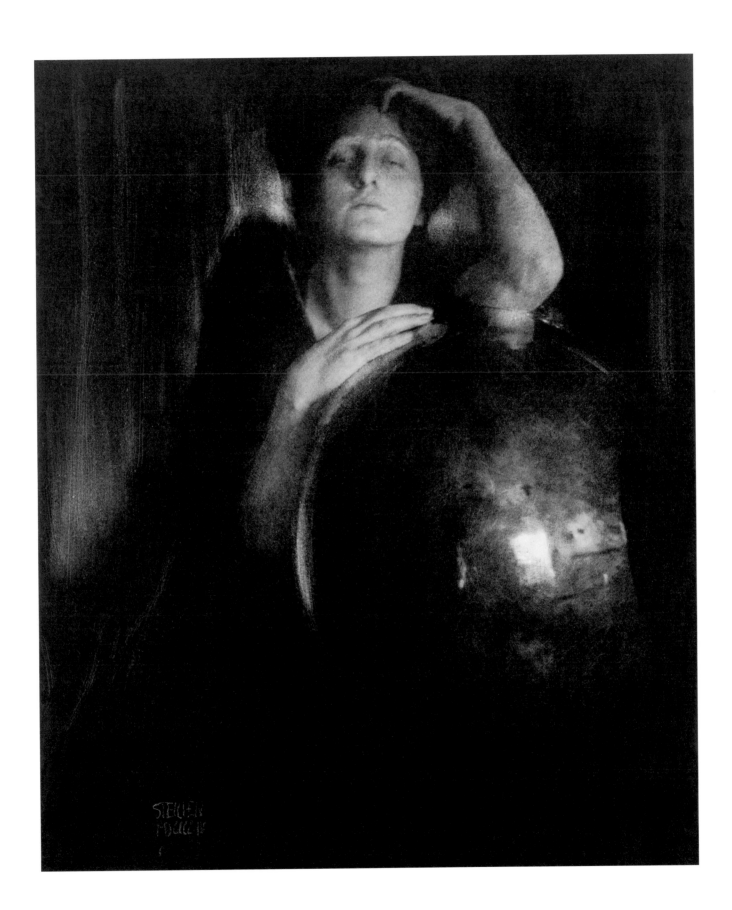

30

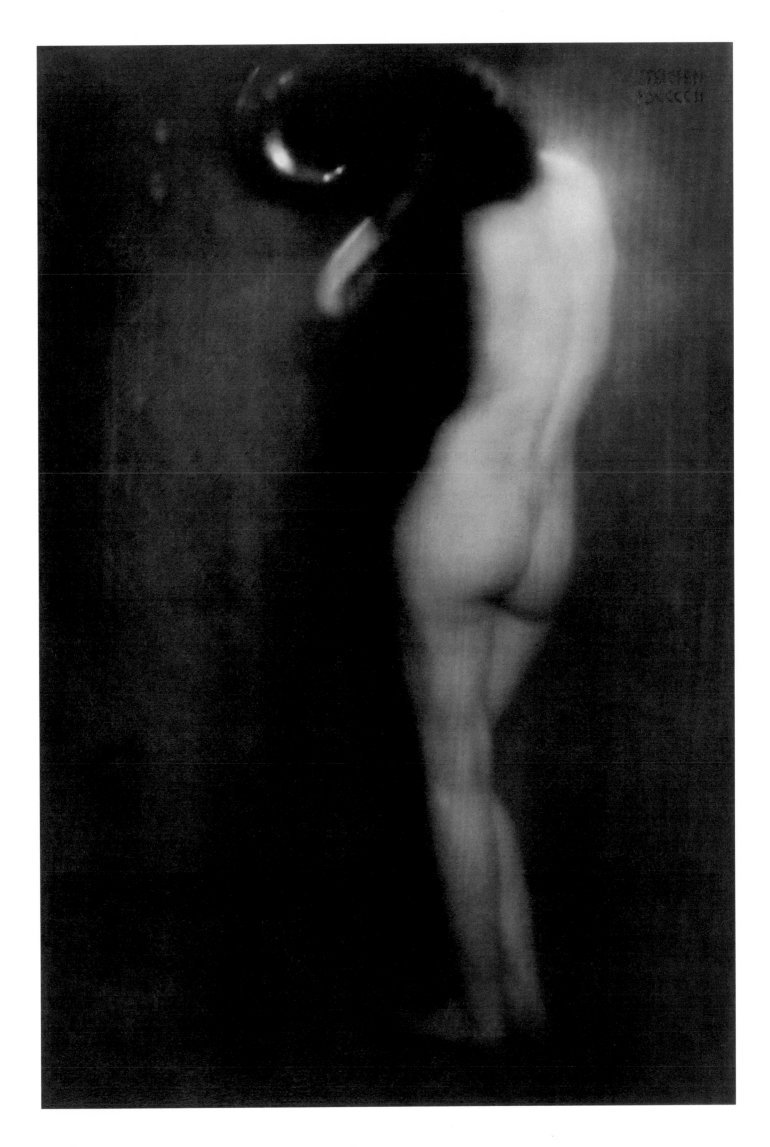

31

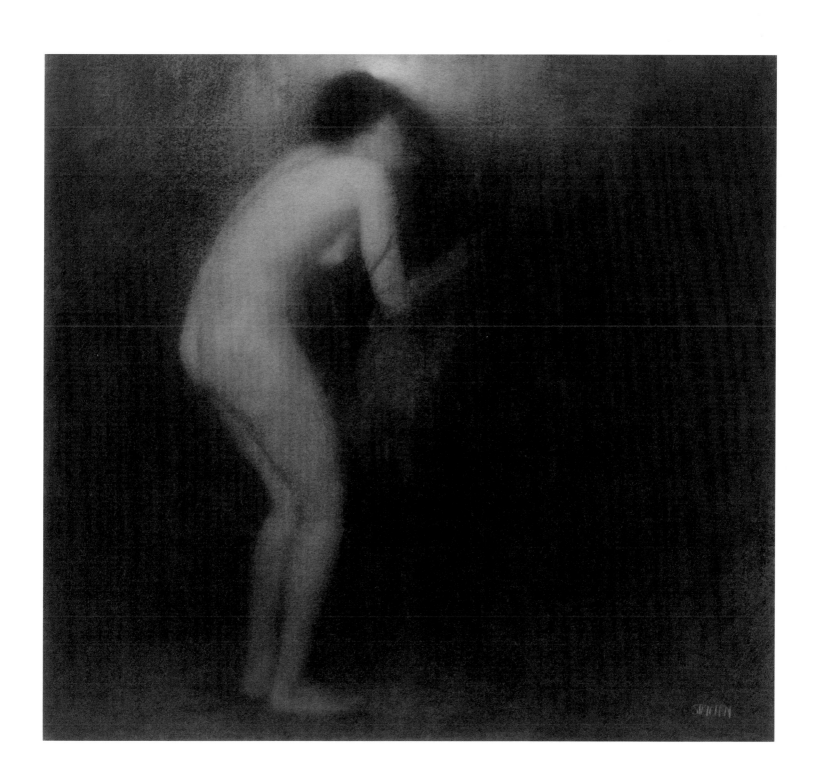

32

33

34

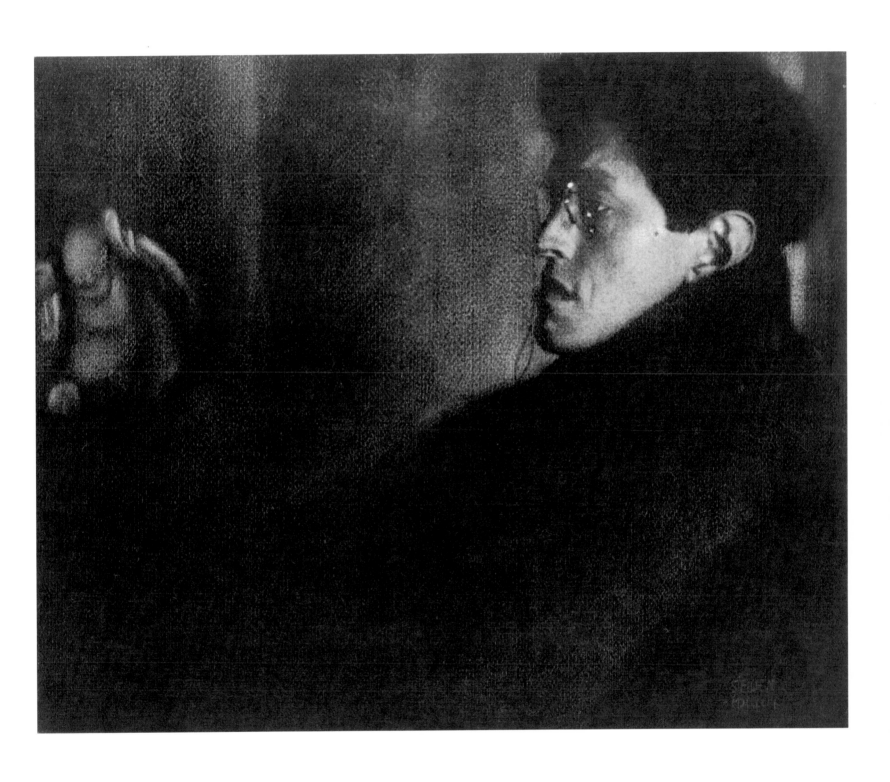

35

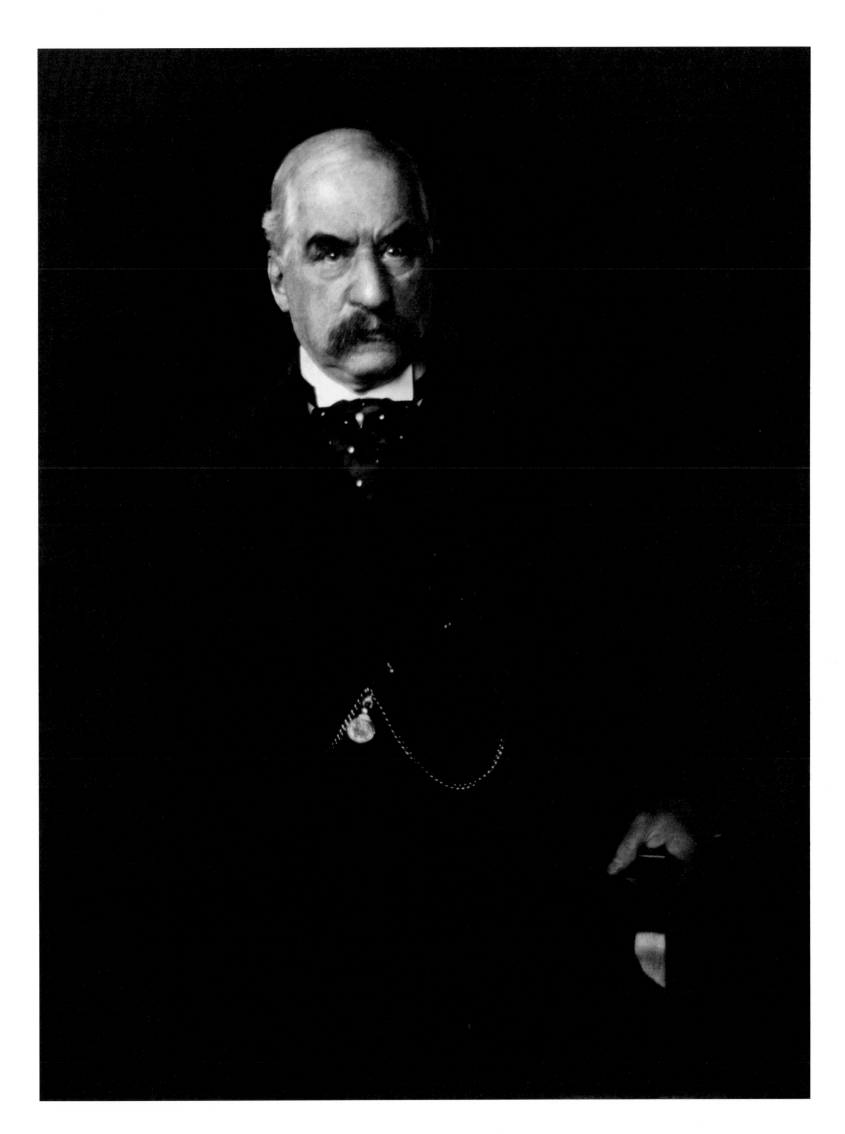

36

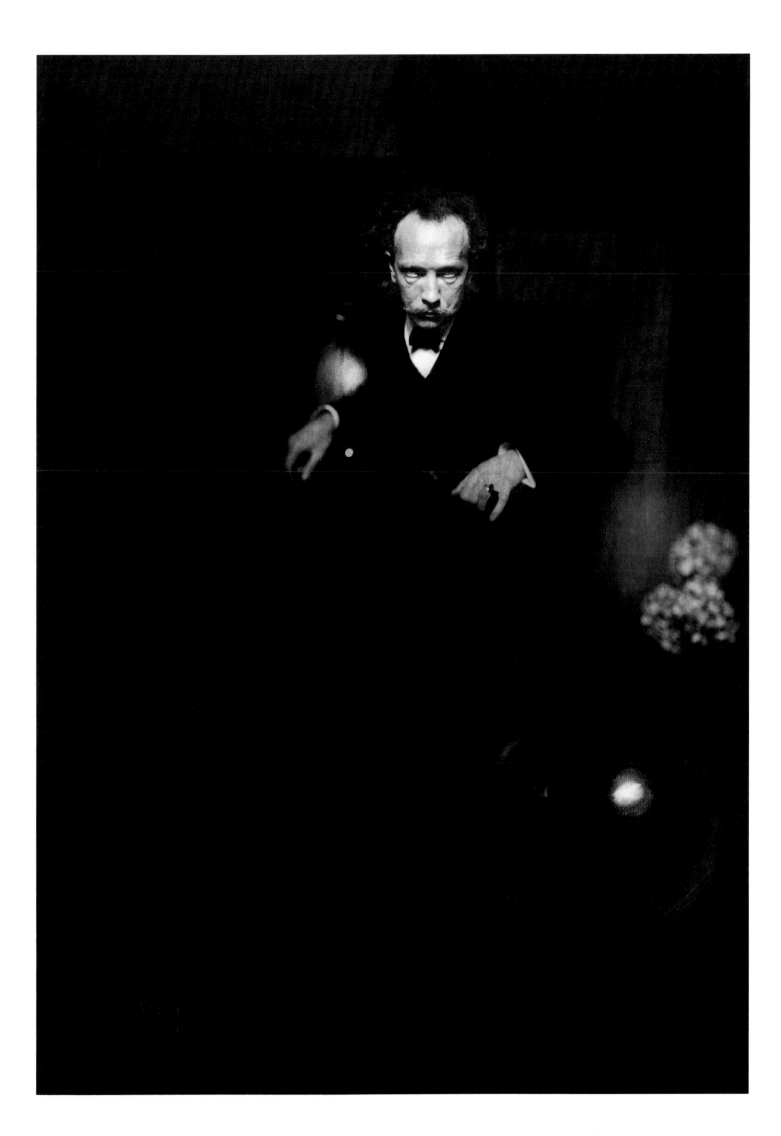

37

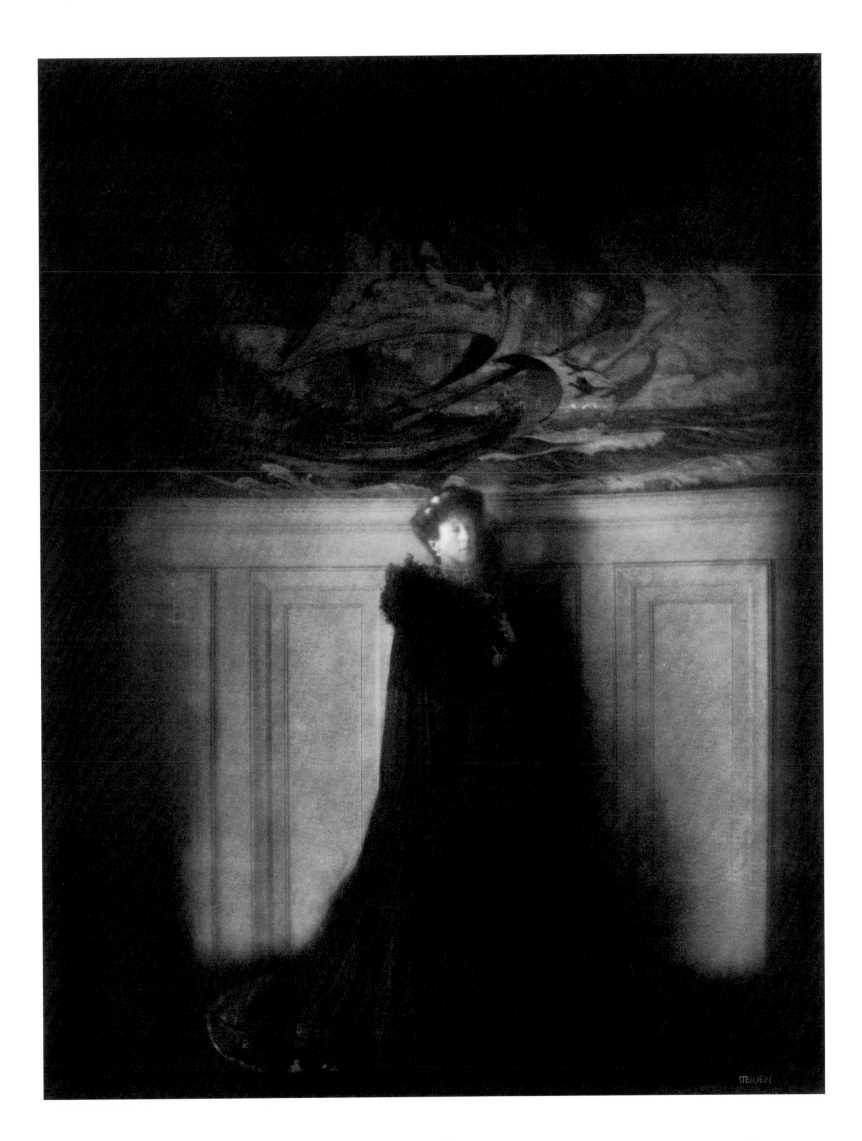

38

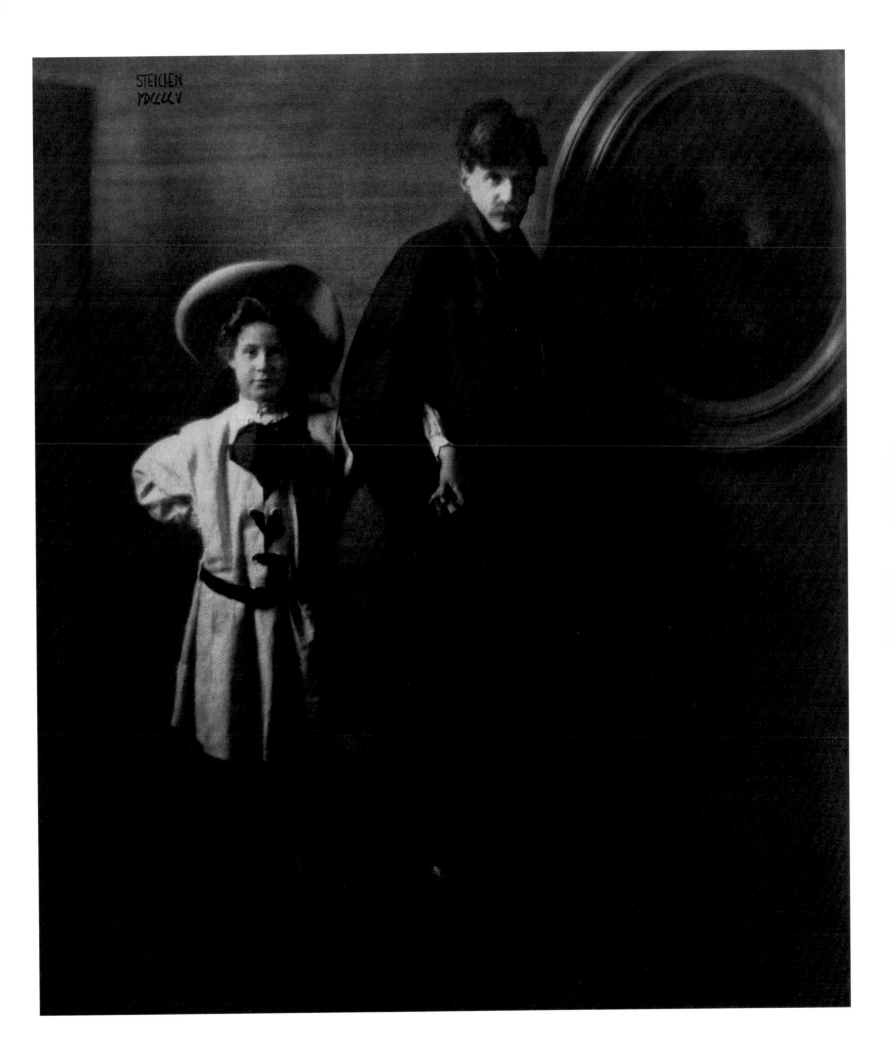

39

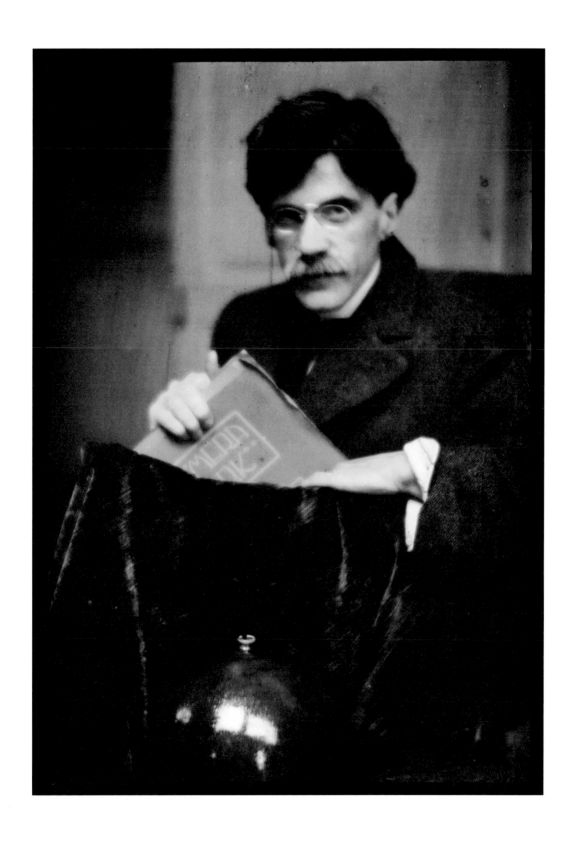

40

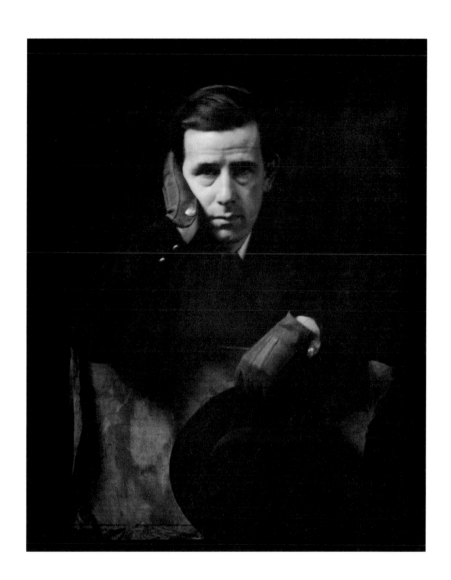

41

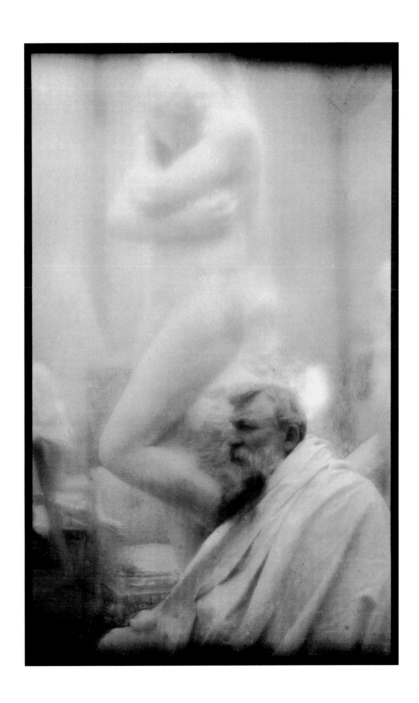

42

43

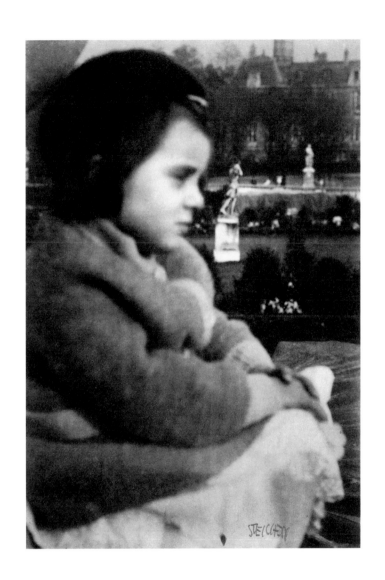

44

45

46

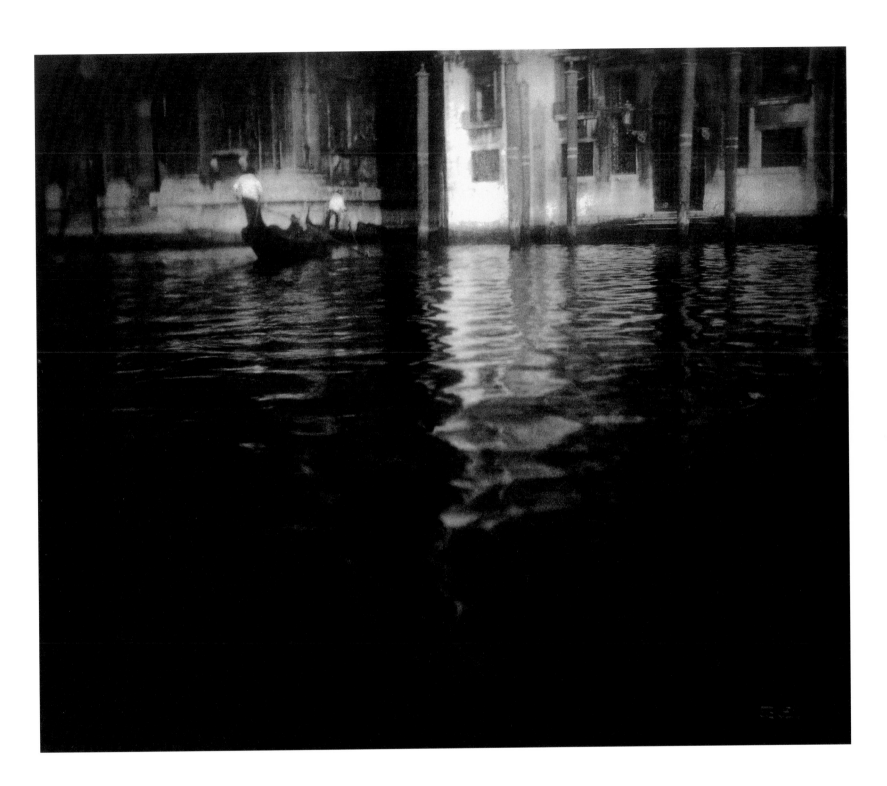

47

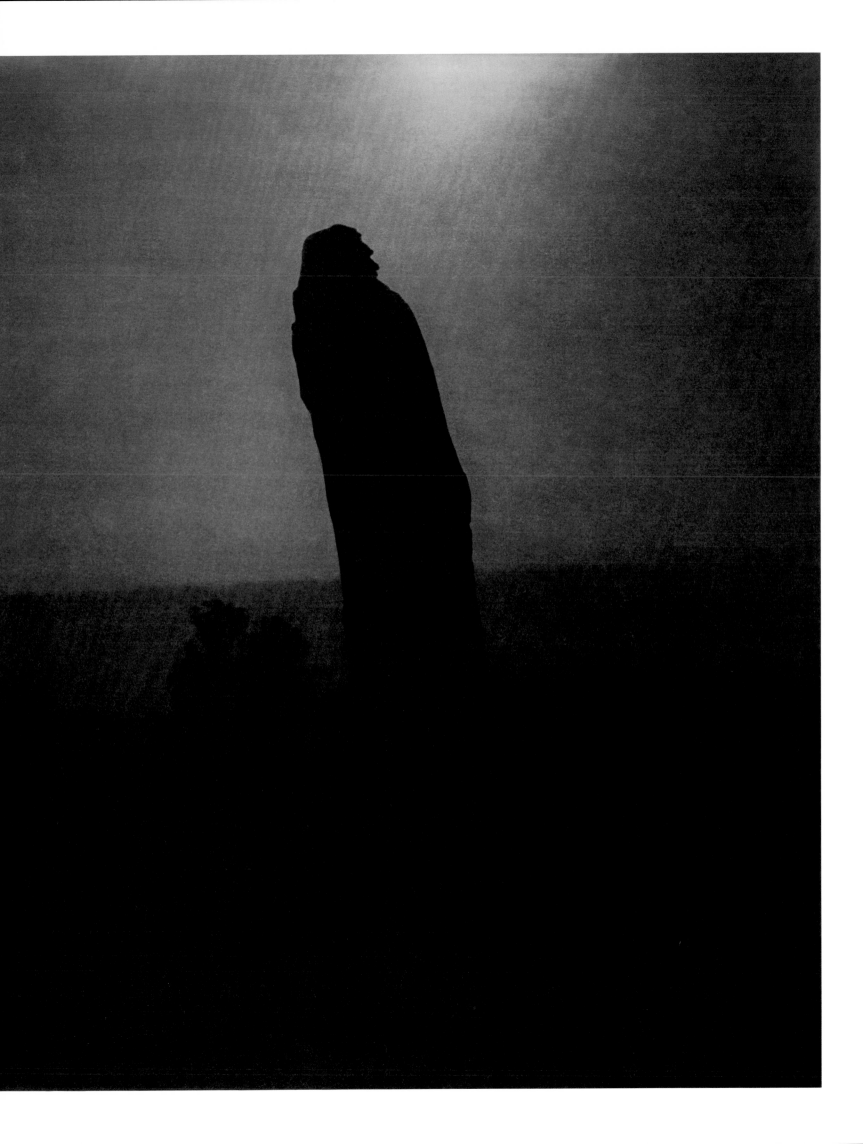

48

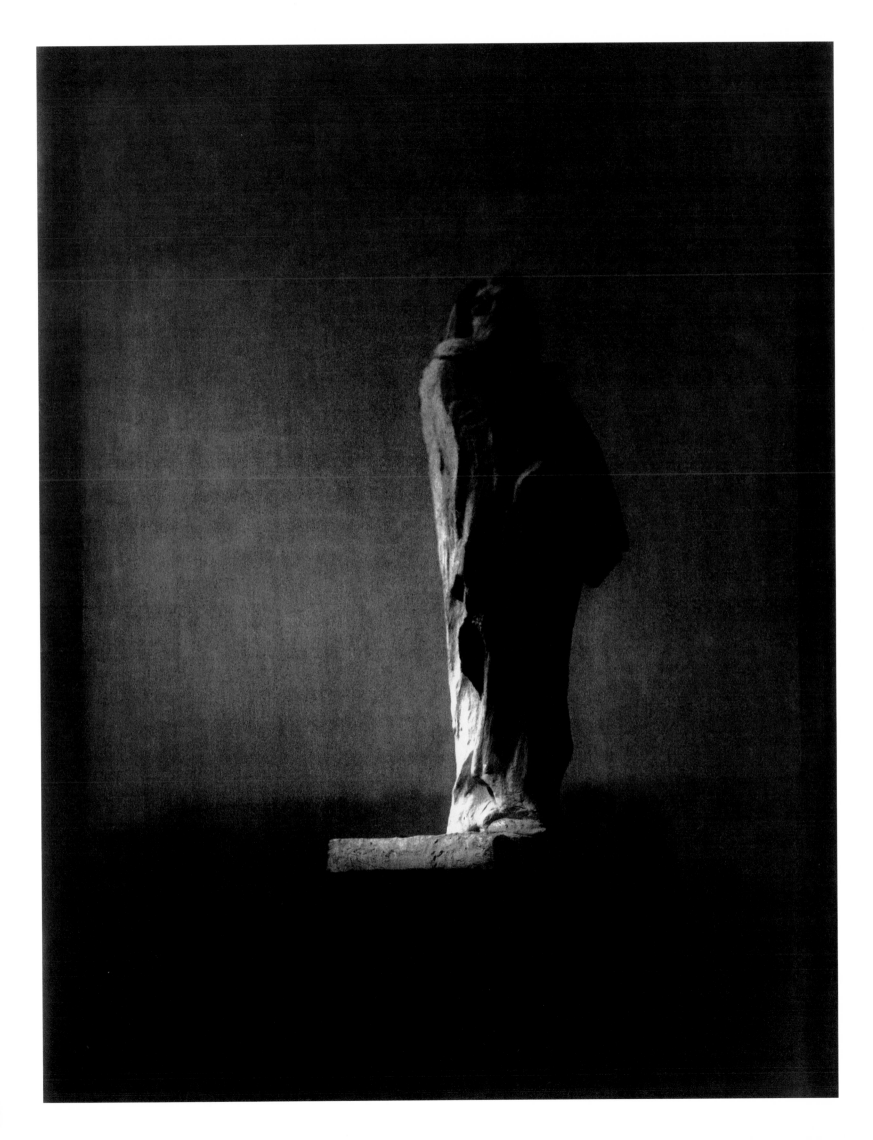

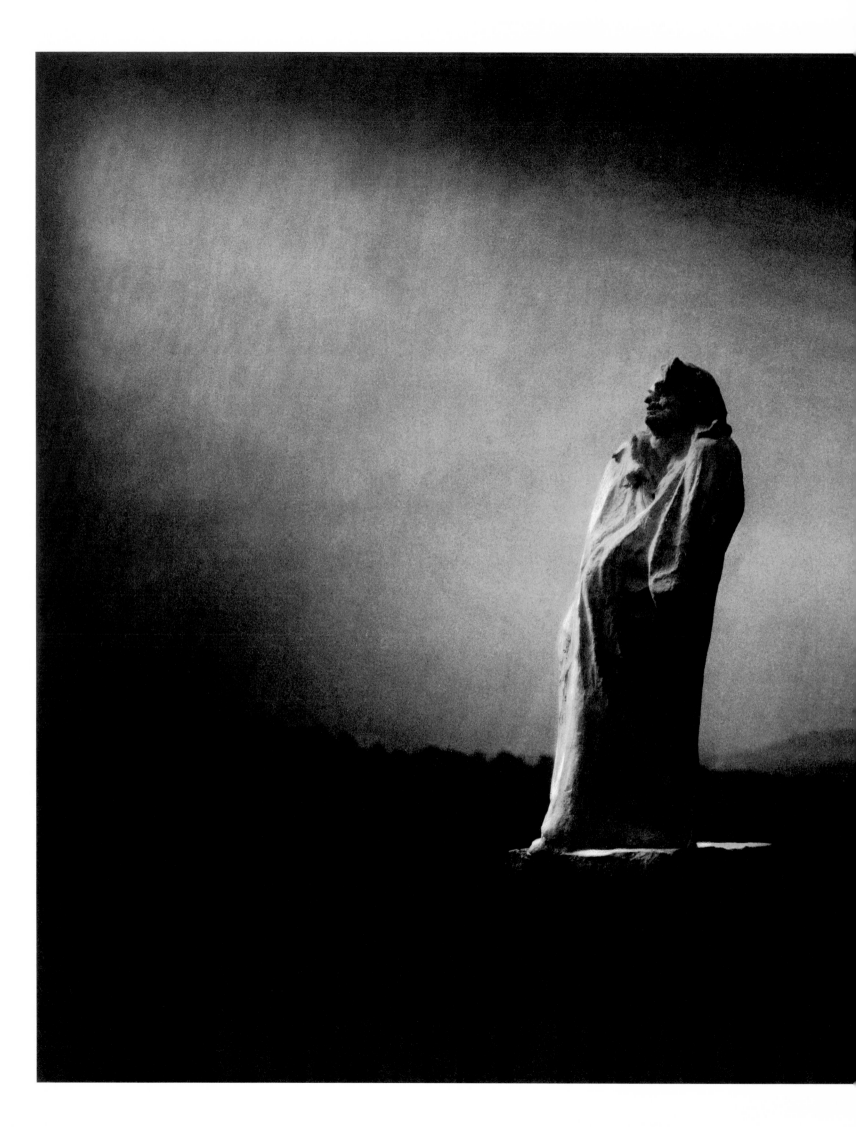

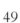

49

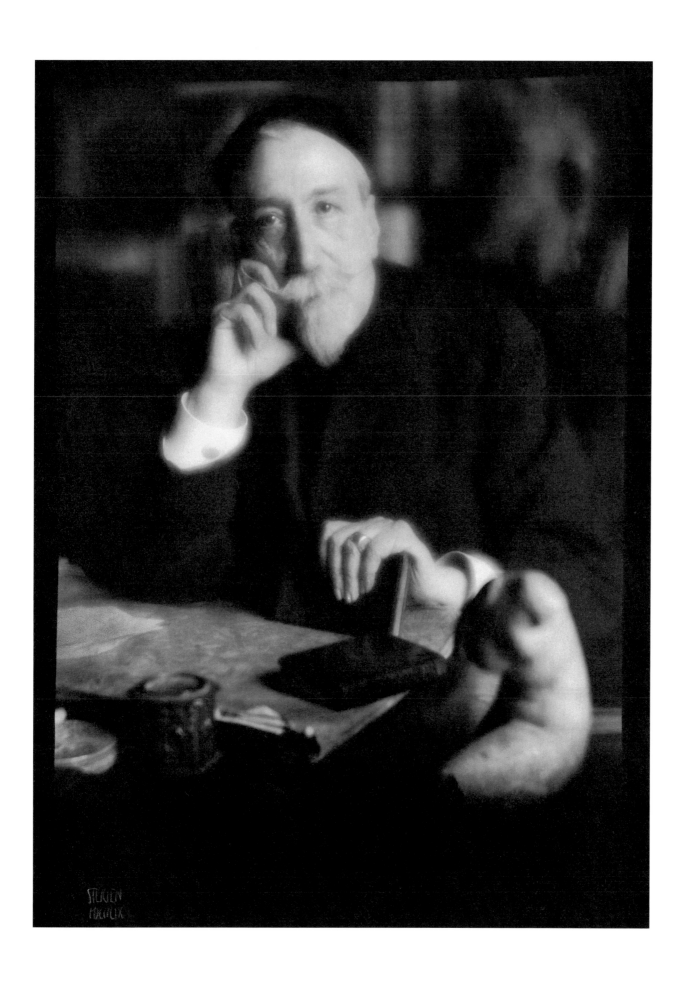

51

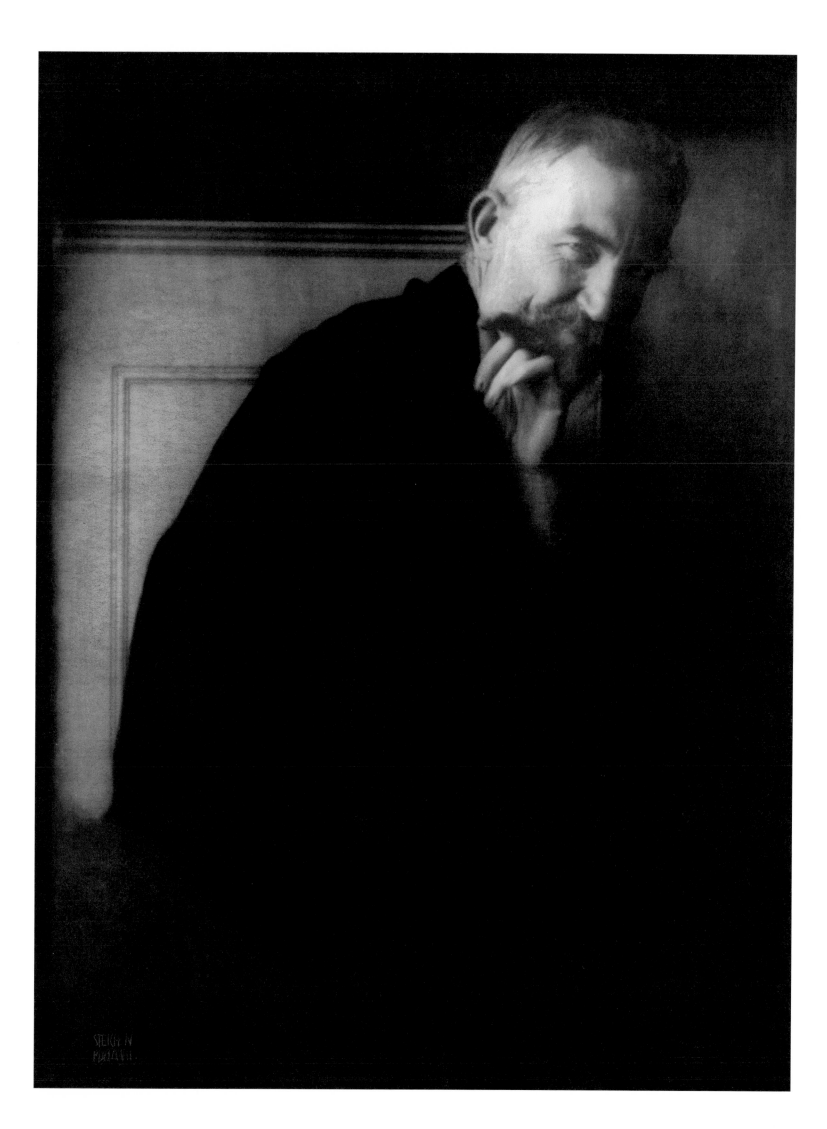

52

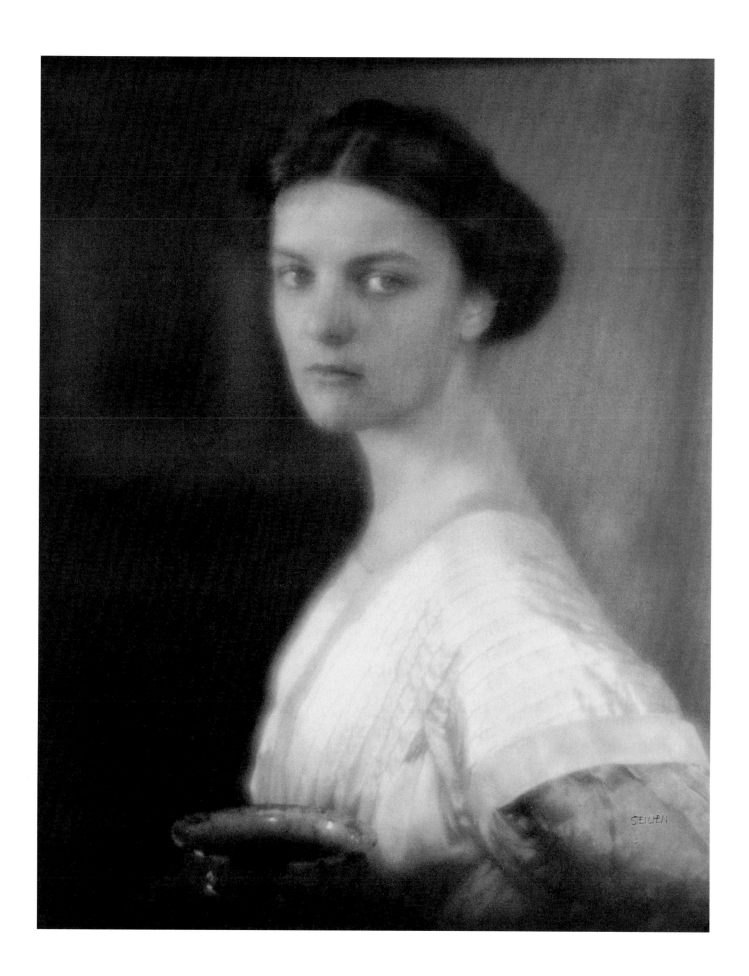

53

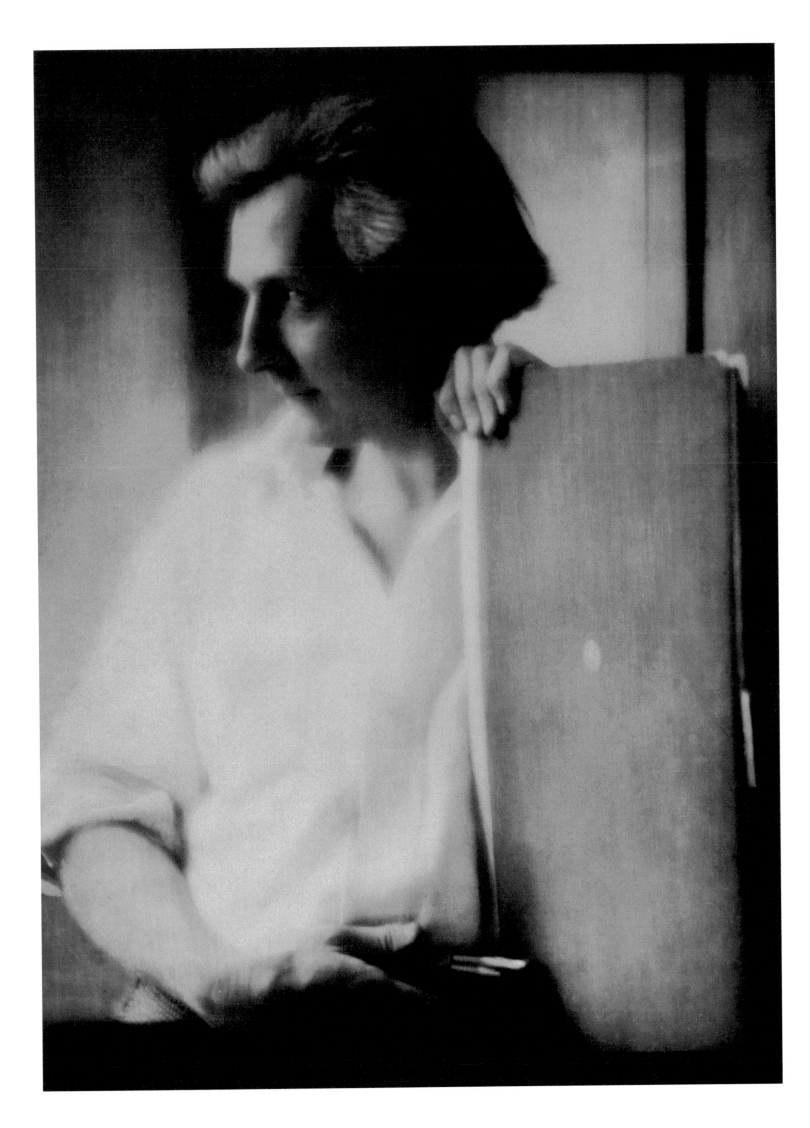

54

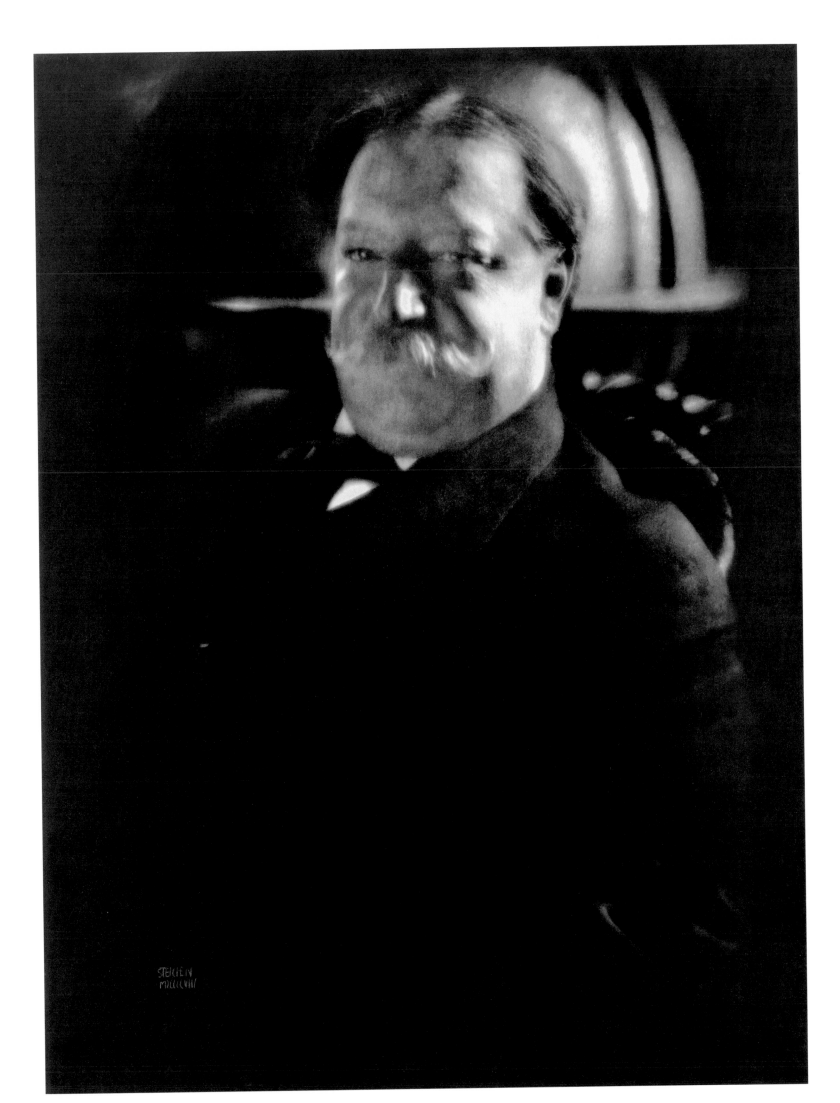

55

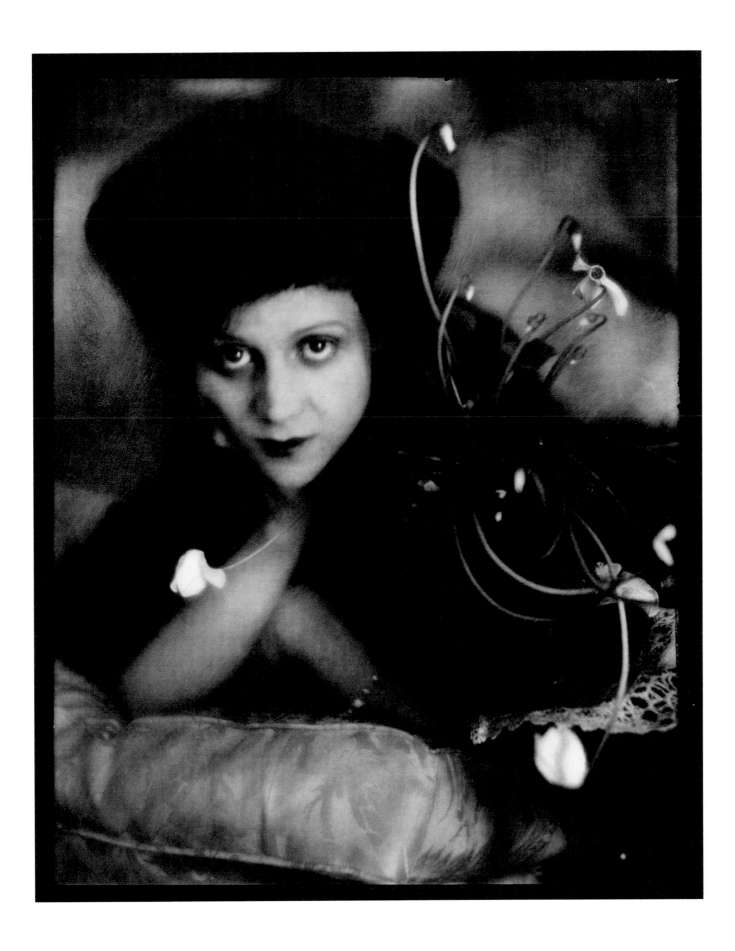

56

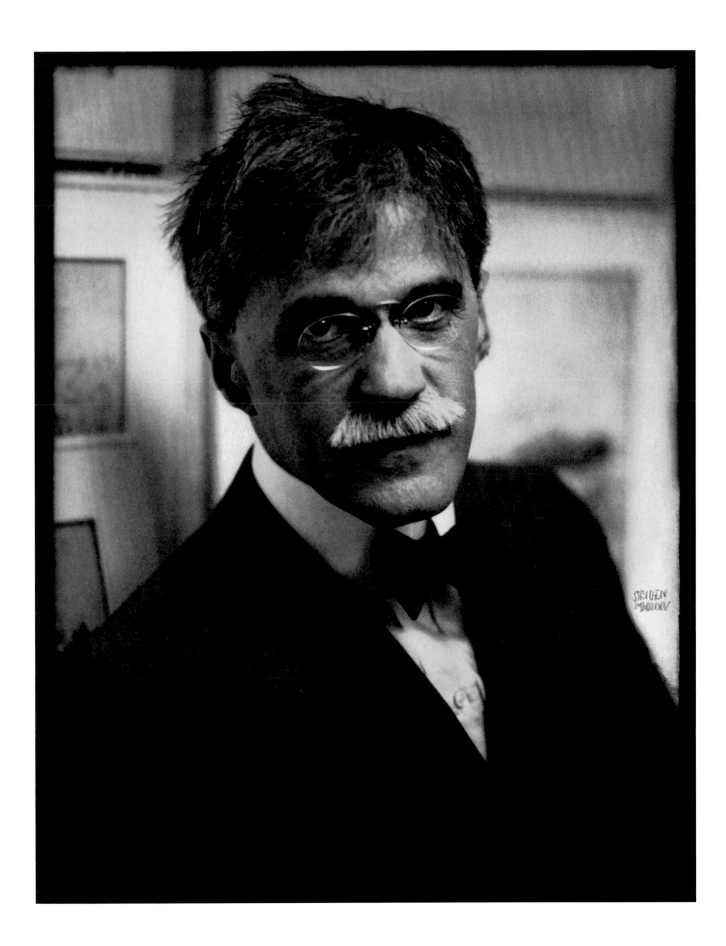

NOTES ON THE PRINTS

Art photographers at the turn of the century needed to prove that the camera was capable of something more than mere fidelity to the facts placed before it; they aimed to establish what one supporter called, in a hopeful phrase, "the unmechanicalness of photography."[1] Edward Steichen's "unmechanizing" tricks as a teenage amateur included unfocusing his apparatus, dripping water on its lens, and jogging its tripod during exposures.[2] Rising to the challenge of making photographs look like objects of craft to viewers who expected from them only windows on the world, the plates in this book chronicle a master printer's decade of proof that photographs could be made to live up to scrutiny as the unique products of an artist's handiwork. As a draftsman and painter, Steichen was instinctively alert to the material qualities of his photographs: their scale, texture, tonal range, and color, and the minute variables of mounting and framing. While experimental flair led him to improvisations that defy full reconstruction, the fundamental printing methods from which he proceeded were of four types.

Steichen printed his first serious photographs in **platinum**, a contact-printing medium preferred among pictorialists over the more common (and enlargeable) gelatin silver bromide, because platinum images settle inside the grain of their paper like ink wash, rendering light and shadow in a long, subtle tonal continuum. A platinum print's slightly bluish cast can be adjusted by immersing it in a chemical toning solution containing gold or mercury, for warmer or more violet effects. Over the years Steichen would push the alchemical possibilities of platinum—his mainstay as a professional portraitist—as far as anyone, but his eye for color and his taste for sheer complication had to be exercised elsewhere.

Steichen had already made tentative experiments in **gum bichromate** printing before he left the United States for Paris in 1900.[3] In this technique, which Robert Demachy and other European pictorialists had been promoting through how-to articles and exhibition prints since the mid-1890s, a watercolor pigment of any color, mixed with potassium (or ammonium) bichromate and gum arabic (a binder of acacia sap), was brushed onto a sheet of paper, then exposed to light in contact with a negative. The emulsion hardened where light fell upon it; when the paper was immersed in water, the unexposed areas of pigment fell away, while midtone details invited bravura textural treatments with a wet brush or a scraping tool. Inspired during his early years in Europe by first-hand study of gum prints by Demachy, F. Holland Day, Gertrude Käsebier, and Heinrich Kühn, Steichen began refining the deft touch that would let him overprint an image two or three times in varying pigments. Doubtless recognizing a procedural analogy between this technique and the Tonalist painter's practice of applying translucent oil glazes over monochrome renderings of nighttime scenes, Steichen imparted atmospheric effects to his photographs with bichromate "washes" of carefully selected hues. He could veil a scene printed in dense lampblack behind a dilute sepia-black haze,[4] or build up a vivid crepuscular light out of successive washes of complementary colors like blue-green and orange.

At about the same time Steichen took up gum bichromate printing in earnest, he began working with a **direct carbon** printing technique that was largely neglected among pictorialists but was favored by professional art-reproduction photographers for its simplicity and permanence.[5] "Art reproduction" was exactly what Steichen was after: starting from copy negatives after his more arduously achieved works in gum and platinum, he could with relative ease create multiple exhibition and sale prints in carbon that duplicated the tonal richness, shadow density, and great size (if not the polychromy or pleasingly rough texture) of gum bichromate. Through selective applications of pigment, he even managed to make a virtue of the carbon print's flat black shadows, playing them against highlight and midtone areas in which the paper was charged with the amber sun of late afternoon or the deep ocean tones of moonlight.

Perhaps Steichen's most characteristic printing method was the virtuosic, open-ended conflation of several processes into one. His rival Alvin Langdon Coburn was the first to go public with a practical **platinum-gum** technique, whereby the platinum "framework" of an image was hung with midtone fields of pigment.[6] A typical platinum-gum print by Coburn resembled an aquatint etching in its schematic bifurcation, with hard-edged platinum foreground elements silhouetted against a softer background of gray-tinted color. But in Steichen's hands, the process lent itself to painterly evocations of the perceptual continuities

between substances and spaces, surface and depth. By overprinting high-contrast gelatin silver prints with brushed-on layers of platinum, gum bichromate, and other materials, he widened his palette still further. At least once, when a moonlit winter sky called for an intense blue, Steichen turned to the simple iron-salt-based cyanotype (blueprint) process used by architects and engineers. (He wrote to Stieglitz that this lowly expedient was to be their "secret"; for the record, the picture became, obscurely if accurately, a "ferroprussiate print.")[7]

To erase what he considered a false distinction between "straight photography and the other one,"[8] Steichen insisted that "every photograph is a fake from start to finish."[9] Even the "straightest" photograph, that is, looks as it does as the result of choices made by a picture-maker, from choice of subject to composition, from exposure time to printing chemistry. When standing before one of Steichen's early masterworks, it matters little to know precisely how he achieved his effects in the darkroom. Like the first painters to suspend pigments in oil, Steichen was an innovator who opened his medium to new sensual possibilities—not in the belief that technique defines the limits of self-expression, but out of determination that it never should.

1. George Bernard Shaw, "The Unmechanicalness of Photography," *Amateur Photographer* (London) 9 (Oct. 1902); excerpted in part in *Camera Work* 14 (Apr. 1906).

2. Edward Steichen, *A Life in Photography* (Garden City, N.Y.: Doubleday, 1963), 1.3.

3. Ibid., 1.5.

4. Edward Steichen, handwritten note headed "Experiment in Multiple Gum," on the original mat for *Untitled* (plate 21). See Weston J. Naef, *The Collection of Alfred Stieglitz: Fifty Pioneers of Modern Photography* (New York: Metropolitan Museum of Art, 1978), 453.

5. On Steichen and the Artigue carbon process, see Naef, *Collection of Alfred Stieglitz*, 445–46.

6. Ibid., 302.

7. Edward Steichen to Alfred Stieglitz, [late July 1904], Alfred Stieglitz Papers, Yale Collection of American Literature, Beinecke Rare Book and Manuscript Library, Yale University. A thumbnail sketch in this letter makes it clear that the print featuring a layer of "plain _blue print_ (secret)" is *Road to the Valley—Moonrise* (see *Camera Work*, Steichen Supplement, Apr. 1906) and not, as has sometimes been implied, *The Pond—Moonrise* (plate 26).

8. Robert Demachy, "On the Straight Print," *Camera Work* 19 (July 1907).

9. Edward Steichen, "Ye Fakers," *Camera Work* 1 (Dec. 1902).

LIST OF PLATES

All works listed are in the collection of the Metropolitan Museum of Art

Frontispiece
Self-Portrait, 1899
Platinum print
$7^{13}/_{16}$ x $3^{5}/_{8}$ in. (19.8 x 9.2 cm)
Alfred Stieglitz Collection, 1933
33.43.1

1. *Woods Interior*, 1899
Platinum print
$7^{7}/_{16}$ x $6^{5}/_{16}$ in (18.9 x 16.1 cm)
Alfred Stieglitz Collection, 1933
33.43.8

2. *The Pool—Evening*, 1899
Platinum print
$8^{1}/_{8}$ x $6^{5}/_{16}$ in. (20.7 x 16 cm)
Alfred Stieglitz Collection, 1949
49.55.232

3. *Woods Twilight*, 1899
Platinum print
6 x $7^{15}/_{16}$ in. (15.2 x 20.1 cm)
Alfred Stieglitz Collection, 1933
33.43.14

4. *Self-Portrait*, 1901
Gelatin silver print
$4^{3}/_{4}$ x $3^{5}/_{8}$ in. (12 x 9.2 cm)
Alfred Stieglitz Collection, 1933
33.43.18

5. *Bartholomé*, 1901, printed 1903
Coated platinum print
$10^{9}/_{16}$ x $7^{15}/_{16}$ in. (26.8 x 20.2 cm)
Alfred Stieglitz Collection, 1933
33.43.16

6. *Rodin*, 1901, printed 1902
Direct carbon print
$10^{9}/_{16}$ x 8 in. (26.9 x 20.3 cm)
Alfred Stieglitz Collection, 1933
33.43.4

7. *William Merritt Chase*, 1900
Direct carbon print
$7^{3}/_{16}$ x $5^{1}/_{8}$ in. (18.3 x 13 cm)
Alfred Stieglitz Collection, 1933
33.43.15

8. *The Black Vase*, 1901, printed 1902
Direct carbon print
8 x $6^{1}/_{16}$ in. (20.4 x 15.4 cm)
Alfred Stieglitz Collection, 1933
33.43.20

9. *Languid Repose*, 1902
Direct carbon print
$7^{9}/_{16}$ x $5^{15}/_{16}$ in. (19.2 x 15.1 cm)
Gift of Grace M. Mayer in memory of
René d'Harnoncourt, 1988
1988.1167

10. *Figure with Iris*, 1902
Direct carbon print
$13^{3}/_{8}$ x $7^{3}/_{8}$ in. (34 x 18.8 cm)
Alfred Stieglitz Collection, 1933
33.43.17

11. *In Memoriam*, 1901, printed 1904
Gum bichromate over platinum print
$19^{5}/_{8}$ x $15^{7}/_{8}$ in. (49.8 x 40.3 cm)
Alfred Stieglitz Collection, 1933
33.43.48

12. *Maeterlinck*, 1901, printed ca. 1903
Direct carbon print
$13^{1}/_{16}$ x $10^{7}/_{16}$ in. (33.2 x 26.5 cm)
Alfred Stieglitz Collection, 1933
33.43.2

13. *George Frederick Watts*, 1900, printed ca. 1902
Direct carbon print
$13^{1}/_{4}$ x $10^{1}/_{4}$ in. (33.6 x 26.1 cm)
Alfred Stieglitz Collection, 1933
33.43.26

14. *Lenbach*, 1901, printed 1902
Direct carbon print
20 1/4 x 14 5/8 in. (51.5 x 37.1 cm)
Alfred Stieglitz Collection, 1933
33.43.33

15. *Frederick H. Evans*, 1900–1901
Platinum print
7 5/8 x 4 7/16 in. (19.3 x 11.2 cm)
David Hunter McAlpin Fund, 1968
68.688.4

16. *Voulangis*, 1900–1902
Platinum print
5 13/16 x 5 13/16 in. (14.7 x 14.7 cm)
Gift of Grace M. Mayer, 1990
1990.1042

17. *The Flatiron*, 1904, printed 1905
Gum bichromate over gelatin silver print
9 7/16 x 7 9/16 in. (24 x 19.2 cm)
Alfred Stieglitz Collection, 1933
33.43.37

18. *The Flatiron*, 1904, printed 1909
Gum bichromate over platinum print
18 13/16 x 15 1/8 in. (47.8 x 38.4 cm)
Alfred Stieglitz Collection, 1933
33.43.43

19. *The Flatiron*, 1904, printed 1909
Gum bichromate over platinum print
18 13/16 x 15 1/8 in. (47.8 x 38.4 cm)
Alfred Stieglitz Collection, 1933
33.43.39

20. *The Flatiron—Evening*, 1904, printed 1905
Gum bichromate over platinum print
19 5/8 x 15 5/16 in. (49.9 x 38.9 cm)
Alfred Stieglitz Collection, 1933
33.43.44

21. *Untitled*, 1904
Gum bichromate print
11 1/8 x 9 1/2 in. (28.2 x 24.2 cm)
Alfred Stieglitz Collection, 1933
33.43.13

22. *Portraits—Evening*, 1903, printed 1908
Gum bichromate over platinum print
11 1/2 x 13 1/4 in. (29.2 x 33.6 cm)

Alfred Stieglitz Collection, 1933
33.43.21

23. *Clarence H. White*, 1903
Platinum print
12 15/16 x 9 13/16 in. (32.9 x 25 cm)
Alfred Stieglitz Collection, 1933
33.43.7

24. *Mother and Child—Sunlight Patches*, 1905
Direct carbon print
13 11/16 x 10 13/16 in. (34.8 x 27.5 cm)
Alfred Stieglitz Collection, 1933
33.43.27

25. *Chestnut Blossoms*, 1904, printed 1905
Gum bichromate over platinum print
19 9/16 x 15 3/4 in. (49.7 x 40 cm)
Alfred Stieglitz Collection, 1933
33.43.42

26. *The Pond—Moonrise*, 1904
Platinum print with applied color
15 5/8 x 19 in. (39.7 x 48.2 cm)
Alfred Stieglitz Collection, 1933
33.43.40

27. *The Big Cloud, Lake George*, 1903, printed 1904
Direct carbon print
15 1/2 x 19 in. (39.3 x 48.3 cm)
Alfred Stieglitz Collection, 1933
33.43.47

28. *Storm in the Garden of the Gods—Colorado*, 1906,
printed 1909
Direct carbon print
15 5/16 x 18 5/16 in. (38.9 x 46.5 cm)
Alfred Stieglitz Collection, 1933
33.43.25

29. *The Brass Bowl*, 1904
Direct carbon print
12 x 10 1/16 in. (30.4 x 25.6 cm)
Alfred Stieglitz Collection, 1933
33.43.6

30. *The Little Round Mirror*, 1901, printed 1905
Gum bichromate over platinum print
19 x 13 1/16 in. (48.3 x 33.2 cm)
Alfred Stieglitz Collection, 1933
33.43.32

31. *La Cigale*, 1901, printed 1904–5
 Gum bichromate over platinum print
 10$^7/_{16}$ x 11$^7/_{16}$ in. (26.5 x 29 cm)
 Alfred Stieglitz Collection, 1933
 33.43.22

32. *Melpomene—Landon Rives*, 1904–5
 Gum bichromate over platinum print
 18$^3/_4$ x 12$^{13}/_{16}$ in. (47.6 x 32.5 cm)
 Alfred Stieglitz Collection, 1933
 33.43.31

33. *Profile [Miss de C.]*, 1904
 Direct carbon print
 12$^3/_8$ x 10$^3/_{16}$ in. (31.5 x 25.8 cm)
 Alfred Stieglitz Collection, 1933
 33.43.3

34. *Sadakichi Hartmann*, 1903
 Direct carbon print
 9$^{11}/_{16}$ x 12 in. (24.6 x 30.5 cm)
 Alfred Stieglitz Collection, 1933
 33.43.52

35. *J. Pierpont Morgan, Esq.*, 1903, printed 1909–10
 Gum bichromate over platinum print
 20$^5/_{16}$ x 16$^3/_{16}$ in. (51.6 x 41.1 cm)
 Alfred Stieglitz Collection, 1949
 49.55.167

36. *Richard Strauss*, 1904, printed 1906
 Direct carbon print
 18$^3/_8$ x 12$^7/_8$ in. (46.7 x 32.7 cm)
 Alfred Stieglitz Collection, 1949
 49.55.168

37. *Lady Ian Hamilton*, 1907, printed 1909
 Direct carbon print
 19$^{13}/_{16}$ x 15$^9/_{16}$ in. (50.4 x 39.6 cm)
 Alfred Stieglitz Collection, 1933
 33.43.24

38. *Alfred Stieglitz and His Daughter Katherine*, 1904,
 printed 1905
 Gum bichromate print, possibly over platinum print
 17$^{15}/_{16}$ x 15$^3/_4$ in. (45.5 x 40 cm)
 Alfred Stieglitz Collection, 1933
 33.43.23

39. *Alfred Stieglitz*, 1907
 Autochrome

9 x 6$^3/_{16}$ in. (22.9 x 15.7 cm)
Alfred Stieglitz Collection, 1955
55.635.10

40. *Clarence H. White*, 1907–9
 Autochrome
 5$^9/_{16}$ x 4$^7/_{16}$ in. (14.2 x 11.2 cm)
 Alfred Stieglitz Collection, 1955
 55.635.19

41. *Rodin—The Eve*, 1907
 Autochrome
 6$^1/_4$ x 3$^7/_8$ in. (15.9 x 9.8 cm)
 Alfred Stieglitz Collection, 1955
 55.635.9

42. *Katherine Stieglitz*, 1907
 Autochrome
 6$^7/_{16}$ x 4$^7/_{16}$ in. (16.3 x 11.3 cm)
 Alfred Stieglitz Collection, 1955
 55.635.13

43. *Mary in the Luxembourg Gardens*, ca. 1909
 Platinum print
 6$^9/_{16}$ x 4$^1/_2$ in. (16.6 x 11.4 cm)
 Alfred Stieglitz Collection, 1949
 49.55.229

44. *Steeplechase Day, Paris—The Grandstand*, 1907, printed 1911
 Direct carbon print
 10$^3/_4$ x 13$^7/_8$ in. (27.3 x 35.2 cm)
 Alfred Stieglitz Collection, 1933
 33.43.49

45. *After the Grand Prix, Paris*, 1907, printed 1911
 Direct carbon print
 10$^{11}/_{16}$ x 11$^5/_8$ in. (27.1 x 29.5 cm)
 Alfred Stieglitz Collection, 1933
 33.43.51

46. *Late Afternoon—Venice*, 1907
 Direct carbon print
 11$^1/_{16}$ x 13$^3/_{16}$ in. (28.1 x 33.5 cm)
 Alfred Stieglitz Collection, 1933
 33.43.50

47. *Balzac, The Silhouette—4 A.M.*, 1908
 Gum bichromate print
 14$^{15}/_{16}$ x 18$^1/_8$ in. (37.9 x 46.0 cm)
 Alfred Stieglitz Collection, 1933
 33.43.36

48. *Balzac, The Open Sky—11 P.M.,* 1908, printed 1909
Direct carbon print
19 3/16 x 15 3/16 in. (48.7 x 38.5 cm)
Alfred Stieglitz Collection, 1933
33.43.46

49. *Balzac, Towards the Light—Midnight,* 1908
Direct carbon print
14 3/8 x 19 in. (36.5 x 48.2 cm)
Alfred Stieglitz Collection, 1933
33.43.38

50. *Anatole France,* 1909
Gum bichromate over gelatin silver print
15 5/16 x 11 5/8 in. (38.9 x 29.5 cm)
Alfred Stieglitz Collection, 1949
49.55.165

51. *The Photographers' Best Model—George Bernard Shaw,* 1907
Gum bichromate over platinum print
19 7/16 x 15 3/16 in. (49.3 x 38.5 cm)
Alfred Stieglitz Collection, 1949
49.55.166

52. *Agnes Ernst,* 1908
Platinum print
10 3/4 x 8 5/8 in. (27.3 x 21.9 cm)
Alfred Stieglitz Collection, 1949
49.55.226

53. *Edward Gordon Craig,* 1909
Gelatin silver print
19 1/16 x 14 1/8 in. (48.4 x 35.9 cm)
Alfred Stieglitz Collection, 1949
49.55.227

54. *William Howard Taft,* 1908, printed 1909
Direct carbon print
19 15/16 x 15 1/4 in. (50.6 x 38.7 cm)
Alfred Stieglitz Collection, 1933
33.43.34

55. *Cyclamen—Mrs. Philip Lydig,* ca. 1905
Direct carbon print
12 3/8 x 8 1/2 in. (31.5 x 21.6 cm)
Alfred Stieglitz Collection, 1933
33.43.9

56. *Alfred Stieglitz at 291,* 1915
Coated gum bichromate over platinum print
11 5/16 x 9 1/2 in. (28.8 x 24.2 cm)
Alfred Stieglitz Collection, 1933
33.43.29

Page 160
"Photo-Secession," 1905
Woodcut with gilt paper
7 3/16 x 2 5/8 in. (18.3 x 6.7 cm)
Museum Accession, 1957
57.627.36

OTHER EARLY WORKS IN THE COLLECTION

Otto, A French Photographer, 1900–1901
Direct carbon print
8 x 5 3/4 in. (20.4 x 14.6 cm)
Alfred Stieglitz Collection, 1949
49.55.231

Carl Marr, 1901
Direct carbon print
7 15/16 x 6 1/8 in. (20.2 x 15.5 cm)
Alfred Stieglitz Collection, 1933
33.43.10
Fig. 11

Edmond Joseph Charles Meunier, 1907?
Gelatin silver print
14 1/16 x 10 3/16 in. (35.7 x 25.9 cm)
Alfred Stieglitz Collection, 1933
33.43.11

Franz von Lenbach, 1901
Direct carbon print
10 3/16 x 5 1/8 in. (25.9 x 13 cm)
Alfred Stieglitz Collection, 1933
33.43.12

Moonlight—Winter, 1902
Gum bichromate over platinum print
13 9/16 x 16 11/16 in. (34.5 x 42.4 cm)
Alfred Stieglitz Collection, 1933
33.43.30

J. Pierpont Morgan, 1903
Carbon print
12 11/16 x 10 1/16 in. (32.2 x 25.5 cm)
Gift of George Blumenthal, 1941
41.71.7

Mrs. Stieglitz and Katherine, 1904, printed 1908
Gum bichromate over platinum print
19 1/2 x 15 3/16 in. (49.5 x 38.6 cm)
Alfred Stieglitz Collection, 1933
33.43.28

Mrs. Stieglitz and Katherine, 1904, printed 1908
Gelatin silver print
7 1/4 x 5 3/6 in. (18.5 x 13.6 cm)
Alfred Stieglitz Collection, 1933
33.43.19

Alfred Stieglitz and His Daughter Katherine, 1904, printed 1905
Platinum print
9 11/16 x 9 3/16 in. (24.6 x 23.4 cm)
Alfred Stieglitz Collection, 1949
49.55.228
Fig. 21

Trinity Church, 1904, printed later
Coated gum bichromate over platinum print
19 x 14 3/4 in. (48.2 x 37.5 cm)
Alfred Stieglitz Collection, 1933
33.43.41

Alfred Stieglitz and His Daughter Katherine, 1904, printed 1905
Platinum print
11 3/8 x 9 5/16 in. (28.9 x 23.7 cm)
Alfred Stieglitz Collection, 1949
49.55.230

Edward Stieglitz, 1905, printed 1907
Direct carbon print
9 9/16 x 7 11/16 in. (24.3 x 19.5 cm)
Alfred Stieglitz Collection, 1933
33.43.45

Edward Stieglitz, 1905, printed 1907
Direct carbon print
9 5/8 x 7 1/2 in. (24.4 x 19.1 cm)
Alfred Stieglitz Collection, 1949
49.55.169

Katherine Eunice Starr, 1907
Autochrome
6 1/2 x 4 3/4 in. (16.5 x 12 cm)
Gift of Starr Lawrence and Prudence O. Harper, 1982
1982.1183.1

Katherine Eunice Starr, 1907
Autochrome
6 1/2 x 4 3/4 in. (16.5 x 12 cm)
Gift of Starr Lawrence and Prudence O. Harper, 1982
1982.1183.2

Katherine Eunice Starr, 1907
Autochrome
6 1/2 x 4 3/4 in. (16.5 x 12 cm)
Gift of Starr Lawrence and Prudence O. Harper, 1982
1982.1183.3

Katherine Eunice Starr, 1907
Autochrome
6 1/2 x 4 3/4 in. (16.5 x 12 cm)
Gift of Starr Lawrence and Prudence O. Harper, 1982
1982.1183.4

Katherine Eunice Starr, 1907
Autochrome
6 1/2 x 4 3/4 in. (16.5 x 12 cm)
Gift of Starr Lawrence and Prudence O. Harper, 1982
1982.1183.6

Allen Starr, 1907
Autochrome
6 1/2 x 4 3/4 in. (16.5 x 12 cm)
Gift of Starr Lawrence and Prudence O. Harper, 1982
1982.1183.5

Theodore Roosevelt, 1908, printed 1909
Direct carbon print
20 1/16 x 15 1/16 in. (51 x 38.2 cm)
Alfred Stieglitz Collection, 1933
33.43.35

Balzac, The Two Lights—2 A.M., 1908
Direct carbon print
11 1/8 x 8 1/8 in. (28.2 x 20.6 cm)
Alfred Stieglitz Collection, 1933
33.43.5

◆　　◆　　◆　　◆　　◆　　◆　　◆

Designed by Bruce Campbell

Composed in Adobe Bembo with Rilke display,

a typeface designed by Daniel Pelavin

Color separations by Martin Senn, Philomont, Virginia

Duotone separations and printing by

Stamperia Valdonega, Verona, Italy

◆　　◆

◆